VGM Careers for You Series

Cheryl McLean

NORTHWEST MISSOURI STATE UNIVERSITY LIBRARY MARYVILLE, MO 64468

Library of Congress Cataloging-in-Publication Data

McLean, Cheryl

Careers for shutterbugs and other candid types / Cheryl McLean. p. cm.

Includes bibliographical references.

ISBN 0-8442-4112-1 (hard). -- ISBN 0-8442-4114-8 (soft)

1. Photography--Vocational guidance. I. Title.

TR154.M38 1995 770'.23'2--dc20

94-3539 CIP

Published by VGM Career Horizons, a division of NTC Publishing Group 4255 West Touhy Avenue

Lincolnwood (Chicago), Illinois 60646-1975, U.S.A.

© 1995 by NTC Publishing Group. All rights reserved.

No part of this book may be reproduced, stored in a retrieval system, or transmitted in any form or by any means, electronic, mechanical, photocopying, recording or otherwise, without the prior permission of NTC Publishing Group.

Manufactured in the United States of America.

4567890VP987654321

770.23 M16c

Contents

About the Author	vii
Acknowledgments	viii
CHAPTER ONE Careers for Shutterbugs and Other Candid Types—Introduction	1
CHAPTER TWO The News Beat—Photojournalism and Press Photography	y 21
CHAPTER THREE Say Cheese—Portrait and People Photography	44
CHAPTER FOUR The Selling Game—Commercial and Advertising Photography	61
CHAPTER FIVE Free-lens-ers and Other Independent Types—Freelance Photography	75
CHAPTER SIX Have Camera, Will Travel—Travel Photography	110
CHAPTER SEVEN The Natural Scene—Nature and Wildlife Photography	129
CHAPTER EIGHT Serving the Public—Government and Military Photography	140

CHAPTER NINE	
The World at Work—Industrial and	
Corporate Photography	155
CHAPTER TEN	
The Fantastic Voyage—Scientific and	
Medical Photography	168
	100
CHAPTER ELEVEN	
The Digital Revolution—Electronics, Computers,	
and Their Impact on Photography	179
CHAPTER TWELVE	107
The Fine Art of Photography—Artist Photographers	197
CHAPTER THIRTEEN	
Related Photography Careers—More Opportunities	
for Camera Buffs	210
	-10

About the Author

heryl McLean has been a writer, editor, and sometime photographer for more than 15 years. She operates a desktop publishing, design, editing, and writing business, ImPrint Services, in Corvallis, Oregon. She holds a bachelor's degree in English and a master's in Journalism. She taught journalism and writing courses at Western Oregon State College and the University of Oregon.

She studied photography independently, and her photographs have been published in books and magazines. Her own book, Oregon's Quiet Waters: A Guide to Lakes for Canoeists and Other Paddlers, is currently being revised for release in 1995. It contains many photographs that help her escape to mountain lakes in her imagination when the work load won't let her get away from the computer.

She is the president of the board of directors of CALYX, Inc., and has served on the editorial boards for CALYX Books and CALYX: A Journal of Art and Literature by Women since 1979. She handles all design and production for CALYX, which has won several national and regional awards for its publications.

Ms. McLean is married and has a young daughter. Her family enjoys taking walks along the stream that runs through their property, feeding the cutthroat trout, wood ducks, and mallards that live in the pond, and giving handouts to the deer and raccoons that come to the back door.

Acknowledgments

Would like to thank the following organizations and individuals for the tremendous help they gave in the preparation of this manuscript. I met many of these people through America On-Line's Kodak Photography Forum, and I was delighted and surprised by the generosity of my new AOL friends. It's not a cliché—I couldn't have done it without them!

American Society of Media Photographers ANDY BAIRD **JOHN BAUGUESS** BRIAN BEAUBAN LAURA BENIAMIN HARRISON BRANCH IENNA CALK MARGOT CONTE MARK CRUMMETT CHARLES H. COOPER, National Press Photographers Assoc. BILL AND JANET DAVIS WALTER FARRELL FRIENDS OF PHOTOGRAPHY TAMLIN GREGORY PETER HOWSON Ron Jameson HARLEY JESSUP NORMA JESSUP BOB KRIST

DON LANDWEHRLE **JESS LOPATYNSKI JERRY MARKOVITZ** DANA MARKS DALE MARTIN DAN MCCOMB BOB MCEOWEN TIM MIRREN LEWIS NELSON **JEFF OWEN** SUSAN PETERS TIM POTTER PAT RAY Kelly Richmond ORRIN RUSSIE JOHN AND ELLIN SAVERIN HAROLD SENN MARILYN SHOLIN MICHAEL THOMPSON Kevin Whitmore **JIM WILLIAMS**

Special appreciation goes to Micki Reaman, who contributed both research and writing for the chapters on scientific and medical, government and military, industrial, and portrait photography.

viii

CHAPTER ONE

Careers for Shutterbugs and Other Candid Types Introduction

There's an old adage that goes something like this: Picture takers are a dime a dozen, but a real photographer is worth plenty. Anyone can take pictures. Even my mother manages to get our heads in the picture frame some of the time. The burgeoning popularity of 35mm point-and-shoot cameras, with their sophisticated light metering and focusing, can give even the most indifferent snapshotter a degree of success.

But a photographer produces much more than a snapshot, much more than a quick recording of an occasion when the family gathered around the Thanksgiving Day dinner, or when the tour bus stopped at a particularly breathtaking vista.

A photographer gives you the moment itself, captured in a way that fills in the sounds and smells and textures that stimulated the senses at the instant the photograph was taken. A photographer tells a story, makes you long to see that enchanting view for yourself, brings to life a fleeting image that most of the world might have missed had it not been for the photographer's keen eye and deft touch with a camera.

A photographer has a passion for the craft itself, thrills when a photograph achieves its potential. A *real* photographer has not necessarily published or shown work beyond an immediate circle of family and friends, but has tremendous potential to turn those talents toward a profitable and enjoyable career.

2 CAREERS FOR SHUTTERBUGS

This book is devoted to those photographers who have developed—or have a desire to develop—their abilities, their photographer's "eye," and who want to take that extra step toward using their passion for photography to make a living.

Careers in Photography

Most professional photographers choose to specialize their work according to their particular interests. This book covers a wide range of career options, including advertising, industrial, portrait, wedding, nature, and fine art photography. For those more interested in the technical rather than creative aspects of photography, careers in science and medical photography, processing and printing, and repair and servicing are also discussed. For the generalist and independently minded photographer, a career as a freelancer might be the perfect choice.

Of the more than 120,000 professional full-time photographers in the nation in 1990, nearly half were self-employed, which is an unusually high percentage. This includes the numerous photographer-owned portrait and commercial studios, as well as freelance photographers who contract with magazines or advertising agencies.

Where the Jobs Are

According to the Occupational Outlook Handbook, most employed photographers, those working for a regular salary, can be found in portrait or commercial studios, newspapers, magazines, advertising agencies, and government agencies. Their titles might be photo editor, staff photographer, assistant photographer, or chief photographer.

The highest concentration of photography professionals per capita is in Washington, D.C., followed by Nevada, Hawaii,

New York, and Alaska. The lowest per capita concentrations are in Iowa and Indiana.

Future Prospects

The job outlook in photography, according to the Occupational Outlook Handbook, is encouraging. Employment in photography is expected to increase as fast as the average for all occupations through 2005. Increasing demand for quality visuals in all areas of communication and marketing, as well as research and development, education, and entertainment will help to fuel this growth.

A high level of competition in virtually every area of photography means that you will need strong technical skills and creativity along with an ability to represent yourself well to prospective employers or clients. Making it on your own rather than in a salaried position involves as much marketing and business savvy as expertise behind the camera. In this field as in many others, however, persistence and patience are the keys to success.

Income Potential

The range of earnings for photographers varies considerably and depends to a large degree on both the type of photography and the amount of time spent developing your career or client base. According to the *Occupational Outlook Handbook*, photographers involved with fairly routine work averaged nearly \$25,000 per year in 1991. More complex or difficult work earned an average of \$37,273.

According to one source in the newspaper industry, staff photographers earn from \$20,000 per year to more than \$45,000 per year, depending on the geographic location and the circulation size of the newspaper. The photo editor of a national

4 CAREERS FOR SHUTTERBUGS

magazine might earn between \$40,000 and \$80,000, depending on the magazine's circulation and the number of employees the photo editor supervises.

Photographers working on their own earn according to their level of expertise and their dedication to marketing. A photographer's day rate can vary from \$250 per day to \$2,000 per day for editorial or commercial photography, and from \$10 to \$2,500 for an individual photograph, depending on its use.

Advertising and commercial photography have perhaps the highest earning potential. In these fields it is possible to earn \$80,000 or more each year. On the other hand, fine art photographers have perhaps the smallest chance of earning a living entirely from their specialty.

For many photographers, however, the question of income is secondary to the many other benefits of a career in photography. The autonomy, the creative potential, and for many the freedom to choose one's own hours can mean more than high earning potential.

Education and Training

The technical expertise and visual "eye" required for a successful photography career can be gained by following a number of paths. No method offers a sure-fire first step into your new career, but some general advice applies to most areas of photography.

If you're still in high school, get involved with the yearbook, student newspaper, and any other school publications that require the services of photographers. You might be rewarded with academic credit or perhaps even a supply of film or a modest payment, but the true reward is the experience you gain working for a publication and seeing your photographs in print.

Classes in photography can be extremely valuable, particularly those giving you experience in operating your camera, processing and developing film, and taking photographs in a variety of experiences. Get as much experience doing your own darkroom work as possible because this provides tremendous insight into what happens to the film once it leaves the camera and what you can do before you shoot to influence the end result.

College Opportunities

In college, sign on with the yearbook or newspaper staff. Make yourself known to the art director in the publications office or the editor of the alumni magazine or newspaper. The more experience you gain, the more material you have to choose from when preparing your first portfolio.

Virtually every college, university, and vocational-technical college in the country offers photography courses, and several offer bachelor of fine arts degrees, which indicates a degree of commitment to the creative use of photography. Photojournalism is another major area of study at many colleges. These courses are usually offered within the journalism school or department.

Some of the areas of study available in colleges offering twoyear associate's degrees (Associate of Arts and Sciences or A.A.S.), four-year bachelor's degrees (Bachelor of Arts, Bachelor of Fine Arts, or Bachelor of Science), and graduate degrees (Master of Arts, Master of Fine Arts, or Master of Science) include the following:

- Advertising photography
- Aerial photography
- Airbrushing and retouching
- Animation
- Archaeological photography
- Architectural photography

- 6 CAREERS FOR SHUTTERBUGS
- Audio-visual production
- Biomedical photography
- Botanical photography
- Color photography & printing
- Computer animation
- Corporate photography
- Digital photography
- Documentary photography
- Editorial photography
- Electronic still photography
- Fashion photography
- Fine art photography
- Food photography
- Forensic photography
- High speed photography
- History of photography
- Illustration photography
- Industrial photography
- Landscape photography
- Medical and dental photography
- Nature photography
- Optical photography
- Photography for publication
- Science photography
- Videography

A college degree is not, however, a prerequisite to a successful photography career. One photojournalist I spoke with advises would-be press photographers to major in anything *but* photography. He asserts that photography as a craft can be learned on one's own or on the job, and that the broader educational background of a degree in liberal arts or other disciplines enhances your ability to understand and interpret the world around you and thus makes you a better photographer.

Photography Courses and Workshops

Nevertheless, basic courses in photography can be an extremely efficient means of developing the technical skills you need. These courses generally instruct students about how to use equipment to take photographs—camera, lenses, light meters, lighting—as well as how to develop and print photographs.

Many professional photographers caution against courses that try to teach a particular style or approach to photography. This, they suggest, is something you develop over the years as you take photographs, evaluate them, and learn from them.

Workshops in specific genres of photography can, however, provide an opportunity to work closely with a master photographer and profit from the feedback of others. There are workshops for amateurs and professionals, covering everything from infrared landscape photography to studio lighting techniques.

There are more than 500 workshops in photography offered through a wide variety of sources. Major camera and film manufacturers often hold workshops or seminars for professionals on new products and their uses that can help you keep up to date on technical innovations in photography. The *Photographer's Market* includes a listing of some 140 workshops in its annual publication. Photography workshops are also listed in *The Guide to Photography Workshops* and *Photographer's Forum: Photography and Travel Workshop Directory*.

In the long run, though, the number and type of courses you've taken won't be what will get you the job or the assign-

8 CAREERS FOR SHUTTERBUGS

ment. That requires great photos. And you only get those by shooting roll after roll after roll of film and becoming your own best critic.

Ernest Hemingway once said that to be a writer you need to have "a built-in, shock-proof crap detector." The same is true in photography or any creative field. You need to know when your work is good—and when it's not! Then work hard to bring your photographs to their full potential.

A Program of Self-Study

Becoming a photographer involves, above all, taking a lot of photographs. Whether you do this as part of a prescribed curriculum, in a handful of photo classes or workshops, or on your own, you need to develop technical proficiency and a thorough knowledge of your equipment and its potential and limitations, and you need to develop your photographer's "eye."

Go on "self-assignments." Give yourself a task to accomplish or a visual problem to solve, then use your camera to fulfill the assignment. As you take photographs, keep a notebook of the lighting conditions, the meter readings, the aperture and shutter speed settings. Photograph the same subject, altering one or more of the variables. Take more notes. When you process and print your film, take notes for the darkroom phase of the process.

Then study the photographs. Evaluate them for their technical quality—contrast, sharpness of focus, depth of field. Evaluate them for their aesthetic quality—composition, lighting, texture, content, or message. What worked well? What didn't work? What could you do to improve the photograph? Take more photographs, more notes, and evaluate again.

Meanwhile read whatever you can get your hands on. Look at the photographs of the photographers you admire as well as those whose work leaves you cold. Ask yourself why you like one photograph but don't like another. Gather as much of a sense of the history and development of photography as you can. Join a photography club to find others who can help provide insight and feedback about your work.

Equipment and Darkroom

If you haven't already invested heavily in equipment and darkroom setups, you might want to move slowly in this direction. Tim Mirren, now a commercial photographer with a thriving freelance business, started out with one 35mm camera body and two lenses. He took his black and white film to the darkroom at a community arts center, which he joined for \$25 per year, plus a usage fee for the chemicals. Color film he sent to a custom lab for processing.

As he got assignments, he took half the payment to live on and he poured the other half into additional equipment. He now has three 35mm cameras, a medium-format camera, and a 4-by-5-inch camera for studio work, as well as a private darkroom and a studio facility.

"That way I was able to build my commitment to this career as I built my experience base," Tim explains. "I didn't have to go into debt and then hope the jobs would come."

Most photographers, whether on staff or independent, prefer to use their own cameras, with the exception of portrait studios or large corporate staff situations requiring special, highly expensive equipment. The equipment you need will depend on the type of photography you will pursue.

Photojournalists, nature and wildlife photographers, and others who must be able to move quickly on the job will most likely use 35mm cameras and have more than one camera body, each loaded with a different type of film or lens. Their work often requires a quick response, and they don't have time to change film or lenses to get the best shot.

Studio photographers, on the other hand, will most likely work with a medium- or large-format camera. Wedding photographers, who shoot both portraits after the ceremony and more photojournalistic photographs during the ceremony, will often use both.

Tim cautions that photographers embarking on a career should wait to buy the best, rather than buy several lenses of lesser quality just to fill the camera bag. As a pro, you'll need your equipment to function at an optimal level. The same is true, he says, for a darkroom.

"I didn't invest in my own darkroom for a long time because I had access to one so inexpensively, and for color work I could always build processing expenses into the job," Tim says. "I set up the darkroom mostly for my own enjoyment. There are very acceptable alternatives available for getting professional processing and printing."

Continuing Education

Even professional photographers can benefit from additional training or expanded opportunities for gaining experience.

Perhaps the most significant technical innovations in recent years have been the development of digital photography and Kodak's Photo CD. The impact of these developments is only beginning to be felt, and future developments herald a major revolution in the way we think of and use photography.

Those on the leading edge of publications and communications technology caution photographers that if they want to hold a place in the future they will need to become familiar with the new world of digital photography. Courses or seminars in the new technology are offered by computer software companies, computer manufacturers, and the makers of the new digital cameras, as well as those colleges or universities with the budgets to afford expensive equipment. Chapter Eleven covers this subject in more detail.

Competitions

Photography contests are being held almost constantly, and they provide both amateurs and professionals an opportunity to gain recognition, remuneration, and publication. Two newsletters, *Entry* and *Photographic Resource Newsletter*, provide regular listings of photographic competitions and juried exhibitions.

Professional and amateur-oriented photography magazines frequently hold their own competitions, as well as publish listings of other requests for contest-entry submissions. *Petersen's Photographic Magazine*, for example, sponsors monthly contests and publishes the winning photographs in a subsequent issue. Kodak, Fuji, Nikon, Minolta, Olympus, and other film and camera manufacturers open anr. al photography competitions and use the winning photographs in advertising campaigns and other promotional publications.

In addition to established competitions, watch for photo contests offered by your local newspaper or chamber of commerce. Consider them photography assignments, then go out and take photographs with an eye toward winning first prize. Not only will this give you additional experience with photographing, it will provide insight into what it means to work "on assignment," with a specific task to complete or problem to solve. If you win, of course you receive both the prize and a "tearsheet" for your portfolio, as well as an impressive line on your resume.

Competitions sometimes have themes, but general competitions are open to all photographers, who then select a category of competition to enter:

- Documentary
- Fashion Illustration
- Feature

12 CAREERS FOR SHUTTERBUGS

- Food Illustration
- General News Event
- Personal Vision or Fine Arts
- Pictorial or Scenic
- Picture Story or Photo Essay
- Portrait
- Sports
- Spot News
- Wildlife or Nature

Competitions are available for both amateur and professional photographers. Some charge an entry fee. The only other word of caution is to avoid contests that retain all rights to your prizewinning photographs. For a more detailed discussion of copyrights and rights sales, see Chapter Five.

Getting Started

Like educational background, your first steps into your career will vary according to your interests and the opportunities in your area. Each chapter offers specific advice for that career path, but some advice is general enough to apply to whichever field you choose.

Before you approach your first job interview or presentation to a prospective client, you need to have demonstrated your technical expertise, your aesthetic or creative ability, and your previous experience. The tools for demonstrating these accomplishments are the portfolio and the resume.

The Photographer's Portfolio

Whether you're hoping to land an assignment with a New York advertising agency or a full-time job with the local newspaper, as a photographer you need a portfolio. The portfolio is a collection of your work that shows what you are capable of, what you have done, and what your work is like in terms of its approach or style.

"Your portfolio should include the best of what you've done," says Harrison Branch, professor of photography at Oregon State University. "You need to carefully evaluate each image, look at how it fits with others as part of a presentation, and then ask what the entire package says about you as a photographer."

If, once you've edited through all your photographs and found those you would call your best work, you see that they're all the abstract landscapes or cute candid kid shots, you'd better be looking for a job that requires you to take pictures of that subject. That's what your portfolio shows that you can do well. If you want a job that calls for shooting a range of subject matter in a variety of ways, you need to show that you can achieve a level of diversity.

As you prepare your portfolio, then, ask yourself what kind of work you are hoping to do. The next question is who will be looking at your portfolio, and what are they looking for. It's not unusual to tailor separate portfolios for specific jobs. Make sure the message you're sending is the one you want to communicate.

The Resume

As a photographer, your resume is often what gets you in the door to show your portfolio. Your resume alone won't get you a job—that's up to your photographs. But it can get you interviewed, and that's an important enough step to warrant spending time polishing your resume. For the most part, resumes should fit on a single sheet of paper. If you have long lists of exhibitions or publications to your credit, you might add a line at the bottom that in addition to a portfolio, you have both references and an exhibit or publication list available on request. Then make sure you have these lists ready if they are requested.

The resume needs to include all relevant education and training, work experiences, military service, or specialized skills that will make it clear you have the credentials needed to get the job done. Professional memberships and other activities that relate to your career field are also important to include.

Several books are available on how to prepare a job-winning resume. You might also want to consult someone who specializes in resumes before you consider it finished.

Developing Your Job Prospects

Armed with a portfolio, a resume, and a good portion each of talent, determination, and patience, you're ready to plan your strategy. As you prepared your portfolio, you determined the kind of work you are seeking to do as a photographer.

Set some goals for the kind of job or the kind of employer you want to find. List all the things you have to offer in that situation. Then develop a list of prospective employers or clients that fit those requirements. Don't worry if they're not actively advertising for a photographer. Often times, jobs are filled or assignments are given through the grapevine or because a persistent photographer kept in touch with an editor who expressed an interest.

If the kind of job you really want is out of reach for your experience or background, look for a job that's both related and that gives you an opportunity to add to your skills or knowledge base. Working in a camera store or processing lab gets you in contact with photographers and others in the business who can be a tremendous resource. When you make job contacts, by phone or by cover letter, always ask for an opportunity to show your portfolio. Remember, it's your photographs that will get you hired. Regardless of the outcome of the portfolio presentation, be sure to follow through with a note of thanks. Call back if you haven't heard anything for a week or so after the presentation. Be sure the employer knows you're interested.

Internships

Working for a school publication provides a brief introduction to the work of photography, but it's vastly different from the "real world" of a daily newspaper or an advertising agency. An internship or apprenticeship in such an organization can give you a clearer sense of the demands and rewards offered in the various career paths in photography.

Many photojournalism programs at colleges and universities offer formal arrangements for internships with newspapers or magazines. In addition to the experience you gain, at the end of the internship you've added a valuable line to your resume.

It is also possible to make internship or apprenticeship arrangements on your own, although this involves almost as much perseverance as your ultimate job search. There are a number of avenues to follow, depending on the area of photography you wish to pursue. An aspiring photojournalist might ask to tag along with the photographer of a local daily or hang out in the darkroom and editorial rooms with the photo editor for a few days.

Someone seeking a career in commercial or advertising photography might approach a studio owner with an offer of free or reduced-wage assistance in exchange for the opportunity to learn the ropes from a pro. Go in as if you were applying for the job of a lifetime, and be prepared for rejection. Cheap labor isn't necessarily always a bargain. It takes time to work with a novice, and a busy professional may not have time to spend training someone who doesn't have a demonstrated ability to build on.

Assisting

Okay, you've graduated from college, you've prepared a dynamite portfolio of self-assignment photographs, you've maybe even spent a few weeks working side-by-side with a master photographer. You're ready to become a professional photographer, ready to take on the big time jobs, right? Well, maybe. Photography is a highly competitive pursuit, and sometimes you need to be prepared to wade in shallower waters before you dive into the deep end.

Working as a photographer's assistant is an opportunity for you to gain what you need in order to swim with the big fish: experience. Regardless of the level of education you've received and the sophistication of your training, you still need experience to get the attention of top employers and clients.

As an assistant, you usually don't get direct experience behind the camera, but you do gain experience with literally everything else. You watch to see how the professional handles difficult lighting situations, unusual creative problems, or picky clients. The procedures for setting up a still life, making arrangements for a location shoot, working with models, and turning in film become commonplace.

Then when you've worked hard, shown talent, and proven your abilities, the photographer you work for won't have any qualms about recommending you when a job comes along that's too small or doesn't pay enough to cover high-priced professional rates. That's when you start to get experience behind the camera as well as behind the scenes.

Professional Associations

For every specialty in photography, there's a membership organization to provide information, networking, and support. Many of these offer student membership rates, and most publish regular newsletters or journals that provide a wealth of information. Employment listings are often included in that information.

Many seminars offer critique services, where experienced professionals review your photographs and provide feedback and advice on how to improve your work. This is an extremely valuable service for someone beginning a photography career.

Conventions, seminars, trade shows, and equipment purchase discounts are some of the extra benefits of membership. In addition, many offer group insurance plans for personal health and disability insurance for photographers working independently.

For someone seriously interested in pursuing a career in photography, membership in a professional organization is well worth the annual dues. Individual organizations are listed at the end of the relevant chapters. Some of the more general membership associations include the following:

- American Association of Media Photographers. 14 Washington Road, Suite 502, Princeton Junction, NJ 08550-1033.
- Associated Photographers International. 5855 Green Valley Circle, Suite 109, Culver City, CA 90230.
- Pictorial Photographers of America. 299 W. 12th St., New York, NY 10014-1833.
- Professional Photographers of America. 1090 Executive Way, Des Plaines, IL 60018.
- Professional Women Photographers. C/o Photographics Unlimited, 17 W. 17th, New York, NY 10011.

On-Line Resources

As I began research for this book, I discovered America On-Line, a computer-accessed information network that linked me to photographers all over the world. I "met" some wonderful people, "eavesdropped" on enlightening "conversations" about photography and art on the electronic bulletin boards, and received a wealth of information about the work of a variety of photographers through the wonders of electronic mail.

As more and more people join the millions already on-line through services such as America On-Line, Prodigy, CompuServe, and Genie, to name only the most popular, these will become increasingly important resources for your job search. Professional membership organizations have on-line bulletin boards where members may pose general questions or post notices about new developments in the field, issues of interest, and even job listings.

The National Press Photographers Association, for example, operates a Job Information Bank, which it has made available through certain on-line services to NPPA members only. As a member of NPPA, you can use your home computer, a modem, and a membership in the on-line service to check daily for new listings, post your resume, and tap into an international network of photojournalists.

Keys to Success

Because photography has so much to offer as a career choice, and because taking photographs and seeing them in print—and then getting *paid* for it—is just plain fun, there are a lot of people out there who'd like to do this for a living. Photography is a competitive field. To assure success, you need more than a camera and know-how. As you develop your skills, hone your talent, and add to your base of experience, remember to work on these fundamentals:

- Technical mastery
- A photographer's eye

- Business and marketing skills
- Determination
- Commitment
- Persistence and patience

The rewards are there if you're willing to go after them and work toward your goals. In the following chapters, I outline some of the many choices you have as a photographer embarking on a career with your camera. Undoubtedly there are some areas I've missed, but I hope this gives you a sense of the range of possibilities and how you might begin to use your camera to make something you love to do what you do for a living.

For Further Information on Starting a Career in Photography

Periodicals

- Darkroom Photography. 9021 Melrose Ave., Suite 203, Los Angeles, CA 90069. (Magazine published eight times a year; devoted to photographic techniques.)
- *Entry*. Box 7648, Ann Arbor, MI 48107. (Newsletter published 10 times per year; guide to photographic competitions and juried exhibitions.)
- Modern Photographer. 825 Seventh Ave., New York, NY 10019. (Monthly magazine for serious amateurs.)
- Petersen's Photographic Magazine. 8490 Sunset Blvd., Los Angeles, CA 90069. (Monthly magazine for amateur and semi-professional photographers.)
- Photographer's Forum. 511 Olive St., Santa Barbara, CA 93101-1638.
- Photographic Resource Center Newsletter. Boston University, 602 Commonwealth Ave., Boston, MA 02215-1300. (Guide to photo exhibits, lectures, conferences, publications, contests, and workshops.)
- *PhotoPro.* 5211 S. Washington Ave., Titusville, FL 32780. (Monthly magazine for professional photographers.)

Popular Photography. Ziff-Davis Publishing, One Park Ave., New York, NY 10016. (Monthly magazine for amateur photographers.)

- Professional Photographer. Professional Photographers of America, 1090 Executive Way, Des Plaines, IL 60018. (Monthly magazine for members of PPA emphasizing technique and equipment for professionals.)
- The Rangefinder. 1312 Lincoln Blvd., Santa Monica, CA 90404. (Monthly magazine on technique, products, and business practices.)

Shutterbug. Box 1209, Titusville, FL 32781. (Monthly magazine of photography news, photo features, and equipment reviews.)

Books

- Provenzano, Steven. Slam DunkResumes. Lincolnwood, IL: VGM Career Horizons, 1994.
- Brackman, Henrietta. The Perfect Portfolio. NY: Amphoto (Watson-Guptill), 1987.
- Duboff, Leonard. Photographer's Business and Legal Handbook. Cincinnati, OH: Writer's Digest Books, 1989.

Johnson, Bervin, et al. Opportunities in Photography Careers. Chicago, IL: VGM Career Horizons, 1991.

Photographer's Market: Where and How to Sell Your Photographs. Cincinnati, OH: Writer's Digest Books, Annual.

Special Resources

A Photographer's Place. 133 Mercer St., New York, NY 10012. (A new and used bookstore devoted entirely to photography subjects.)

Photography Book Club. Watson-Guptill Publications, 1515 Broadway, New York, NY 10036. CHAPTER TWO

The News Beat Photojournalism and Press Photography

irtually every newspaper, no matter how small, employs at least one photographer; that person also may be the paper's editor, reporter, and darkroom technician. However, with the notable exception of the *Wall Street Journal*, any newspaper's content includes photographs.

Readers want pictures with captions that tell a story quickly —they often don't have time for more than that. Reader surveys have shown repeatedly that first a reader looks at the photograph, then the caption, then the headline, and then perhaps the first paragraph of the story. The photographer works with the reporter in the desire to "hook" the reader with an interesting photograph, something to entice the reader into reading the story to find out what is happening in the photo.

Some have called photojournalism "reporting with a camera." *Photojournalism* is a term coined to describe the unique merger of pictures and words to present newsworthy information in print media. A news photograph tells the story with imagery rather than words. It brings a sense of immediacy and validity to a story.

Toward this end, the photojournalist is as much involved with communication as is the reporter. Whether it's the anguished look of a basketball player who just missed a crucial shot or the triumphant salute of a victorious candidate for the presidency, the photojournalist seeks to capture what Henri Cartier-Bresson called the "decisive moment"—the moment that expresses the heart of the story.

Photography is an elemental part of the design or look of a newspaper. A photograph might be a "drop-in" that provides some welcome relief from column after column of gray type. In an increasingly visual world, the importance of photography in the print media has increased, as witnessed by the expanding use of color in newspapers across the country.

Working Conditions

Even when not on assignment or in the darkroom, the photographer of a news organization is always "on duty." The camera is as much a part of the news photographer's requisite accessories as the notepad and pencil are of the reporter's.

How a news photographer spends the day depends on whether the newspaper is a daily, weekly, or monthly, and if it's published for morning or afternoon distribution. A photojournalist also may work for one of the major news bureaus, such as the Associated Press or Knight-Ridder.

What the photographer shoots depends on the size of the paper. The larger the paper, the more opportunity for the photographer to specialize in an area such as sports or features. With a smaller paper, it's more likely that assignments will range from covering local school board meetings and high school basketball games to being on the scene of a four-alarm fire.

Life at a Daily Newspaper

Mark Crummett works as a photographer for the 45,000-circulation *Frederick News-Post*, a community daily newspaper in Maryland. "We cover the community like a blanket," Mark explains. "If it doesn't happen in Frederick County, it doesn't happen for us. Our managing editor tells people, 'if you want to know what happened in Bosnia, read the *Washington Post.*"

The *News-Post* photographers get their assignments from an assignments editor. This person fields the calls from people wanting their picture in the paper, then logs the information into the assignment book. Photographers check the book when they come on shift, then get assignment forms that specify who and what to photograph. If needed, they check with the reporter, editor, or subject of the photograph for more information. Sometimes Mark works directly with the reporters to provide shots for their stories.

Variety Is the Spice of a PJ's Life

A staff photographer might cover any and all of the following subject areas:

- Advertising
- Business and industry
- Celebrity photos
- Documentary photo essays
- Fashion
- Features
- Food
- Home and real estate
- Photo illustration
- Planned event coverage
- Public Relations (the newspaper's PR)
- Sports
- Spot news

24 CAREERS FOR SHUTTERBUGS

Sports is a subject that gets many beginning photographers into the news business. Usually the fascination starts in high school or college when you're sitting on the sidelines watching the game, maybe with camera in hand, and you manage to shoot a fantastic picture of the quarterback catching the winning pass in the end zone. The thrill is infectious and tenacious, and keeps many a photographer working hard to repeat the significant moment.

Sports is also a common section of the paper for which to find freelance work. Staff photographers often can't cover everything, especially with the increasing popularity of women's sports and once lesser-known sports such as soccer and rugby. A freelancer who manages to snap some telling photos at these events has a good chance of making a sale.

All five staff photographers at the *News-Post* shoot for the business, agriculture, food, and family/entertainment sections of the newspaper, and occasionally for the advertising department and for internal company communications such as the company directory.

"For me, one of the great things about working at a newspaper is that almost every day is different," says Mark. "Certainly there are the perennial assignments, things that come up every year—the fair, fundraising events and their promos, new organization officers. But we get to shoot a lot of different things."

When there aren't assignments on the book, or between assignments, photographers often cruise for feature photos—wild art, enterprise, slice-of-life photos that show what's going on in the area. "These are probably the best part of the job for me," says Mark. "They give me an excuse to walk up to total strangers and say, 'Hey, what ya doin'?"

While out of the office, each of the photographers on the *News-Post* carries a two-way radio to be able to contact other photographers and the newsroom to report spot news (events occurring "on the spot," such as automobile accidents or police

actions), or to check on assignments. "These have really come in handy for things like presidential visits," Mark explains. "George Bush occasionally played golf near here, and Camp David is in the northern end of Frederick County."

The Pressure of Deadlines

On a daily paper, deadlines are set throughout the day to meet various printing times for editions of the paper. A late-breaking story may involve getting an assignment at 10:00 P.M., driving across town to shoot the story, and returning to develop and print the film in time to put photos on the editor's desk by 11:30 P.M. A daily paper scheduled for afternoon delivery might have deadlines at 4:00 A.M. and again at 7:00 A.M. and 10:00 A.M.

At the *News-Post*, at least one photographer is on duty from 7:00 A.M. to 10:30 P.M. every day, and the chief photographer usually listens to a police scanner at night. The late-shift photographer is responsible for covering sports, usually local high school or collegiate events. After shooting the first half of the game, the photographer returns to the darkroom to develop the photos for the next day's paper.

Darkroom Duty

During the last half of his shift, Mark returns to the office to process film, make prints, and write captions. Each of the photographers is responsible for doing his or her own darkroom work, and all share responsibility for mixing the chemicals and maintaining general cleanliness. At the *News-Post* and most daily newspapers across the country, approximately 95% of the film is black and white, with color being used on page one, above the fold, and on section cover pages.

USA Today, in contrast, shoots only color photographs, and many Sunday editions use color photos throughout certain sections. At the *News-Post*, color is printed on Monday and Tuesday, so the weekend photographer is responsible for getting a color photo, either a stand-alone or something that accompanies a story. Color processing is done at a local one-hour shop, although the paper plans eventually to do color in-house with a scanner.

The Weekly Routine

The pace at a weekly paper revolves around one deadline each week. The photographer will most likely be assigned to cover local meetings, school sports, and the standard "grip and grin" shot of the mayor handing over the key of the city to a visiting dignitary. In addition, the editor may assign some photography for a forthcoming feature story, or the ad director may need a few shots of the new grocery store in town for an advertising spread.

It's not uncommon to see events, people, or scenes of interest on the way to work, but once at the paper's offices, the photographer picks up assignments from the photo editor. There may be several assignments, some for immediate action, some for next week's deadline. The photographer then works with the reporter to get familiar with the story, schedules the shoot, and develops and prints the film.

Staff Photographer: Weekly Newspaper

Jenna Calk is a staff photographer for two weekly papers in Oregon. She works as the primary photographer for one of the papers, and handles all the darkroom work for the other. She works four days a week and has the freedom to develop her own story ideas.

Jenna believes that working for weekly papers offers several advantages over working for most dailies. Deadlines are more relaxed, which allows time for creativity and thoroughness. "If I find out that we're missing the name of a player on the football shot, I have a couple of days to run out and get the player's name," Jenna explains. "Also there's a lot of freedom for special projects. If I come up with an idea and the editor buys it, I may end up with a full-page photo story. On a daily, you have to lobby a lot more aggressively to get half that space."

As the only photographer on staff, Jenna likes the fact that she gets all the assignments. She doesn't have to take only the dull grip-and-grin shots while someone else gets to attend a celebrity event.

"I would like to move to a daily paper, but I'm also realizing how competitive it is," she admits. "I've been doing this since I graduated from college in 1984. I've applied to a lot of jobs, but I'm married and like this area, so there aren't a lot of options."

Staff Photographer: Monthly Tabloid

There are many monthly publications that straddle the line between newspapers and magazines. These are often approximately half the size of a newspaper, and twice the size of a magazine. Their content generally includes both news and features. Most are too small to include more than one photographer on staff.

Bob McEowen works as the staff photographer—and sometimes writer, designer, and editor—for a monthly statewide newspaper published by a regional utility company. Combining responsibilities for writing and photography, as well as decisions about what does and does not appear in the newspaper, has changed the way he looks at photojournalism.

Bob had worked as a newspaper photographer but felt there was something missing. "When I was a news photographer I was pretty much an order filler," he explains. "Now I believe I am truly a photojournalist. Not only do I do it all now, but I have more freedom than I did when working for a newspaper."

The Ups and Downs of Press Photography

With any paper, the photographer has to be ready to be sent out on a breaking story any time of day or night. They have to

28 CAREERS FOR SHUTTERBUGS

be quick, agile, and capable of carrying a heavy camera bag for long hauls. And they have to be able to get the shot taken without getting shot.

Photojournalists covering wars or civil unrest, natural disasters, or a feature story that takes them into dangerous segments of society have to face the possibility of personal injury or even death. When I was in London in 1993, a photographer whose newspaper had been tipped off to a bomb threat in the City's financial district was killed as he wandered the virtually empty street seeking a photograph. The bomb blew out several buildings and I felt the trembling force of it several miles away, but the press photographer was the only person killed.

Photographers might have to face deeply moving or tragic situations that they capture on film, and it can be difficult to turn in the film without taking home some of the agony of the experiences. A photographer sometimes confronts the moral dilemma of whether to take a photograph or to respect an individual's need or right to privacy.

One Photographer's Adventure

By the same token, photojournalists share in some remarkable triumphs. As one photographer relates, it helps to be prepared for all eventualities in this business. Mark Crummett, a photographer with the *Frederick* (Maryland) *News-Post*, went to photograph a rescue from an icebound home far back in the Maryland woods. A man had fallen while walking the dog and hurt his leg. His wife fell trying to help him, breaking her ankle. It took her two hours to drag herself back up the icy road to their home where she called rescue personnel.

Mark arrived at the scene after the first truck had gone in. He followed, picking his way over the ice-covered road through the woods, falling himself a couple of times. With the first fall, he broke his radio, which left him unable to contact the newspaper. The second fall broke the bulb in his flashlight. A state helicopter was circling and lighting the area, but the wildly moving shadows from its search light made taking photographs without his own lighting difficult.

As he approached, Mark slid down the road a couple of hundred feet to the scene, where he found a crew of firefighters working their way up the road on the other side of the valley, roped together and hacking footholds in the inch-thick ice with an ax. There was nowhere to stand except where they had chopped—any misstep would send him sliding to the bottom of the hill.

As the firefighters mountaineered up the hillside, Mark started taking photos of the chopping-and-roping routine. After one frame, he heard a familiar groan from his camera that meant only one thing—the batteries were dying fast in the subfreezing air. He was about to be stuck in the middle of a dramatic rescue, a mile from anywhere with no way out and no means of reporting to the paper, in the dark, with no flash.

"I suddenly remembered that I had my brand new Nikon Litetouch in a case on my belt!" Mark realized. "I was saved!"

He continued up the hill with the rescue workers and photographed them sliding the woman out her front door in a Stokes basket and down the hill to the rescue truck. And, thanks to a co-worker, the film made it out in time for the shots to appear on the front page of the next morning's paper.

Toward the 21st Century

The newspaper industry has been radically altered by the development of computer and satellite technology. Much of the "hands on" work of putting a newspaper together has shifted to the electronic environment of computers, scanners, modems, and imagesetters.

The News-Post has been scanning photographs into computers, and their composing room—formerly staffed by typesetters

working at desk-sized compositors—is now entirely equipped with desktop computers.

Photographers working for news bureaus and larger metropolitan daily newspapers have, willingly or not, had to come to terms with the digital revolution in photography. A laptop computer, portable scanner, and modem are standard equipment for a photographer traveling on assignment.

After printing the photograph, the photographer then scans it into the computer and sends it over the telephone wires to the newspaper's photo editor. From there it is cropped electronically and placed within the page layout on the newspaper. Once the layout is complete, it is downloaded to the printing plant. There is no more rushing wet prints to the layout department, or driving paste-ups across town to the printer. When the newspaper is "put to bed," it's with the touch of a button.

Digital Cameras

The next phase in the digital revolution, which is already on line at some of the larger papers and news weeklies, will eliminate the darkroom from the process. Digital cameras, only recently released on the market, store images on an internal computer chip that can be downloaded to the photographer's computer. From there, computer software programs such as Adobe Photoshop allow the photographer to work some "darkroom magic" within the electronic environment of the computer. Dodging and burning, sharpening highlights, and masking images all can be done electronically without ever turning out the lights or mixing chemicals.

Kelly Richmond, who works as a freelance stringer for the Associated Press and several daily newspapers, says that a means of instant transmission to the newspaper is a must for photojournalists who work on tight deadlines or with breaking news stories. The amount of time needed to shoot the image and get it to the news desk is compressed to a matter of minutes rather than hours.

The High Cost of High-Tech Equipment

Photojournalists working on their own may find the cost of high-tech equipment prohibitive. Digital cameras cost \$6,000 or more, and the systems for sending to the news bureaus, such as the Associated Press Leafdesks, run another \$5,000. Some photojournalists, however, suggest that a good scanner and communications software program can work well and reduce the cost to around \$3,500 for essentially the same result, with only a slight loss in the speed of transmission.

Getting Started

In today's hiring market, the photographer with a bachelor's degree or a graduate degree will have an edge in an interview, portfolios being equal. But there's no replacement for experience photographing for publication, with the clips to prove it.

Jumping into Photojournalism

Dan McComb, an intern at the Spokane Spokesman-Review, started his career in photojournalism in a dramatic but roundabout fashion.

"When I was about 18, my main mission in life was figuring out how to pay for a ski season pass," he explains. He took up fighting forest fires during the summer for the United States Forest Service, eventually working his way into the elite smoke jumping ranks. "One particularly grueling day, I found myself looking down as I drifted toward a patch of jagged rocks and burning trees, and I thought to myself: 'This is pretty ridiculous. Nobody would believe it!' "He decided to start carrying a camera with him, and after a couple of seasons he found he was spending more time working the shutter than working the fire line.

32 CAREERS FOR SHUTTERBUGS

A broken back and pelvis on a fire jump made a career change extremely attractive. He went to the University of Montana's School of Journalism; then won a scholarship to study photojournalism in London with a former *National Geographic* director of photography.

Following graduation, Dan worked as an intern for papers in Montana, Michigan, and Tennessee. His experience attests to the high level of competition in this fast-paced area of photography.

"I had no idea it would be this tough to get a 'real' job," Dan says. "Internships come easy because newspapers don't have to pay you benefits. But they're great experiences, so I'll probably bounce around from paper to paper until somebody gives me a place to hang my hat."

But he's not discouraged. "In photojournalism, as in smoke jumping, it pays to keep an airborne attitude."

Advice from the Pros

Shoot, Shoot, Shoot

As with any field in photography, the key element to success is taking pictures—shoot all the time; then go into the darkroom and develop, print, and see what you've got.

Mark Crummett's advice is to keep a camera (or several) with you all the time. As one of his editors once said, "When in doubt, take lots of pictures."

"Shoot anything you think the paper may be interested in," Mark continues. "The worst that could happen is they won't use it. Our paper doesn't use freelancers for assignments, but we will run just about anything they send in for local organizations or promotions."

Networking

Mark also suggests "buddying up" with photographers at the local newspaper. The newspaper may not have any openings available, but the photographers are in a position to tell you about jobs opening at other papers. They'll also probably be happy to comment on your work; however, Mark cautions, "be prepared for some honesty!"

Get a degree in something *other* than journalism, such as business, political science, sociology, or another academic discipline, Mark advises. "Journalism and photography are crafts," he explains. "They can be learned easily enough. But you have to learn how to *think* first."

Another important tool for photographers in the coming decade is the computer. Most likely, within the next 10 years you will have to know how to manipulate an image on the computer, as well as on film and paper. Many job descriptions for photographers already specify computer experience as required.

The Importance of Communication

Degrees in journalism, history, political science, or art are all good starting places for careers in photojournalism. Because of its strong emphasis on communication, journalism is a natural fit that provides valuable insight into the workings of the news industry and the job of a reporter.

The job of communicating with photographs for a news publisher involves more than just shooting pictures. You need to develop a "nose for news." What makes a good story, both visually and in print? Is it new? Is it timely? Is there a human interest angle? Does it capture local interest?

Photo Captions or Cutlines

In addition to getting the image, you need to be able to get the story as well. Most newspapers require their photographers to provide full caption information when submitting the print. That means getting the five Ws of journalism answered with as much information as possible. Not all of it will be used in the caption, but it's better to err on the side of too much information than not enough. If you don't get a contact name and number, you'll never be able to go back to the subject of the photo to fill in the gaps in your information.

The five Ws of journalism form the basic building blocks of any news story.

WHO. To satisfy this element, you need to get all the names of the individuals appearing in the photograph. When getting names, it's essential to get correct spellings and any initials or additions, such as Jr. or Sr., to help specifically identify each individual. Addresses are also important identifying information.

WHAT. What's happening in the photograph? Use active, present tense verbs to describe the action of the image: a fire burns out of control, the mayor addresses a crowded news conference, the players run onto the field. The action of the image is the centerpoint of a strong photo caption.

WHEN. "When" is an important element for most photographs in news publications. While a story on the state's senator might run with a file photo, a story on a political rally for a senator would need to include a photo of the event itself. A newspaper isn't interested in running a photo that isn't "new," even if it's just a "passing scenes" shot of a nice image to break up an otherwise gray news page.

WHERE. The degree of specificity required about location depends on the situation. Is the subject of the photograph in a courtroom? Fishing along the Muskogee River? Boarding a plane bound for Rio? Maybe you need to indicate that the car in which the subject is photographed is a police car on its way to the county jail. Often the "where" of an image will be irrelevant in the final caption, but as with the other elements, it should be included in the complete caption that you turn in with the photo.

WHY. Many photo captions don't address the question of "why" an action took place, although it can be important to explain what's going on in a photograph. The caption for Mark Crummett's picture of an emergency rescue worker chopping footholds into an icy hillside might include the "why" element for clarification: to rescue a couple injured by falls on the ice.

Useful Skills

The ability to speak a foreign language is a big asset for photographers working for larger papers, in metropolitan areas, or on travel assignments. A familiarity with computers, especially software related to photography and image-editing, will become more essential in coming years.

It also helps to be an "idea person." Reading the newspaper the one you want to work for especially, as well as other papers you admire—provides insight into what the editors are doing with the photographs, how the photos relate to the stories they accompany, and how the work you do would fit with the image a newspaper presents. Newspapers are also a terrific source for story ideas, which can help you get published if you haven't yet made a staff connection.

Finding Your Opportunity

As Green Bay Packers coach Vince Lombardi told his players, "Luck, that's where preparation meets opportunity." Being prepared, for the photojournalist, means that the camera or cameras are within easy reach, are loaded with film, and have charged batteries. Being prepared also means the photojournalist is always looking for the opportune moment.

With 1,570 daily newspapers, 891 Sunday editions, and thousands of weekly newspapers published in the United States alone, the opportunities for photographers in this field are broad. Photojournalism is one aspect of photography that is not limited geographically. A town doesn't have to be very large to warrant having its own newspaper, and it's at these small-town weekly papers that beginning photojournalists may find their first real breaks.

The most glamorous and exciting jobs in the field will most likely be found in major cities such as New York, Washington D.C., Boston, Chicago, or Los Angeles. For the photojournalist elite, these cities are merely jumping-off points for even more exotic and often more dangerous locations, such as Beirut, Bosnia-Herzogovina, and the Persian Gulf.

There's a limited amount of upward mobility in the field of newspaper photography. Major newspapers might list a senior vice president-art, a position that might be held by someone who started out in the newspaper's darkroom. Any daily newspaper and some larger weeklies will have a photo editor on staff. As a working press photographer, your goal might be to get glamour jobs like covering the campaign trail of a presidential candidate for the *New York Times* or *Washington Post*, or being assigned to the Paris bureau of the Associated Press.

Starting in the Darkroom

You might begin a career in newspaper photography in the darkroom, spending six months working on developing and printing film by others. Use that time to critique the work you see, figure out how the good shots were taken, what it is that makes them compelling or informative. Work with the photo editor to learn what kinds of photographs typically are run in the newspaper, what that particular paper looks for in its photography and why.

Working as an Assistant

You next step may be to serve as assistant to a veteran photographer, going out on assignments and helping to gather information or change film in cameras. Such an experience can help you learn the protocol for working your way into situations to get the best photographs, getting the information you need for captions, working at crime or accident scenes around medical or law enforcement personnel, and so forth.

Working as a Stringer

In newspaper jargon, a "stringer" is someone papers use to cover stories the staff photographers can't get to. Most stringers don't live in the same town in which the paper is published. They are called upon to cover local events when the paper doesn't have a staff photographer to send. If you prove your worth, you can eventually work your way into a staff position, or gather enough clips in the meantime to apply to other newspapers. Stringers are generally paid by the day or the assignment.

Persistence Pays

When Jenna moved to the area and began looking for work, it was persistence that paid off. In addition to doing all the freelance work she could round up, she called all the area newspapers and spoke with the photo editors. If there were no openings, she asked to meet with them and show her work anyway.

"I wasn't always warmly received," she says. "Once I asked someone if I could stop in with my portfolio and he said, 'Don't bother, you'd be wasting your time and ours.' So it doesn't work on everyone." The editor of the state capitol's city newspaper who agreed to look at Jenna's work but had no assignments to offer, later recommended her to a colleague at a nearby weekly paper who needed someone in a hurry.

"The editor of the weekly called and asked if I could please come down to the paper and make some prints," Jenna recalls. "His staff photographer had just walked out and the deadline was approaching. He said we would discuss the possibility of hiring me permanently later. So I worked several hours that day making prints. We chatted informally, and he ended up asking me to take the job."

Opportunities for Advancement

Photograph Production Supervisor

On a large newspaper, the darkroom needs to have someone in charge to get the film processed and prints made in time to meet the paper's deadline. This individual may rise from among the ranks of the newspaper photographers, but is more likely to be someone who has worked in the darkroom for some time and has little desire to work in the field as a press photographer.

Assistant Photo Editor

The next logical position for a photographer who's ready for an in-house job is assistant photo editor. This person works with the photo editor, handling everything from communicating assignments to staff photographers to archiving film negatives.

The assistant also might be responsible for pulling photographs from past issues for use by other newspapers or for historical features, such as the "year in review" issue that many papers publish around New Year's Day.

Photo Editor or Chief Photographer

The photo editor meets daily with the editors to determine special photographic needs for the paper, then makes assignments to staff photographers. A finely tuned sense of newsworthiness, gained, most likely, from years of experience as a press photographer, is an essential requirement for the person who decides what image appears on the newspaper's cover and section pages.

The photo editor or chief photographer is responsible for checking photographers' contact sheets and selecting the images to be printed for publication, often choosing a vertical and a horizontal version of the same subject to give the graphics layout department an option as the page spreads are created.

Freelancers who want to submit their work to the newspaper or who are hoping to gain assignments should apply to the photo editor, who also hires photographers for staff positions.

Managing Editor: Graphics

The professional at this level oversees not only a staff of photographers, but an entire crew of designers, paste-up artists, and production people. The managing editor for graphics is responsible for the "look" of the paper.

Photographers and designers are equally likely to achieve the rank of graphics managing editor. Both are involved with visual communication, and both will have had several years of experience in the newspaper business.

Income Potential

Newspaper salaries depend on both union contracts and the size and geographic location of the paper itself. Salaries are higher in the more densely populated Northeast and in larger metropolitan areas. Staff photographers earn a low starting salary of about \$15,000, an average of \$21,607, and a high of \$48,781, according to the *Jobs Rated Almanac*. The *Occupational Outlook Handbook* lists average starting minimum salaries at \$426 per week, with the average top starting wage being \$659 per week. Ten percent of news photographers earn \$812 per week or more.

An average starting salary for an assistant photo editor is approximately \$25,000. Photo editors earn between \$29,000 and \$55,000. Salaries at the managing editor level generally exceed \$50,000 per year, but vary with geographic location, newspaper circulation size, and longevity with the paper.

Newsmagazines and Other Magazines

Unlike newspapers, very few magazines have a large photography crew; however, they do provide some staff opportunities. Magazines usually have a list of several freelancers they work with regularly, but the person making the photo assignments is usually a photographer with a photo editor's title and responsibilities. Some of the very large magazines, or magazines that rely heavily on a specific type of photography, have photographers on staff. *National Geographic*, for example, has a crew of approximately twenty photographers.

Staff Photographer

Salaried magazine photographers working for weekly newsmagazines must be prepared to travel at a moment's notice, often into dangerous situations. For many photojournalists, a regular position with such a magazine represents the peak of success. It certainly means you're one of the best.

Other magazines do not offer the same level of excitement or financial reward. The salary of a typical magazine staffer starts at between \$18,000 and \$25,000; an average salary would be \$27,000. Very large magazines with photographers on staff usually have a darkroom and processing facility on site, which provides job opportunities for a film processor or printer. Although it may seem like a long way to a shooting job, just getting in the door of some of these magazines can be pretty difficult.

Photo Editor

Every magazine that uses photographs in its editorial pages from *People* and *House Beautiful* to *Rolling Stone* and *Hot Rod News*—has a photo editor on staff. Whether that person is called the Managing Editor for Graphics or the Graphics Editor, the responsibilities of the position include making sure the magazine has the photography it needs to put the issue to the press.

The photo editor makes assignments to staff photographers or freelancers based on meetings with the editors who determine the magazine's editorial content. When I worked as a writer for *Sunset* magazine, I could choose the photographer I worked with, and together the photographer and I would determine the shots we wanted to be sure to get. In this case, the photo editor is involved, with staff graphic designers, in selecting the images to be printed from those submitted by the photographer.

Photo editors also can take advantage of their authority and give themselves the most desirable assignments. Look at it this way, if the magazine is going to send someone to cover a weeklong festival on a Caribbean island, are you going to send a freelancer or go yourself?

In addition to the obvious benefits of the position, the photo editor also makes more money than the photographer. An average salary for a magazine photo editor is \$40,000, although much higher salaries are commanded in positions of major responsibility.

For Further Information on Press Photography and Photojournalism

Organizations

American Society of Media Photographers (Formerly American Society of Magazine Photographers). 14 Washington Road, Suite 502, Princeton Junction, NJ 08550-1033. (Publishes monthly ASMP Bulletin and provides extensive member services.)

Associated Press. 50 Rockefeller Plaza, New York, NY 10020.

- National Press Photographers Association (NPPA). 3200 Croasdaile Drive, Suite 306, Durham, NC 27705. (Publishes monthly magazine; offers Job Information Bank for job postings; offers additional services for staff and nonstaff professional press photographers.)
- United States Senate Press Photographers Gallery (USSPPG). United States Senate, Washington, D.C. 10510.
- White House News Photographers Association (WHNPA). 7119 Ben Franklin Station, Washington, D.C. 20044-7119.

Periodicals

American Journalism Review. 4716 Pontiac St., Suite 310, College Park, MD 20740-4705.

- American Photographers. American Reference Publishing Corp., 2210 N. Burling Road, Chicago, IL 60614-3712.
- Columbia Journalism Review. Columbia University, School of Journalism, 700A Journalism Bldg., New York, NY 10027.
- Folio. Box 4949, Stamford, CT 06907-0949. (Monthly magazine featuring trends in the magazine industry.)
- News Photographer. NPPA, Suite 306, 3200 Croasdaile Dr., Durham, ND 27705. (Monthly tabloid newspaper published by the NPPA.)

Books

- Color Photography Annual. Ziff-Davis Publishing, 1 Park Avenue, New York, NY 10017.
- Horton, Brian. The Associated Press Photojournalism Stylebook: The News Photographer's Bible. NY: Addison Wesley, 1990.
- Hoy, Frank P. Photojournalism: The Visual Approach. Englewood Cliffs, NJ: Prentice-Hall, 1992.

International Editor & Publisher Yearbook. 575 Lexington Ave., New York, NY 10022. Annual.

Keene, Marton. Practical Photojournalism: A Professional Approach. Stoneham, MA: Butterworth-Heinemann, 1993.

Kobre, Kenneth. Photojournalism: The Professional's Approach. Stoneham, MA: Focal Press, 1991.

Say Cheese Portrait and People Photography

P ortraiture has a long history—far longer than photography, though the two have been a natural combination since Louis Jacques Daguerre, a painter and inventor of the daguerreotype, made his first portraits on metal plates. An invaluable part of historic and sociologic records, portrait photography catalogues social history and human experience, including people both famous and ordinary.

Careers in portraiture range from working as a staff photographer for a large or chain portrait studio to freelancing as an event photographer. The essential ingredient for a portrait photographer, whatever your venue, is an ability to work with the people you photograph. Portraiture offers an accessible, though competitive, opportunity for entrepreneurship, as well as a great base of experience for an aspiring photographer.

Working with, and Pleasing, the Client

The most important skill for a successful portrait photographer, says Marilyn Sholin, a successful studio owner in Florida, is "a genuine interest in people, an ability to work with a variety of people, a willingness to please a client, and an ability to sell a quality product." Pleasing the client means understanding that success doesn't always include the freedom to follow your own artistic vision—not until you are someone like Annie Liebowitz or Richard Avedon taking pictures of celebrities.

Are You Cut Out to Be a Portrait Photographer?

- Do you enjoy working with people all day?
- Are you good at making people feel comfortable?
- Do you have the patience to deal well with the unexpected crying babies, shy toddlers, grim-faced octogenarians?
- Do you have a genuine interest in discovering and satisfying the client's wishes?

Getting Started

As you begin a career in portrait photography, you have many options for gaining the experience you need to become an independent professional. Portrait studios sometimes work with educational institutions to provide internships for students. Often chain studios or department store studios will hire inexperienced photographers and put them through on-the-job training programs. If you are willing to do support work for a small business or assist a high-quality professional portrait studio photographer, you are likely to gain valuable experience.

There are, of course, many photography courses and programs of study at colleges, universities, and art schools. Portraiture specializations in professional photography programs will likely include courses like Portraiture Fundamentals, Lighting People, Intermediate and Advanced Portrait Methods, and Advanced Color Portraiture. The paths to careers in portraiture vary greatly, but becoming skilled with a camera is essential, whether by learning on the job or by pursuing a degree in photography.

If you're looking for a position in a high-quality professional studio, your portfolio will be the most important asset in winning the job. Studio pros want to know that if they turn a job over to an employee, it will be handled with both creativity and technical perfection.

The studio owner might ask to see contact sheets as well as individual finished prints. The contact sheets show how you take photographs—do you take many different poses or only a few? Do you try different angles, lighting, backgrounds?

School Photography

Consider the fact that virtually every student from preschool through high school and college is usually photographed every year, and you begin to see the wealth of possibility in the school portrait business. Schools may need classroom group photographs, student identification card photographs, photographs for student files, photographs for the student yearbook, photographs of student activities and clubs, dances and events.

Schools rarely have a photographer on staff. School photography—annual student and class portraits, club and sports team portraits, and teacher portraits—is handled by any of three types of companies. The first is a local studio that contracts with the school for all photography needs. The second is a chain studio that offers school photography as part of its repertoire. The third is the specialty school photographer who bids on school contracts and sends the film to development labs that specialize in school photography. Some of these school photography companies specialize in class and individual portraits or events such as dances or student productions, and some handle all kinds of school photography.

The Work Day

A school photographer works during school hours in the months that school is in session. Because the work load isn't constant, photographers are often part-time employees. For individual portraits, the photographer usually sets up a portable "studio" in the gymnasium or other room at the school. Portrait sessions are scheduled at five- or ten-minute intervals, and the photographer must keep a careful record of which frames were taken of which students.

The film is sent to the development labs, and the photographer selects the frame to be printed. Proofs are made and then distributed to the students for approval, unless "package deals" are ordered in advance, in which case the image is printed in an agreed upon number and size for distribution to the students.

Usually provision is made for "retakes" for those who were absent for the first sessions or dissatisfied with their photographs, as well as additional print orders for those who were delighted. Needless to say, you want there to be more extra print orders than retakes.

Working with young people, not all of whom want to be photographed, can be challenging. Given the short time allowed for taking each photo, it is important to work efficiently and interact well with people.

Portrait photographers start at about \$15,000 annually. There are many available jobs, and sometimes sales commissions or other employee benefits enhance the salary. The work also provides valuable experience for the beginning photographer. Although you don't have to have experience to apply, companies are likely to hire those with some photography background.

Chain and Department Store Studios

Working for a chain or department store studio allows you to gain experience and sample the work environment before striking out as an independent. Often you will be only one of many photographers on staff. In many cases, photographers work with a manager and assistant manager in these studios, and their supervisory responsibilities include scheduling enough photographers to cover the long hours, particularly at department stores and malls.

The equipment is standard and fixed, and the major challenge, as with school photography, lies in capturing the expression of the client. Often chain studios are willing to hire students part-time or as interns. Because of the standard equipment set-up, people skills are often more important than photography experience. Clients are most often families with children or children alone. The number of photo sessions is high, particularly around holidays. Jobs are plentiful, easy to obtain, and the experience gained can be invaluable.

Independent Portrait Studios

The variety of work situations is greater in independent establishments. Independent studios sometimes send photographers to shoot on location and often shoot weddings or other events. Some studios are small one-person operations; others are minichains in themselves. Sometimes the lab work is done in-house, sometimes it is sent out. Entry-level work can involve everything from sweeping the floors, loading film in the camera, or general business chores, such as phoning clients, processing orders and sales, and keeping records of portrait sittings.

Don't underestimate the value of learning how a small business functions from the ground level up. It may provide the impetus and insight you need later to start your own business!

Owning Your Own Studio

For independent types, starting and owning a business is a dream that can be made real as a freelance portrait photogra-

pher or studio owner. Be forewarned: Competition is fierce! A lot of portraiture is done by low-cost regional and national chains located in department stores and malls. They offer convenience, and more and more frequently, services such as onehour portrait development, passport photographs, and photographic restoration. Independent portrait studios do exist and thrive, though, because they can offer a level of quality and personal service that makes them unique.

Before you hang up your shingle and spend a lot of money on studio space, equipment, and advertising, make sure you've got what it takes to make it on your own. Marilyn Sholin sums it up this way: "The prime prerequisite to becoming a professional photographer and to make a living at it is to have the heart and soul of an entrepreneur. Without that you will end up working it just like it's another job and end up 'shooting kids' at JC Penneys and Sears."

Spend some time thinking about the pros and cons of starting your own studio. Your own abilities aren't the only variable to consider. Thoroughly research your locale and the logistics of operating a business. Numerous resources exist for small business owners. Start with your nearest Small Business Development Center, operated through community or junior colleges. The SBDC provides information and assistance on marketing, taxes, accounting, loan proposals—everything that may affect you as a small business owner. Depending on the individual center, available resources may include evening classes, counseling by appointment, or a library of books, videos, and computers.

Benefits of Owning Your Own Business

- Being the boss means having the freedom to set your own hours and organizational procedures.
- With the appropriate portable studio equipment, you can work out of your home.

50 CAREERS FOR SHUTTERBUGS

- There's a direct relationship between how much energy you put into your work and how much you earn.
- You can establish a specialty for your studio that relates to an area you're especially interested in.

Things to Consider Before Starting Your Own Business

- You are solely responsible—it won't be as easy to leave your job at the office at the end of the day.
- You'll have to spend time on finances and accounting and making the business go—not just working the camera.
- You'll have to make a significant capital investment in equipment, advertising and promotion, and studio facilities.

More Questions to Ask

There are many other questions to consider as you plan. What are the needs in the community you hope to serve? What competition exists in your region? Is there something you can offer that will set your studio apart from the others? Do you have a network to connect you to people and help get you started? Do you have clients who will recommend you? Will you advertise? What other marketing will you do? Do you own enough equipment to get started? What equipment will you purchase? What about a studio space? What about storage? What about the legal issues of incorporation and licensing in your community? Who will handle your accounting? Do you need additional capital? Can you do it alone? Can you support yourself?

Advice from Entrepreneurs

Building up a client base and starting a business can be incredibly challenging—but extremely rewarding as well. Brian Beauban, owner of Beauban Photography in Berwyn, Illinois, advises that the aspiring studio owner develop "an understanding of sound business practices—marketing, bookkeeping, management skill, and luck." Read every book on marketing and salesmanship that you can find and seek out local photographers who are willing to talk to you about their experiences. Study your market. Develop a reputation for good work and ethical business practices. "But most important," Brian says, "is to learn from your mistakes; don't keep tripping over them."

Doing the research first was crucial to the success of Rick Nye, owner of Rick Nye Photography in Orem, Utah. "The best thing I did was to visit all the local studios, study their layouts, get price information, determine where they are lacking and capitalize on it." Rick Nye Photography has grown from a freelance business to a retail store location despite a glut of studios in his small town because, Rick says, "I put a lot of emphasis on creativity and customer service. I firmly believe a studio's atmosphere and treatment of the customer determines whether or not the sale brings in repeat business, not the price structure as most will believe."

In considering entrepreneurship, in the words of Rick Nye, remember: "It's a business as well as an art, and you need to be proficient at BOTH! One can't survive without the other."

A Case Study

Marilyn Sholin owns a professional studio, Photography by Marilyn, Inc., in North Miami Beach, Florida. Working as a buyer in a major department store gave her a solid retail background in both buying and advertising. Her older brothers were camera nuts who had a darkroom in the basement. She borrowed a camera, and the first roll of film she ever shot won a regional Kodak contest for amateurs.

She began her portrait photography career by photographing her sons and taking every photographic course she could find locally. She took portrait photographs for friends of their children and was encouraged to start charging for her work.

Working out of her home, Marilyn started to build a client base. She has since operated in three retail locations, the current being a 2,600-square-foot studio in an office complex.

The Pros and Cons

Marilyn stresses the large amount of time spent dealing with the public coping with varied personalities. "The one thing I can say is that you MUST like people to be in this business," she advises. That aspect of her work provides Marilyn with both delights and challenges. "I would say that my number one reward is becoming part of so many families. I get to watch the babies grow into young men and women and to see the happiness on grandparents' faces. I get to participate in the happy moments in a family's life and put a little piece of myself into their homes for them to enjoy forever."

She also cites the benefits of being one's own boss ("although the clients are always dictating the hours") and the creative rewards of trying out her own ideas. "I enjoy watching the perfect expression on a mother's face as she looks at her newborn. When I can paint her with beautiful lighting and put her in a soft setting, the end result can take my breath away."

A Typical Week, a Typical Job

Marilyn's work week includes meeting with employees to resolve questions, receiving updates from her bookkeeper about unpaid invoices from previous clients, and answering correspondence, as well as, of course, taking photographs of clients. One two-hour session she recalls illustrates the humor, demands, and rewards that are a constant element of portrait photography.

"Eight people arrive for a family portrait with grandparents, parents, and children and a dog and a 3-month-old baby. I start with the largest group and the baby has trouble staying awake. When the baby wakes up the dog starts barking and the baby starts crying. Everyone falls out of the pose and tries to calm the dog down. I put everyone back together and check clothing and makeup and get a few good poses done.

"Baby starts crying again. I decide to do some portraits of just the grandparents. While I am doing that the baby falls asleep again. Baby's two-year-old sister suddenly wants to do pictures right now. I finish the grandparents and go on to do some pictures of the sister alone ...then the grandmother says she won't want those photos without the baby. I tell her I can also photograph the baby alone, and she can put the pictures in a double frame. She says no because it will cost too much. I try now to wake up baby softly and put her in sister's lap.

"I get a few shots done until someone lets go of dog and he runs into shot and starts licking baby in face and makes baby cry again. I finally get the whole thing settled down and we get all the portraits done. They are all happy now and the baby is wide awake and smiling as they put her in the car...."

Wedding and Event Photography

Wedding photography is a huge business, both for professional studio photographers and freelancers. Still photography and videography are commonly used for weddings and events. Events include bar mitzvahs and bat mitzvahs, first communions, baptisms, graduations, installations, and any other ceremonial functions.

The unique features of event photography make it more like photojournalism than studio work because there are no second chances to catch the significant or "decisive" moments. You need to anticipate the action, and be in the right place at the right time or the opportunity is lost. Dealing with the high emotions usually surrounding an event like a wedding can be a challenge as well. Such situations call for highly skilled people management and client interactions. Weekend work is a necessity, of course, and as with all portrait photography, the client sets the hours to a necessary degree.

Wedding and event photography can provide some freedom in terms of equipment, approaches, and artistry. As in any business, the freedom gained by freelancing also carries responsibility—you will be judged by your product!

Wedding and event photographers often develop their own prints; however, many custom labs specialize in wedding photography. One freelance wedding photographer advises that "not having full control of the prints is a surefire way to go out of business fast....Never, never, never give the client the negs!"

The Work Day

Because most weddings take place on the weekends or in the evening, that's when you do a large part of your work. For this reason, wedding photography is something people often do in addition to a regular "day job" or as an extension of a regular portrait studio business.

The wedding photographer is involved with documenting the entire wedding process, sometimes including the rehearsal dinner and stag parties. Certainly it involves photographing at the wedding itself, with most formal portraits taken very soon after the ceremony or after guests have passed through the receiving line at the reception. The idea is to photograph the bride and all the attendants—flower girls, ring bearers, parents, and grandparents—*before* the inevitable cake and coffee stains start to appear.

This can be a Herculean task for a photographer working alone, which is why many wedding photographers work with an assistant or draft the services of a young relative at the event to help on the roundup. Everyone is understandably excited about the ceremony and busy visiting with long-lost friends and relatives, so an orderly procession for portraits is a challenge.

A Freelance Wedding Photographer

Laura Benjamin, a freelance photographer since 1986, takes on many wedding jobs. "They are among the best and worst in terms of work conditions," she says. "Emotions run high. It's difficult sometimes to stay calm. Of course I worry about ruining the shoot—the disappointment involved is excruciating to consider. It's never happened," she adds.

"But still, I worry. But it can also be an immensely satisfying role, to be capturing one of the most important events in someone's life. When I get candids that reveal special moments, like the bride's niece throwing rice over her head, laughing, at the reception, I know I've caught a moment that will make people smile."

Sometimes Laura uses an assistant, often a student, to help her. Assistants don't do any of the shooting—they help haul equipment and arrange people for group shots. They stay on the lookout for good photo opportunities. Laura comments about having assistants, "it helps relieve the chaos of some of those long wedding and reception days—and it gives them a great chance to experience this sort of work."

How One Wedding Photographer Got Her Start

Marilyn Sholin's foray into the wedding photography business offers some lessons in chutzpah!

"I had a children's outdoor portrait business going great, and had a lot of samples," she recalls. "One of my clients had a sister getting married. I went to her home and showed all my outdoor kids work and told her that doing a wedding is the same, I just hadn't printed any wedding samples yet. "She said okay, liked my portraits, liked my price, and booked the wedding.

"Oh, my gawd! I had a wedding booked and no idea how to shoot it!"

She had just purchased some medium-format cameras, so had the right equipment for the job, but none of the know-how. Someone she knew had some of the same equipment, and was an experienced wedding photographer.

"I called him and said, 'Hey, will you shoot a wedding for me using my equipment? The only catch is, you have to pretend you are *my* assistant, and while pretending, teach me what to do!"

For \$150 he did it, and Marilyn was on her way. "The family loved the pictures and never knew otherwise," she says now, some fifteen years later. "Oh, to be young and stupid again!"

Getting Started on Your Own

Marilyn doesn't recommend her method as the way to go. But since most of any photographer's wedding business comes from referrals, getting started can be the most difficult part of the business. A good approach is to start taking photographs for friends as your wedding gift to them. Those photographs become your portfolio.

For young photographers breaking into the portrait business, Marilyn Sholin suggests getting a job with Glamour Shots, a chain studio across the United States for female portraits, or with a department or chain store studio operation. "It will give them a chance to work with a lot of people and learn while they earn some money," Marilyn explains. "It also will allow someone else to absorb their beginners' mistakes, and it won't hurt their name when they go out on their own."

One tip is to attend local bridal fairs as an exhibitor. Although renting a booth can be expensive, the advertising opportunity can be well worth it. Potential clients will get to see your work, bringing them one step closer to hiring you.

Income Potential

A professional private studio charges an average of \$125 for a portrait sitting, or a range between \$75 and \$250. The sitting includes one 8 x 10 inch print; then the client places an order for additional prints from an a la carte price list that includes discounts for the large orders.

The same studio charges between \$800 and \$3,500, or an average of \$1,800, for professional wedding services. The photographer then prints proof sheets, and the bride, groom, and their family members place orders for prints.

An assistant working for a professional studio starts at between \$10 and \$15 per hour and can earn as much as \$30 to \$50 per hour as an experienced assistant or associate photographer. An associate is someone who is capable of taking over for the photographer if necessary and generally works with his or her own equipment. A photographer without previous studio or wedding experience might be hired as a trainee and be paid close to minimum wage.

The Video Angle

Some clients will want to have both still photographs and videos taken at their wedding. If you want to keep all the business in-house, you might consider subcontracting the videography, or hiring someone to perform these services on staff. See Chapter Thirteen for more information on videography careers.

Magazine Sales

Some of your best wedding photographs might well be marketable to any of the numerous bridal magazines on the market, as well as to photography magazines. A magazine might pay \$200 or more for a color photograph used full page, and up to \$1,500 for a cover photograph. Before you can sell a wedding or portrait photograph to a magazine or other publisher, you must receive the client's or model's permission in writing.

Glamour and Boudoir Photography

Glamour photography is primarily, though not exclusively, involved with glamorous portraits of women. This genre may have had its start during the war, when soldiers wanted keepsakes of their sweethearts to carry with them.

Nowadays, these portraits are taken for aspiring models, both male and female, young and old. Would-be models need to have "slicks"—photographs showing them at their most photogenic—to show to agents or prospective employers.

Boudoir photography, as the name implies, involves bedroom pictures. Again, these are mostly women, but not always, in a provocative pose or setting, either nude or scantily clad. The purposes for these photographs vary according to the client: A wife might want to give her husband a special Valentine gift; a young man may be hoping to "audition" for a magazine centerfold.

The boudoir photography market has emerged as a result of a variety of influences: the expanding popularity of magazines such as *Playboy* and *Playgirl*; the sexual revolution of recent decades; and the growing popularity of intimate apparel stores, such as Victoria's Secret.

Working with Models

Seasoned glamour and boudoir photographers advise beginning photographers, when working with a client or model, regardless of gender, to have an assistant on hand at all times, preferably of the same gender as the client. This helps to put the client at ease, and protects you and the model or client from charges of impropriety.

If you're just getting started in this field and need to build a portfolio, you can often find models who will pose in exchange for their own slicks. If you're hoping to sell the photographs, you need to have a model release form signed (see Chapter Five for more information). You also need to have someone who is extremely proficient in makeup, hair styling, and costuming to give your clients the right look. They may come to you with no idea how to go about making themselves look glamorous, so you may need to do some "directing." Without expert application of makeup, styling, and wardrobe, the portraits probably won't cross over into the realm of "glamour."

You also need to be something of a diplomat, flattering sincerely without pouring on the butter boat. You might need to pose a client to minimize less attractive features or capitalize on good features. Certainly you can emphasize the good, but beware of pointing out the less-than-perfect.

Income Potential

Many glamour and boudoir photographers work solely as portraitists for clients. The photographs are most often made as gifts, and the studio often includes a gift folder in the package price. Fees for glamour or boudoir photographs are typically higher than for a standard portrait because of the additional attention to makeup and setting.

The market for glamour and boudoir photographs, aside from taking photographs for clients, is primarily in magazines and paper products, such as calendars. Advertisers, too, look for photographers with a strong glamour portfolio for products ranging from cosmetics to lingerie, cars to travel resorts.

Catalogs, especially those for intimate apparel or swimsuits, are a good market for a photographer with glamour and boudoir experience. Photographers working on assignment for advertisers or magazines can expect to make \$350 to \$2,500 per day, depending on their experience and reputation. Per photo sales range from \$25 to \$500, depending on the use. Some paper products companies pay a percentage of sales earnings (see Chapter Five for more information).

For Further Information on Portrait and People Photography

Books

- Cohen, William A. The Entrepreneur and Small Business Problem Solver: An Encyclopedic Reference and Guide. New York: Wiley, 1990.
- Hart, John. Fifty Portrait Lighting Techniques. New York: Watson-Guptill, 1987.
- Photographing People. Rochester, NY: Eastman Kodak Company, 1990. Publication AC-132.
- *Portrait Studio Information Package.* (Compilation of articles on the portrait studio business available from the Photo Marketing Association, updated regularly.)
- Professional Portrait Techniques. Rochester, NY: Eastman Kodak Company, 1990. Publication O-4.
- Small Business Sourcebook: An Annotated Guide to Live and Print Sources of Information and Assistance for 163 Specific Small Businesses. Gale Research, 1989.

Periodicals

- *The Professional Photographer*. Professional Photographers of America, 1090 Executive Way, Des Plaines, IL 60018.
- Studio Photography. PTN Publishing Company, 445 Broad Hollow Road, Melville, NY 11747.
- The Wedding Photographer. Wedding Photographer's International, Box 2003, 1312 Lincoln Blvd., Santa Monica, CA 90406-2003. (Monthly membership newsletter.)
- The Wedding Photographer's Notebook. Monte Associates, 10887 Lockwood Dr., Silver Spring, MD 20901. (Newsletter.)

Professional Organizations

- Professional Photographers of America. 1090 Executive Way, Des Plaines, IL 60018.
- Professional School Photographers Association (PSPA). A Division of the Photo Marketing Association (PMA). 300 Picture Place, Jackson, MI 49201.
- Wedding Photographers International. Box 2003, 1312 Lincoln Blvd., Santa Monica, CA 90406-2003.

The Selling Game Commercial and Advertising Photography

I fyou're interested in combining artistic vision and creativity in your photographs with high income potential, a career in advertising or commercial photography may suit you perfectly. Advertising is probably the highest paying field in photography, and it involves nearly every possible subject matter, from high fashions to farm implements, exotic animals to eggs Benedict.

Allyn Solomon, a photographer's representative in New York City who has worked with some of the top photographers in the business, wrote in his book *Advertising Photography*, "Advertising photography at its best represents something attractive to the public, not because it 'manipulates' but because it makes us visually aware.... In advertising, those with a style, a vision, are hired as photographers...much as the artists of the Renaissance were engaged by the Medicis."

Solomon suggests that it is the artists among the commercial photographers who have attained the pinnacle of success in this demanding, high-paced field. Their sense of personal style and vision have made their work stand out among others, and advertisers want their products to do the same.

The Growth of Commercial Photography

The 1950s saw a surge in the growth of advertising in general and in the use of photography in particular. America's growing affluence meant more discretionary income was being spent on

62 CAREERS FOR SHUTTERBUGS

a wide variety of goods and services, and it was up to the advertisers to let the public know what was available.

Today advertising and marketing are a complex amalgam of market testing research and psychology, as well as artistic vision and creativity. Before a corporation spends millions of dollars on advertising, the executives want to be certain that the "pitch" of the campaign is going to be successful. The cost of getting information to the buying public has increased dramatically, and the number of channels for advertising has also expanded, both in print and in broadcast media. Cable television companies are competing vigorously for advertising revenue against established network and local stations.

Virtually every magazine on the newsstand today has an editorial-to-advertising ratio that edges closer to 50-50 all the time. Recent growth in the mail order catalog business, too, has boosted opportunities in this field as well. There are currently some 8,000 mail-order catalogs being sent to homes and businesses across the country and more than 19,000 firms using direct mail promotions to market goods and services. The central content of those catalogs and promotional materials is photography. The market for advertising and commercial photography has never been larger.

Who Employs Commercial Photographers

Corporations

Major corporations employ large staffs in their advertising departments, including researchers, copywriters, graphic designers, photographers, and art directors. Companies without—and sometimes those with—advertising departments hire advertising agencies, which may or may not have photographers on staff. The art director for a corporation or advertising agency is responsible for hiring photographers to work on various projects. The art director is the liaison between the photographer and the client with the product to be photographed.

Every business, large or small, needs some means of letting the public or potential patrons know about what it offers, whether a product or a service. Most often, this will involve a photographer at some level.

The range of photography subjects is as broad as the products and services currently on the market. You might take a series of still life photos one day, and action-oriented people shots the next. Your work might take you on location, especially if you're involved with the fashion or auto industries, where exotic or picturesque locations serve as an enticing backdrop to the high-priced products.

The larger the corporation, the better the chance that the advertising staff will include one or more photographers. If there isn't a staff photographer, the advertising art director will review portfolios presented either by photographers themselves or through photo representatives.

Even smaller corporations may hire photographers directly to provide executive portraits or "grip and grin" shots to accompany press releases or publicity packets, as well as product photographs for advertising purposes.

Advertising Agencies and Design Studios

Hired by the corporate client, the advertising agency or graphic design studio fulfills the role of the corporate advertising department, but not in-house. A team of advertising professionals together develop the strategy, concepts, and design and layout for the advertising campaign and its components. The design studio becomes involved primarily with design and layout and may be the one to provide photographic services.

Advertising agencies and designers generally develop a "stable" of photographers on whom they rely to get the images

they need, but art directors will often review new portfolios for particular projects or to keep tabs on who is available and who is producing what kind of work.

Magazines

From fashion magazines to publications for car buffs, the slick publications on the newsstands today are filled with the work of commercial photographers. Since not many magazines have photographers on staff, opportunities abound for becoming one of the stable of photographers called upon for top assignments.

Photographing for magazines covers virtually every possible subject area. If you have developed a subject specialty, you will be in a good position to establish an ongoing relationship with the magazines published for that interest. Chapters Two and Five cover magazine photography in more detail.

Public Relations Firms

Public relations, or PR, photography is closely related to advertising; in fact, it's often referred to as "free advertising." The goal of public relations photography is to make the public feel good about a product or a company. A company sends out a news release about a new product, an award won by the marketing department, a new development by the research department, or a new CEO ready to take the reins of the organization. The press release is often accompanied by photographs for the newspaper or trade magazine to use.

A PR photographer is involved with a variety of subjects, from product photography to portrait photography. PR photographers also have a close relationship to photojournalists because the photographs they take are generally intended for publication as part of a news article.

Retail Stores and Mail-Order Catalogs

I combine these categories because often a retailer that is large enough to advertise and need the services of a photographer also produces its own catalog. This is a good area for photographers beginning in the industry to get an introduction to fashion photography because of the large number of clothing catalogs—from the status-oriented Nieman Marcus to the down-home look of L.L. Bean, from Macy's to J.C. Penney.

Department store photographers might be involved with product photography, window display photographs, public relations photos, and events such as fashion shows. A department store photographer might also set up a Polaroid camera production for photographs with a store Santa.

Furniture stores often produce mail-order catalogs, which involves staging and shooting interiors. A photographer with strong experience photographing interiors might also work for interior decorators or architects, or for magazines such as *House* and Garden, Home, or Architectural Digest.

Government: Tourism and Economic Development Departments

State and city governments often have a need to advertise or promote their product with the purpose of attracting tourists or businesses interested in investing in the local economy. Departments of tourism or economic development often produce colorful, descriptive pamphlets or brochures, and sometimes advertising campaigns, featuring beautiful photographs of the region, its architecture or scenic attractions, and its people. A photographer might work directly with the project manager or with an advertising agency hired to produce the promotional piece.

Colleges and Universities

The competition for students among the nation's colleges and universities, both public and private, involves the development of catalogs and brochures that are becoming increasingly sophisticated in both content and quality. In striving for quality, the art director or designer will most likely want the services of a professional commercial photographer, one who knows how to shoot for "product" appeal. The product, in this case, involves the campus itself, students, faculty, research and creative endeavors, sports, and any other aspect of college or university life.

Entertainment Industry

Although we think of movie camera operations when we think of the television and film industry, still photographers are much in demand in this business. A still photographer working for Turner Broadcasting, for example, would be involved with taking publicity stills of shows in production, portrait shots of star actors, stage shots, or other promotional product shots.

In Hollywood, too, photographers on the back lot are a common part of the scene. They capture still shots on location, behind-the-scenes shots for public relations purposes, and posed photographs for both trade and fan publications.

Performing Arts Organizations

Theaters, especially, require the services of photographers in preparing production stills for advertising purposes. Symphony orchestras, opera companies, ballet corps, and modern dance troupes all require specialized photography for promotions, advertising specific performances, showcasing big-name talent, and fundraising publications.

Performing arts photography is generally done during a full dress rehearsal, a "photo call" arranged specifically for the pur-

pose of taking photographs, or on opening night. Major concert or performance houses that present traveling productions may have a photographer on staff to handle local publicity needs.

Photographs taken during performances by musicians have other potential markets. Local newspapers and magazines, trade publications for professionals in the arts, and record companies are all buyers of performance photos. Publications markets are discussed in Chapter Five.

Record Companies

From shooting album covers in the studio to rock concerts in the coliseum, the commercial photographer who works for record companies has many professional opportunities and great earning potential. Like the fashion and entertainment industry, the record industry is one in which a photographer can earn a measure of fame, as well as good money. But that takes years of hard work and experience.

In order to get started earning that experience, newcomers to the field often approach smaller, independent record companies. Larger companies generally have several freelance or staff photographers they work with regularly.

Genres in Advertising Photography

Fashion Photography

This is the glamour trade, the world of high fashion. Photographers at the top in this industry are earning big money, gaining fame and prestige, and living a glamorous life filled with beautiful people in beautiful places wearing beautiful clothes.

Richard Avedon is perhaps the guru of fashion photography.

Photography writer Steve Anchell, in a May 1994 *PhotoPro* article, wrote of Avedon's images: "Carefully conceived, meticulously controlled, precisely executed slices of time which tell us more about the subjects and the time in which they live than volumes of photographs by others."

Although Avedon was not *just* a fashion photographer, he is largely responsible for the status of the craft today. Most photographers don't aspire to such heights, but a lot can be learned about the genre by studying the works of Avedon, Beaton, Horst, Scavullo and others whose names are household words.

Fashion photographers work in all corners of the country, from department store fashion shows to the new fall announcements in Paris. Fashion is an area that offers international opportunities because so much of the high fashion world is centered in Europe—Paris, Milan, London.

Garment manufacturers, clothing stores, mail-order catalog merchants, magazine publishers, and modeling agencies are all potential customers of the fashion photographer.

Food Photography

According to one professional photographer, food is where the money is, not necessarily because the day rate is higher here than in other areas of advertising, but because there are so many different food-related companies needing your services. It's not too difficult to keep busy—if you're good.

Food is one of the most difficult advertising subjects to master. It takes a special skill to make your photograph so powerful that the viewer salivates just looking at it. Some photographers rely on oils, resins, and other tricks of the trade to make the product look appetizing. Others prefer to shoot immediately when the food has been prepared in order to capture that "fresh from the oven" presentation. Composition, lighting, and design are the dominant considerations in food photography.

Dana Marks is a still-life photographer who specializes in food. Her clients include cooking magazines, as well as several

New York restaurants and food products corporations. Her studio has a separate kitchen with three restaurant-sized ovens, a walk-in freezer, and two refrigerators. Her staff includes a cook, a food stylist who scours stores for the perfect strawberry or a set of flatware in a style that complements the arrangement of food in a still-life, a lighting technician, and a general assistant who helps with everything from rushing food hot from the kitchen to labeling film and keeping photo session logs.

Food photographers work for magazines, food growers and packagers, appliance manufacturers, restaurants, and industry trade associations.

Product Photography

Although food and fashion are considered products, the genre of product photography involves broader technical expertise that allows a photographer to take on virtually any product challenge, from photographing a new Boeing 747 to shooting a package of sewing needles.

Lighting, composition, background, color, and texture—all the elements of art and design—come into play when taking product photographs. Commercial product photographers are often darkroom magicians, creating special concoctions with developer chemicals to achieve the right effects.

The product photographer working for advertising purposes needs to have an artist's vision in order to set up still-lifes of a product that can entice the viewer into buying. But another aspect of the product photographer's work involves strict documentation of a product for purposes of identification or trademark registration.

Photo Illustration

An illustrator is someone who creates a visual "story" to accompany written text. A photo illustrator does the same thing but uses photography rather than pastels and paints.

70 CAREERS FOR SHUTTERBUGS

Photo illustration is used by any of the clients described earlier in this chapter, primarily for purposes of advertising and promotions. Magazines and newspapers use photo illustration to illustrate articles. Book publishers are also potential clients.

With the advent of digital technology, photo illustrators often combine photographic talent with computerized manipulation. Andy Baird, author of *The Macintosh Dictionary* and prototyper of experimental multimedia educational software, works with photographs pulled from a camcorder into the computer. He captures still images using computer software to scan through the video film images until he finds the perfect combination.

"One of the best things about this style of work," Andy says, "is that unlike a still camera, with videotape there's no fear of missing the 'decisive moment' because you can replay a scene over and over until you manage to hit the 'Grab Frame' button at just the right instant. Add Photoshop and a Wacom ArtZ tablet with pressure-sensitive stylus, and you have the makings of some real fun!"

What It Takes

Commercial and advertising photographers need to have their technical expertise down cold. Handling lighting, cameras, formats, and film needs to be second nature. There is no room for error when a client is paying you \$1,500 per day to shoot beautifully lit, perfectly proportioned, aesthetically compositioned photographs of a product—whether it's a bowl of cereal or an expensive *objet d'art*.

Original Style

With technical expertise as a given, the highly successful advertising photographer also has a certain flair or style that's unique, not a pale imitation of some one else's. Get to know the work of the major photographers in the field; look closely at all kinds of advertising photography and analyze the styles you see.

Your own style is something that is developed over time through experimentation, trial, and error. What is more important initially is that you bring to any project a level of creativity, a collaboration in the effort to capture the viewer's attention and hold it long enough for the message to come across. An art director reviewing your portfolio will be looking for both technical ability and aesthetic vision.

Special Expertise

As you gain experience, you might want to begin to specialize, to create a niche within which your work is recognized and your name is the one art directors think of when they have a project that fits your specialty. Specialty areas in commercial and advertising photography include still-life, fashion, food, beauty or glamour, portraiture, setting or location work, annual reports, and photo illustration.

There may well be cross-over categories in commercial and advertising photography. For example, you may be photographing potato chips both as part of a still-life and within a setting of people enjoying the product. Or an advertisement for shampoo becomes part still-life and part beauty or glamour photo. When you're just developing your portfolio, you will probably want to include several representations for each of several categories or specialties. Follow Allyn Solomon's advice: "Shoot to eat, but don't lose sight of the need always to heed the development of your style. This is the key to creative survival."

Knowledge of Printing Requirements

An understanding of what considerations the printing process demands of photography is an important skill to offer to an advertising client. For example, knowing whether or not the images will be "ganged"—grouped together for color separation, one of the more costly elements of color printing production will make a great deal of difference in how you shoot a series of products for a catalog producer.

It's important for the photographer to come to a job with this information; otherwise, when the project gets bogged down in production, the client will come back unhappy that your lack of understanding is going to mean higher printing costs on the final product. The best way to gather this information is to work closely with the designer and production people who will be working with your photographs.

Business Savvy

A good business sense is also important for a commercial photographer working independently. You need to be willing to market yourself, or work with a good rep who will present your portfolio to art directors, schedule your projects, and negotiate your fees.

People Skills

Depending on the situation, you may have photographers' assistants, models, stylists, food preparation specialists, designers, and art directors to deal with in the course of a photo session. You need to work both as a director of people and as a photographer. In addition, independent commercial photographers need to be able to work with clients, discovering their preferences and prejudices, encouraging a more creative or effective solution, or simply maintaining a good business relationship.

Income Potential

Salaried employees starting out with any of the organizations described above will likely earn \$20,000 to \$30,000 per year. That figure will rise to \$40,000 to \$75,000 or more with experience and depending on the specific field of commercial photography.

An independent photographer operating a commercial studio can earn a great deal more—\$100,000 to \$200,000 per year, especially in the areas of fashion and entertainment. But these figures imply that the photographer is someone with excellent business savvy, as well photographic skills, creativity, and a solid reputation.

Freelancers in commercial photography can earn from \$200 to \$7,500 per day for their services, or sell individual photographs for \$25 to \$1,500. The rates vary by photographic subject, client, and geographic location. Fashion and entertainment photographers tend to earn more than, say, photo illustrators; advertising agencies pay more than public relations agencies; and New York, Chicago, and Los Angeles continue to be more lucrative markets in commercial photography than other cities.

For Further Information on Commercial and Advertising Photography

Organizations

- Advertising Photographers of America. 27 W. 20th St., New York, NY 10011.
- Professional Photographers of America. 1090 Executive Way, Des Plaines, IL 60018.
- The Society of Photographers in Communications. 60 East 42nd St., New York, NY 10017.

74 CAREERS FOR SHUTTERBUGS

Periodicals

Advertising Age. 740 Rush St., Chicago, IL 60611-2590. (Weekly advertising and marketing publication.)

Adweek. A/S/M Communications, Inc., 49 E. 21st St., New York, NY 10160-0625. (Weekly advertising and marketing magazine.)

Art Direction. 6th Floor, 10 E. 39th St., New York, NY 10016-0199. (Monthly magazine featuring art directors on design and photography.)

Communication Arts. 410 Sherman Ave., Palo Alto, CA 94303. (Magazine covering design, photography, and illustration.)

- *Photo/Design*. 1515 Broadway, New York, NY 10036. (Monthly magazine on photography in advertising and design.)
- *Photo District News*. 49 E. 21st St., New York, NY 10010. (Monthly trade magazine for the photography industry.)
- Print. 9th Floor, 104 Fifth Ave., New York, NY 10012. (Bimonthly magazine on creative trends in design, illustration, and photography.)

Professional Photographer. 1090 Executive Way, Des Plaines, IL 60018. (Monthly magazine for professionals.)

Books and Directories

The Design Firm Directory. Wefler & Associates, Inc., Box 1167, Evanston, IL 60204. Annual directory of design firms.

Gottlieb, Richard. Directory of Mail Order Catalogs. Lakeville, CT: Grey House Publishing, Inc., 1991.

Guide to Literary Agents & Art/Photo Reps. Cincinnati, OH: Writer's Digest Books, Annual.

Madison Avenue Handbook. Peter Glenn Publications, 17 E. 48th St., New York, NY 10017. (Annual directory of advertising agencies, audio-visual firms, and design studios in New York.)

O'Dwyer Directory of Public Relations Firms. J. R. O'Dwyer Company, Inc., 271 Madison Ave., New York, NY 10016, Annual.

Piscopo, Maria. Photographer's Guide to Marketing and Self-Promotion. Cincinnati, OH: Writer's Digest Books, 1987.

Professional Photographic Illustration Techniques. Rochester, NY: Eastman Kodak Company, 1989, Publication O-16.

CHAPTER FIVE

Free-Lens-ers and Other Independent Types Freelance Photography

 $P \begin{tabular}{l} robably the most common career area for photographers, freelance photography offers opportunities in virtually all the categories presented in this book. The whole world of photography is open to the freelancer! \end{tabular}$

A freelancer might work at a wedding on Sunday, shoot glamour portraits on Monday morning and a Little League game in the afternoon, work on a corporate advertising assignment on Tuesday, and sell a series of photos to the newspaper on Wednesday. Thursday the fine art gallery exhibit opening reveals more creative work, and Friday the local auto racing club wants group photos and action shots of the rally. Saturday means hiking along a new nature trail for a travel magazine assignment.

Wait a minute! When does the freelancer get a day off? Well, the work schedule, too, is up to you. You can work as much or as little as you like—or have time and energy for. But as a freelancer, when a job comes up, it's tough to say no.

Freelancing represents an ideal way to break into a career in photography. While keeping the day job for the sake of security, you can freelance on weekends to build your portfolio before making the break to full-time freelancing.

Many independent photographers, in the interest of efficiency, specialize in a given field so that their self-marketing energies are spent getting well-known by the editors or buyers in that area. The better known you are, the more work comes your way. The chapters in this book describe several of the specialties themselves, as well as some of the ways that freelancers break into these fields.

The Publishing World

We're living in the "Information Age" of global communications and technological revolutions; yet the high-tech world of computers hasn't derailed the continuing growth of printed publications—more magazines, books, and newspapers are published today than ever before. Photographs are a staple ingredient in publications, and freelancers are responsible for a great many of those photos.

Magazines Today

More than 22,000 magazines are published in America today, and that number fluctuates month to month as new magazines start publishing and unsuccessful ones fold.

Most magazines seldom have photography staff positions except the photo editor. To fill the need for photographs, magazines rely heavily on freelancers. A glance through *Photographer's Market* reveals that many magazines use freelancers to supply more than half and sometimes all of the photos appearing in the editorial content of the magazine.

Magazines can be further broken into categories by the audience for which they are intended: the general consumer, the special interest association reader, and the trade reader. Newsmagazines, part of the general consumer market, were covered in Chapter Two on photojournalists.

The magazine industry is changing drastically because of the technological innovations of the last decade. Several are exploring non-paper publishing options such as CD-ROM or online formats. The savvy beginner will look toward the future to prevent being left behind.

Consumer Magazines

For many photographers, the beautiful, exotic photographs that leap from the pages of magazines like *National Geographic* or *Life* or *Travel & Leisure* evoke visions of becoming a globe-trotting photographer with an expense account. A dream? Yes, but one that can come true—though not overnight. Breaking into the consumer magazine market, which covers most of the magazines you'll find on the newsstands and more, takes perseverance, marketing strategy, and, of course, great photos that meet the magazine's publishing needs.

"First, I look for the photos I *need*," says R. B. Stevens, photo editor of *time* magazine. "Second, I buy the photos I *like*."

Photo editors at major magazines receive far more submissions in a month than they can possibly print in a year, so your work needs to stand out to be noticed in this market. One photo editor for another major magazine warns freelancers to study the magazine's content. He gets annoyed with photographers who send submissions that are clearly inappropriate for his publication. Submissions also need to fit the magazine's publishing style and content.

Smaller consumer publications, such as regional or local magazines or those with a targeted audience, such as gardeners or outdoor sports enthusiasts, also fit into the "general consumer" category. These publications might offer more opportunities for the beginning photographer than larger-circulation magazines.

Special-Interest Publications

National and regional organizations usually need a means of communicating with their members throughout the country, and a magazine or newsletter is often the chosen format. The largest of these association-based publications is *Modern Maturity*, the official publication of the American Association of Retired Persons, which is distributed to anyone over 50 years old in the United States who pays the modest \$8 membership

fee. The Automobile Association of America produces a slick magazine with a circulation of more than 2.5 million.

Special-interest publications offer good opportunities for freelancers because many are not large enough to hire staff photographers. They do, however, frequently rely on stock photos to supplement the work done by freelancers on assignment or the work of freelancers who submit photos directly for consideration.

Financial rewards are generally smaller with the smaller publications, but consider the tearsheets a part of the pay package. The evidence you gain in this market of your capabilities will help you get jobs in more lucrative markets later on.

Trade Publications

Like special-interest magazines, trade publications are directed toward a very specifically defined audience. Some trade publications facilitate communication among members of a given profession or trade, such as *Firehouse Magazine* for firefighters or *Food Distribution Magazine* for executives in the food industry. Trade publications, such as computer or in-flight magazines, also communicate to consumers of a given trade area.

Many of these publications use stock photos because their budgets tend to be more limited than either the special-interest or consumer magazines. The editors and photo editors for these publications are often experts in the profession or trade. It is also important that the photographer's work demonstrate an understanding of and appreciation for the particular subject matter of the trade publication.

Freelancing for Magazines

The ideal situation for a freelancer is to have several magazines for which to do work fairly consistently. It takes time to establish this sort of relationship with a magazine. The first step is getting someone to look seriously at your work and consider you for an assignment. One of the most sure-fire ways to get an assignment is to present an editor with a great idea for an article with the promise of great photos to accompany it. Magazines come out every month, sometimes twice a month or even weekly. The editors are always looking for fresh ideas and viewpoints. If your idea is a winner and your portfolio shows some talent, you'll probably get the job.

Presenting Ideas

Coming up with story ideas, though, means that someone has to do the writing. If you can combine writing skills with your photography, you become a very attractive bargain to editors.

Before you approach a magazine with an idea, do your homework. Thoroughly familiarize yourself with the content of the magazine. What kinds of stories does it publish? What kinds of photos? Does the subject matter fit with your interests? Is the pay scale worth the trouble? You'll find information about what a magazine pays freelancers in the annual *Photographer's Market*. Not all magazines are listed here, though, so you may need to request submission guidelines from the magazine directly.

Once you've had one assignment, don't rest on your laurels. Come back with more good ideas. Send a photo postcard with a note to keep your name in the editor's mind. If you make too many phone calls, though, you'll be considered a pest. It's a fine line to walk between persistence and pushiness. After thoughtful perseverance, the payoff is the phone call from the editor with a request for you to cover an assignment.

Earning Potential

Magazines usually have established rates for paying freelancers, and until you've made yourself indispensable, keep the negotiating to a minimum. The rates vary tremendously from one publication to the next. Pay is generally per photo, per assignment, or per day. One source lists a low day rate as \$350 plus expenses, although not all magazines have budgets that allow payments at even this level. You'll need to decide for yourself what your time is worth, but be careful not to undervalue yourself. "Cut-rate" photographers in the end only see their own profits being undermined as someone else comes along and undercuts the competition. Do ask if expenses are covered for film and processing, as well as any travel costs involved with the assignment.

Per-photo prices depend on some fairly complex variables, including the photo's expected use, the circulation of the magazine, the size the photo will be published in, and whether the photo will be on the magazine's cover. The *Photographer's Market* magazine listings usually include information about the range of payment for individual photographs, as well as photographer's day rates.

The American Society of Media Photographers publishes a directory of members, called the ASMP Silverbook, that includes advertisements of photographers with full-color photographs. This book is used by photo editors at magazines, advertising agencies, and design studios to help locate photographers for assignment work.

Freelancing for Newspapers

Many newspapers, especially statewide dailies, Sunday editions, or newspapers with national distribution, such as USA *Today* or the *New York Times*, use freelance photographers, or "stringers," as they're called in the news business. A stringer in another city or state can cover a local event more easily and cost-efficiently than a staff photographer from the newspaper's home town.

New is News

Timeliness and newsworthiness are the watchwords in the news media. Did it happen today? Get it in the paper. Did it happen last week? It's old news. Don't bother unless there's some new angle that makes the story interesting all over again.

A "breaking" news event is of special interest to newspapers. If you happen upon something newsworthy—a fire or accident scene, a celebrity event, an arrest (always be careful to stay out of the way of officials)—cover it from as many "news angles" as possible, then race the film to the newspaper to make the sale.

The question of timeliness means that the freelancer might also need to have access to sophisticated wire or electronic transfer media so that the newspaper can receive photos for rapid deadline processing. Chapter Two on photojournalism and press photography discusses this in more detail.

Earning Potential

Newspapers generally have their own staff photographers and so don't rely as heavily on freelancers as do magazines. Also, the budget for freelance photography isn't as generous in the newsprint press, so the earning potential is not as high. Although it is difficult to make a living as a full-time newspaper stringer, especially if you are only working for one paper at a time, it can be a good way to get started toward a career either as a freelancer or as a photojournalist.

Day rates for newspapers vary from a very low \$40 (essentially minimum wage, which might be offered to a raw beginner) to \$350 or \$500 at the outside. More often, though, a newspaper pays by the assignment or by the number of photographs published. This rate will vary, too, from \$10 for a black and white photograph in a small weekly to \$650 for a color photo in the *New York Times*.

Freelancing for Book Publishers

The book publishing industry has been undergoing a tremendous period of change in the past decade. Megamergers, consolidations, and buy outs have shifted the corporate structure within the book publishing world, creating confusion throughout the industry. The economy of the late 1980s and early 1990s deeply affected the book industry. As a result, budgets are much tighter and editors are thinking twice about whether they can afford to hire a photographer for specific needs or whether it will save money to buy stock photos.

Before you send a publisher your portfolio, discover the name of the art director or editor who makes decisions on photography for books. It's always best to submit your work to the person with the power to make the decision. Packages marked simply "Editor" without a specific name get shuffled into a pile that will be reviewed first by an assistant before being passed to the person in charge.

Check with the editor, or with the listings in *Photographer's Market*, to learn the preferred method for photographers to submit portfolios. Some publishers will prefer to receive a query letter with a resume of credits and a list of the photographs you have in your "stock." (Stock photography is covered later in this chapter.)

The best job for photographers in the general book industry is to have a photo used on the cover of a book because it pays more and achieves wider recognition. Payment varies according to how the photograph is used, how large it is reproduced, and whether it's in black and white or color. Rates range from \$25 to \$500 per photograph, and potentially more for a cover photo. Some publishers will hire a freelancer by the project or by the day, with day rates varying from \$250 to \$1,200 or more.

Freelancing for Tabloids, Newsletters, and Other Small Publishers

Several specialty publications are too small to be called magazines and too infrequent to be called newspapers. They often carry the banner title of "Newsletter" or "Monthly." These usually small-budget publications still include photography and are often produced by so few staff people that a photographer isn't among them.

Most small communities have organizations that publish limited-circulation tabloid-sized newspapers. They are published weekly, monthly, or sometimes quarterly, and almost all of them include photographs.

The approach to getting freelance work with these publications is not unlike that for magazines or newspapers. Find out what they publish and what the editors are looking for; then present yourself with your portfolio and your ideas.

The potential remuneration, almost always on a per-photo rate, is lowest here, but for that very reason the opportunity to be published is often the highest. Prices vary from \$5 to \$50 per photo, sometimes more. When you're just starting out, the photo credit can be as important as the paycheck.

Selling Photos to Postcard and Calendar Publishers

Companies that produce greeting cards, calendars, and posters are often willing to pay top dollar for a photograph that meets a specific need or that appeals to a targeted buying audience. *Photographer's Market* lists more than 50 such companies, with information on the pay scale for purchasing photographs and how freelancers should submit their work. Some prefer stock lists with a query letter, others prefer color contact sheets, and others will want to see a complete portfolio.

Photographs of nature and wildlife, nostalgia, seasonal images, scenics, children, humor, and inspirational images are the mainstays of this market. Be sure to know the needs of the company before you send your work, though. One company might want only photographs of children, while another emphatically does not want to see any photographs of children.

Photos sold for this purpose can earn from \$15 to \$500 or more. Some companies offer a royalty percentage of sales revenue, but be sure to ask for an "advance" against royalties, and determine what you will receive from the publisher in the nature of sales reports.

The Corporate World

Advertising and Commercial Photography

Most of the magazines and newspapers in the nation earn far more profits from the advertising revenue they receive than from subscriptions. Look at the advertising you see in the publications you encounter every day. They're filled with photographs, and many of those were taken by freelancers.

Advertising photography can be the most lucrative in the field. Day rates range up to \$3,000 for a photographer whose portfolio justifies such confidence; however, the higher the income, the higher the expectations. Before you reach too high, be sure you can follow through in this extremely demanding and competitive field.

The key to "making it" in this area is establishing connections with those who provide the major buyers of advertising space—manufacturers, producers, restaurants, entertainment establishments, hotels, service industry operators—with the creative product that appears in the print media:

- Advertising agencies
- Advertising and design departments of major corporations
- Commercial printers
- Design studios/desktop publishers

On a smaller scale, any business or organization with a service or product they need to sell needs photography. It's your

job to convince them of that need! This is where your marketing skills come in handy. Many small local businesses may not realize the value in producing quality advertising materials or brochures to enhance their sales and profitability. Once you've helped one business with the preparation of promotional advertising materials, you've begun to develop the portfolio that will help you get your next job.

Corporate and Industrial Photography

Corporate and industrial photography is another area with tremendous income potential, one that sees a lot of competition at the upper levels of the pay scale. Someone breaking into the corporate market has a stronger chance with local companies, although it's not impossible to develop national clients.

Corporate and industrial photography involves taking photographs that reflect the role, product, people, service, or "image" of a corporation. Other areas of corporate photography involve documenting a company meeting or event, such as the company picnic. Portraits of newly hired executives or the employee of the month might be commissioned to be sent with press releases to industry trade publications.

Manufacturers often exhibit their products at trade shows and require strong, colorful photographs for the display area. Slide shows for these events or for employee training are other possibilities for industrial photography.

Any business that offers stock on the public market must by law produce an annual report. In recent years, annual reports have become slick, high-cost documents that serve more as promotional literature than as reports to shareholders. The freelancer starting out might very well get an assignment to do annual report photography for a smaller company or organization. This is a big first step toward success in this area.

86 CAREERS FOR SHUTTERBUGS

Other Corporate Freelance Opportunities

Some other opportunities for photographers in the world of business include working with companies that exist in nearly every community.

REAL ESTATE COMPANIES. Larger real estate agencies print weekly or monthly tabloid advertisers with photographs of the houses listed for sale.

ARCHITECTS, BUILDING CONTRACTORS, AND INTERIOR AND LANDSCAPE DESIGNERS. Professionals in the construction industry frequently need photographs of their projects, from the design phase through final construction and decoration.

INSURANCE AGENCIES. Sometimes insurance agencies will recommend that a client have valuables photographed for insurance records.

LAWYERS. Litigation can involve the need for documentation or evidence photography.

ARTISTS, MUSEUMS, AND ART GALLERIES. A photographer with a strong understanding of lighting can be very effective at taking photographs of fine art objects.

PERFORMING ARTS ORGANIZATIONS. Theater companies, ballet and dance troupes, symphony orchestras, and opera houses all need to photograph performers, both in performance and individually, for advertising and promotions.

BUSINESS OR ORGANIZATION CONVENTIONS. Working at a convention to provide photographs of display booths or executives in attendance can be a profitable short-term time investment. MANUFACTURING COMPANIES. Products need to be photographed for advertising, catalogs, or trade shows.

RESTAURANTS. Photographs of food, the chef, or patrons enjoying the restaurant's atmosphere can enhance a restaurant's advertising efforts.

HOTELS, MOTELS, AND RESORTS. Most inns and resorts prepare a variety of self-promotional pieces, from brochures to flyers to pamphlets.

DEPARTMENT STORES. Special promotional events, window displays, sale flyers, or fashion shows are all opportunities for the freelance photographer.

People Photography

Working with people can be one of the most enjoyable—and sometimes the most trying—part of photography. Chapter Four discusses the role of the commercial portrait studio photographer, but freelancers can find opportunities in photographing people without maintaining an expensive studio.

If you're unsure of your experience, begin by working with friends and relatives, treating the situation as professionally as if they were paying clients. The work you produce in these situations can become examples you show to prospective clients.

Generally the freelancer establishes a price for creating the photograph, then offers additional prints at a separate rate. Be careful to respect the "going rate." As a beginner, it's reasonable to charge less than the current standard because the client is taking more of a gamble hiring you to complete the work rather than a studio photographer with an established reputation. When you become more confident, however, you will want to charge what your time and talent are worth. (There's more on portrait and school photography in Chapter Three.)

The Range of Options

PORTRAITS. Many people prefer to be photographed in their homes or in a natural outdoor setting, which makes this an ideal way for the freelancer to get started in this lucrative field.

GLAMOUR PORTRAITS/BOUDOIR. Aspiring models need to develop their portfolios for presentation to potential clients. The boudoir market has grown in recent years with the increasing popularity of lingerie shops. The boudoir market has a wealth of potential pitfalls, and the wise photographer will study the issues involved before embarking on a career in boudoir photography.

BAR/BAT MITZVAHS OR FIRST COMMUNIONS. Many families want to document these momentous occasions with photographs of the children or formal portraits at the church or synagogue.

GRADUATIONS. High schools, colleges and universities, and sometimes elementary and middle schools hold formal graduation ceremonies that provide ideal job opportunities for photographers.

PROMS. Many high schools holding proms contract with photographers to photograph couples in a staged setting. Other formal dances held during the year also offer opportunities.

WEDDINGS. Although highly seasonal, concentrated during the summer months, weddings happen all year round and can be a strong sideline for freelancers.

SPORTS EVENTS. Every community has some kind of sports event, whether it's intramural volleyball, Little League baseball, elementary school soccer, or community team softball. Photographing the team, taking action shots to sell to the local newspaper, or setting up for individual portraits of team members can be a lucrative sideline for the freelance photographer.

SCHOOLS. Ballet or dance schools, theater programs for children, gymnastics schools and the like all provide wonderful opportunities for the freelancer. Most of these schools work toward a recital or performance. Your photographs will help parents treasure the moments for a lifetime.

Elementary schools bring in photographers to provide class and individual portraits. This requires a special portable portrait set-up, but the investment can pay off if you obtain enough contracts to cover the expense.

PASSPORT PHOTOS. A special dual-shot camera, which provides two identical images on the film, or a 2 1/4 format camera is all you need to begin taking passport photographs. You can offer a portable service or establish a relationship with a local department store or other business where you make yourself available to take passport photographs at specified times.

CLUBS, ASSOCIATIONS, ORGANIZATIONS. The local garden club's annual rose show, the booster club's summer carnival, and the senior center's "Pensioner's Prom" are examples of events that provide freelance opportunities for a photographer. Photograph individual members, officers, or the entire membership.

College towns often have fraternity and sorority houses that sponsor a variety of dances, outings, and other events that members would like to have documented with photography.

Stock Photography

Some photographers manage to make a majority of their income from selling and reselling photographs through stock photo agencies. Stock agencies are like photo libraries or rental companies that maintain an inventory of thousands of photographs covering a wide range of subjects. Clients check out or rent the use of a photograph for a magazine article, corporate brochure, annual report, or catalog.

Photographers who have been working at their craft for a long time and have developed their own extensive photo library might consider becoming a mini-stock house, developing a client base that could include other stock agencies, as well as the usual clients for stock photography: advertising agencies, book publishers, magazine publishers, corporate advertising departments, travel companies, resorts, the entertainment industry in short, anyone who uses photography in the course of doing business.

What Sells in the Stock Market

For a photograph to do well in the photography stock market, it needs to communicate, it needs to be impressive in terms of its technical perfection, as well as aesthetic presentation, and it needs to be general rather than specific. You need to be able to envision a hundred different ways for the photograph to be used in order for it to sell to a variety of clients.

Stock agencies often specialize in a given subject matter or several somewhat related subjects. If you've developed a specialty in your own work, you will most likely be able to find a stock photo agency that fits your interests. The very large agencies cover everything and often hire photographers to go out and shoot photos to fill in the gaps in their ability to meet potential client needs.

Some of the categories covered in stock libraries include the following:

- Agriculture
- Architecture
- Celebrities
- Fashion
- Fine art and Crafts
- Food
- Industry
- Nature
- People
- Planes, trains, and automobiles
- Plants and botany
- Recreation
- Religious or inspirational images
- Scenics
- Science and medicine
- Sports
- Travel
- Wildlife

How to Sell Stock Photos

If you're seriously interested in developing stock photograph sales, obtain a copy of the American Society of Media Photographers' *Stock Photography Handbook*. This comprehensive guide provides a wealth of information on how to go about selling stock photos. Here are some brief guidelines to follow.

The first step in selling stock photos is to have a large enough body of work from which to choose some 200 to 400 images for submission to a stock agency. "The more photos in your submission the better," recommends Tim Potter, Director of International Operations for the stock agency MT USA. "However, tightly edit your work to your best areas of expertise—don't show us a little of everything. We look for very strong, thematic work. We've signed contracts with some people for only five photos and up to 500."

He says that most stock agents prefer 35mm transparencies (slides), although some specify 4 x 5 negatives. You'll need to have your slides "duped," or copied, and send the copies rather than the original.

Tim also recommends sending photos via express services, and including a self-addressed stamped envelope or Federal Express account number with your submission. "It will greatly speed up the return process and show us agents you're a fair and organized business person," he adds.

"A cover letter with your bio or resume is very helpful; tear sheets and other printed samples are also nice, as are photo books you may have published. Most agencies, like ourselves, publish catalogs to market our photos, so keep in mind that these catalogs aren't done overnight and that your photos may not get to market for six to twelve months, depending on when you submit them."

Inventory Your Photographs

Once you're satisfied with your body of work, develop an inventory record that includes the following information for each image: the subject, the date, the medium (black and white, slide, transparency), the place it was taken, whether you have a model or property release (a release is required if there are people, pets, or personal property that can be recognized in the photograph), and any other pertinent information. A printed list containing this information is an essential tool for developing sales. Label slides with your name, phone number, a copyright mark (for example, Copyright © 1994 Cheryl McLean), and either the title, subject matter, or an inventory number that corresponds to your list. Many photographers who work extensively in stock have developed computerized database inventories that help keep track of the images in their collections, where they've been sold, and, if so, what rights were sold.

Select Prospective Agencies

Review available information about stock agencies to determine which are appropriate markets for your work. *Photographer's Market* annually lists some 200 agencies with specific information about their subject needs, as well as submission and payment policies.

Write to the agency to request submission guidelines, subject needs, and, if possible, a stock catalog. It's important to try to match your photographs with the stock agency to increase the likelihood of a sale.

Talk with other photographers (the agency should provide a list if you request one) about what it is like to work with the agency. You want to be sure you are working with an agency that pays regularly and promptly, that actively sells the work in its collection—not just the work of its top photographers, and that concentrates in the areas in which your work fits. You'll also want to avoid agencies that charge excessive fees, sell rights for use of the photos to clients at large discounts, offer substantially less than the standard 50 percent commission, or do not offer access to audit records for verifying sales in the case of a dispute.

One photographer who specializes in stock photos suggests consulting the Picture Agency Council of America Directory. The PACA has established a standard code of ethics, to which member agencies subscribe.

Making the Sale

After you submit your work for review, you'll get an offer from the agency if the editor feels your work merits inclusion in the collection. Arrangements between photographers and stock agencies involve a written contract, which you should consider a negotiable document. Review it carefully. Consider all the elements before you sign.

Most photographers will refuse to sign an exclusive arrangement with a stock agency, though some agency reps will tell you this is standard procedure. An exclusive contract means that you can only sell your own work through the agency. This is not a very good deal from your perspective.

Once you've reviewed the terms and signed the contract, you've established a relationship with an agency that will now review your work regularly when you submit it. The agency will send you regular reports of photo sales along with a check for your commission.

The Move to Digital

Don Landwehrle has 14,000 photographic images in his own library, which he recently had converted to Photo CD. He does both assignment and stock photography, which he processes on his extensive computer system.

"The assignment end of my work is what paid for the equipment," he says. "I've always had the belief that if the job would pay for (or close to) the equipment, then buy the equipment and do the job."

For assignment work, Don shoots with a $4 \ge 5$ camera, then takes the transparencies to a service bureau to scan them on a drum scanner. After manipulating the images, he sends the client a file instead of outputting a chromalin print, or chrome.

"I still find most clients have to be talked out of outputting to chromes and staying digital," Don adds, "but after talking to them and telling them the benefits, they will go with a digital file." The benefits are primarily in the reproduction quality. By keeping the photograph in its digital form, the designer is working, essentially, with an original image, especially if it was processed in Photo CD. Every step in the traditional printing process involved getting one step further from the original image. The digital file allows there to be only two steps: from computer to printing plate to the printed page.

The Freelance Assistant

Many professional photographers with large corporate contracts for complex projects require the services of a photographer's assistant. This position offers aspiring professionals to learn the ropes working with an experienced photographer.

Freelance assistants are self-employed and can earn from \$50 to \$300 per day, based on their experience and knowledge, and the work required from the photographer. Someone hired to put film in the camera will not earn as much as someone responsible for assisting with staging, lighting, or processing and printing.

A Freelance Assistant's Experiences

Peter is a freelance assistant who works in the Washington, D.C., area. Although he started out in a college art photography program, he left to work in a camera store where he learned a great deal about photography. He recommends business courses to anyone wanting to freelance for a living, either as a photographer or taking the stepping-stone approach by working as an assistant. Design courses, too, are useful because it helps to speak the same language as the designers who hire you.

"Assisting has allowed me to travel fairly extensively while working on photographic projects and getting paid a relatively fair wage," Peter says.

The freelance assistant does just about everything the photographer would do plus run out for lunch, according to Peter. He looks for angles for shots, and watches to make sure the lights are firing, the camera is set correctly, the film is going through the camera, the subject's clothes are straight, and all the client's needs are met. He runs errands, and takes the film in for processing. "The only thing we really don't usually do," he says, "is get the clients and push the button on the camera."

Peter's advice for getting jobs as an assistant is to get to know every photographer you come into contact with and be so good at what you do that when a photographer is stuck and needs someone to help, you're the one to be called.

This approach also works for developing clients on your own, too, once you've gained the experience you need. It's unethical to steal clients from the photographers you work for, but if the time comes when they're unable or choose not to take a job and the client turns to you, you want to be ready to jump at it.

Assisting gives a freelancer the opportunity to explore a variety of photographic areas. You might work with a commercial photographer one day on a fashion magazine spread and with an architectural photographer the next day.

"The advantages of assisting are that you learn everything about being a photographer except the unlearnables," says Peter, "which include the 'eye' and the 'schmooze' factor. The downside is that you reach a certain point where you can do anything the photographer can do and it's all you can do to keep from throttling photographers who are obviously incompetent. Then it's time to move on and start shooting on your own."

Darkroom Work

If you've set up your own darkroom and enjoy working with this part of the photography process, you can earn extra income by processing and printing the film of other photographers and amateurs. Davis Photo is a father-and-daughter operation in the elder Davis's garage-turned-darkroom. What began as a personal hobby and then grew to supplement other full-time work has become a thriving business. Bill and his daughter Janet work exclusively with black and white and are the only black and white processors in their community of 45,000 population.

They process and print film, contact sheets, and prints ranging in size from $2 \ge 2$ inches to $11 \ge 14$. In addition to standard processing, they handle copy work, make black and white prints from color slides or prints, and take product photographs for a variety of commercial clients.

Recently they have begun to expand into the computer graphics field with the addition of a scanner and computer station, as well as a printer that can prepare color slides and transparencies for presentations. They have been surprised at the rapid growth of their business in this field, and are ready to take on a staff person to handle the demand.

The Business of Freelancing

If you're going to work on your own, you need to explore some of the business aspects of working independently. One of your first investments should be a telephone answering system so that you will never miss a call from a prospective client. When the client calls, you want to be ready to get down to business. Here are some important areas for you to understand.

Copyright Basics

You need to become well-versed in the intricacies of rights sales to protect yourself and your future income as a photographer. The moment you develop the film or print an image, it is ostensibly copyrighted. You don't need to register an image with the U.S. Copyright Office in order to obtain legal protection unless you are preparing to file suit against a photo buyer for copyright infringement. Infringement means someone is using a photograph without your permission.

To register a photograph, write to the Copyright Office, Library of Congress, Washington, D.C. 20559, and request Form VA (visual artist works). The cost for filing a copyright registration is \$10, so registering every image is impractical, but if you have images with a high risk of infringement and a high income potential, it may be worth the investment.

Selling Rights

When you sell a photograph to a client, you are not necessarily selling all rights to that photograph. You want to be able to sell it again to other clients or use it yourself in self-promotional pieces. In essence, you're "renting" your photograph for someone to use for a specifically defined purpose. Ownership of the copyright should remain yours. To retain ownership, however, you need to be diligent in understanding the rights that you offer for sale when you sell individual photographs or your photographic services to a client.

Copyright Law

In 1989, the U.S. Supreme Court affirmed the standards of copyright ownership for all creative works, including photography, established in the Copyright Law of 1976. Ownership can be transferred only by written agreement.

To help ensure copyright protection, be sure to mark everything you send out with the international copyright symbol, ©, followed by the year in which the photograph was taken and your name. In addition, you might want to include the phrase "All rights reserved." A computer labeling program or a rubber stamp and indelible ink pad will help to simplify this process.

Basic Rights Definitions

The rights that photographers might offer for sale include the following:

ALL RIGHTS. This involves selling the right for the buyer to use the photograph in any way and as often as desired for a specified or unspecified period of time.

EXCLUSIVE RIGHTS. The buyer is the only one, including the photographer, who can use the photograph. Exclusive rights can be negotiated by time period, and by specific use, however. For example, a client might negotiate to keep the photograph from being used by a competing company in the same industry, such as greeting cards, for the period of one year.

FIRST RIGHTS. The client is buying the right to be the first to use the photograph. Generally the price for first rights is a little higher because the buyer is paying for the privilege of being the first to use it. Obviously first rights can be sold only once.

ONE-TIME RIGHTS. The client is buying the right to use the photograph only once.

PROMOTION RIGHTS OR AGENCY PROMOTION RIGHTS. This allows the buyer to use the photograph in materials that promote the publication in which the photograph originally appeared. Agency promotion rights give the stock agency or advertising agency permission to use the photograph in its selfpromotion.

SERIAL RIGHTS OR FIRST SERIAL RIGHTS. These terms relate to the right to use the photograph in a periodical or magazine. First serial rights are generally priced higher than subsequent serial rights sales, and can be sold only once. WORK FOR HIRE. According to the Copyright Act, this is "a work prepared by an employee within the scope of employment; or a work specially ordered or commissioned for use ... if the parties expressly agree in a written instrument signed by them that the work shall be considered a work made for hire." A work made for hire means that the photographer permanently relinquishes all rights to the photographs created under the terms of the contract, as well as rights to any future compensation or royalties.

For More Information on Copyright

The Society of Photographer and Artist Representatives offers a package of sample forms and copyright explanations that can be very useful when you're negotiating your own rights sales. It's called the SPAR* *Do-It-Yourself Kit*, and is available direct from the Society.

Other resources include the subdivision of American Society of Media Photographers devoted to issues of copyright, Media Photographers Copyright Association (MPCA), and the U.S. Copyright Office, which has a variety of publications available explaining copyright laws. The ASMP White Paper on Copyright Registration is available from the association.

Finding Clients

In addition to the prospects described above, don't forget about some of the more obvious resources for finding clients who might need your photographs. At the local library, you'll find a number of trade directories that list names, addresses, and phone numbers of corporations, manufacturers, periodicals, and book publishers. Often these are indexed by geographic region. Some of these references include *Standard Directory of Advertisers*, *Adweek Directory of Advertising Agencies*, *Literary Marketplace*, *Ayer Directory of Publications*, *Standard Rate & Data Guide*, and Bacon's Publicity Checker. The newspaper, industry trade shows, local telephone directories, the chamber of commerce, and business publications also provide sources for potential clients. As you take down the name and address of a potential client, keep notes on your ideas for what kinds of photography that client might need and how you might sell yourself most effectively. When the time comes to make a presentation or draft a letter, you'll have made a start toward developing an effective sales message.

Marketing, Advertising, and Public Relations

As a freelancer, you need to get the message to potential clients that you are available and that you're the best person to provide the photography they need. Taking the time to develop your client base often involves so much work that you find yourself spending less time being a photographer than being a business person. Over time, though, as you develop a rapport with a number of repeat clients, your need to market yourself will become more manageable and you'll feel more like a photographer again.

Selling Yourself

Part of the marketing you need to do is develop a resume, which can be updated regularly as you increase your credentials. List your photo experience, education, and previous publication credits or satisfied clients.

Query letters require careful thought and preparation for each prospective job or client. These letters are written to inquire about the client's interest in an idea you have, the stock list you've prepared, or the work you could do if granted an assignment. These letters don't speak as loudly as your photographs, but they're an important introduction. They should rarely be more than a page long, should look highly professional, and should be typed on your letterhead stationery. They should include specific information about what you are proposing as well as the rights you are offering, if appropriate.

When mailing photograph submissions, include a cover letter that explains the proposal or mentions the editor's agreement to review the work, if that was the response to your query letter. Be sure the photos are packaged appropriately, that you've included a stamped, self-addressed envelope (SASE) for their return, and, to be on the safe side, send the package via certified mail with a receipt that confirms delivery. This will help with your record keeping and assist in tracing a package that gets lost in the mail (it really does happen, though not often).

Always follow up on contacts with prospective clients. Send a quick thank-you note or message of appreciation for their consideration. Make a "just touching base" phone call to see if there are any questions or other needs the clients might have. If you've had one unsuccessful query but feel there's room for optimism, send another letter with a different approach or a new idea or angle. There's a rule of thumb with marketing that it takes at least six contacts to make a sale. Don't give up, do follow up.

Developing Self-Promotion Pieces

A business card is the first self-promotional tool that you will want to invest in as a freelancer. You need to have something to hand a potential client or to send with a portfolio for the client to keep on file. Have the card designed by a graphic artist to assure a professional look. Some photographers choose a particularly striking photograph and print business cards with this as the background, either in black and white or in color. Your local print shop will have a variety of samples for you too look at.

A lot of your marketing to potential clients will be through direct-mail inquiries or promotions. The more skill and experience you have to offer a client, the more you want to invest in self-promotion pieces. Some options include the following:

- Brochures
- Catalogs
- Pamphlets
- Postcards
- Posters

Resources for self-promotion include A Photographer's Guide to Marketing and Self-Promotion by Maria Piscopo, and various publications produced by the American Society of Media Photographers, including Business Practices Manual.

Advertising

There are a number of avenues for buying advertising space, and the cost varies according to the number of people the advertisement will reach and how frequently or for how long the advertisement will appear. Advertising may not be the most cost-effective form of marketing. You want to be sure you've selected the best possible medium, that your ad presents a strong sales message, and that the likely return on the investment will make running the ad worthwhile.

Photographers can advertise in local newspapers, national magazines, the *Yellow Pages*, and in source books or directories. Source book ads and display advertisements in the *Yellow Pages* run \$2,500 and more. Magazine ads cost approximately \$250 to \$500 or more per issue of the magazine, depending on the size of the advertisement and whether the magazine prepares the copy for you.

Once you've run an ad, be sure to do appropriate follow-up on any calls you receive. Add the prospect to your mailing list even if the advertisement didn't immediately net a sale. Continued contact will increase your opportunities for success.

Public Relations

Public relations is sometimes called "free advertising." The goal of PR efforts is to get your name in print as part of an editorial article rather than a paid advertisement. Not only is it more likely to be noticed in an article, there's a level of credibility to seeing something stated as part of a news story that doesn't apply to an advertisement.

"New is news" for public relations stories, as well as for photographs. If you win a big national account or expand your services, that's news for the business pages. If you just received a photography award or some special recognition from a community organization, write up a "press release" to be sure the local newspaper and any other relevant publications know about it.

Insurance

As a freelancer, you need to protect yourself and your business against potential loss. You will want to cover all aspects of your business, and perhaps obtain personal health, disability, or life insurance.

Business insurance involves questions of liability and protection of property. Liability insurance protects you in case of personal injury and property damage—yours, your client's, or anything that happens in the process of pursuing your work. Insuring your equipment against theft, vandalism, or damage from fire, water, or accidents just makes sense. Be sure you're covered wherever you are working—at home or in the field.

Another form of insurance is making duplicates of important photographs in your collection and keeping them in a safe deposit box, or at least in a different location, in case of fire or theft. Back-up disks of your computer records are also a valuable protection against computer "crashes" or theft. Health insurance can be purchased through several professional organizations. Disability insurance is based on your previous freelance income, so you will need to have developed a history of established income before investing in this option.

Pricing and Billing

Freelancers, especially those starting out, probably have the greatest difficulty determining what their photographs and their services are worth. I've attempted to present the range of prices that are common in each area of freelancing, but the variables are considerable. Where you live or where the client is located can affect the price as much as the client's budget and the level of your skills and experience.

Using *Photographer's Market* as a resource, you can get a sense of the general range of acceptable prices for a given field, as well as the specific payment offered by a publication or organization. If you've decided that your photographs are worth more than \$25 for use in a magazine, you can rule out certain potential markets before taking the time to query directly.

A recently published book, *Pricing Photography* by Michal Heron and David MacTavish, presents a series of charts and tables that help determine an appropriate pricing for whatever market you're selling in. A computer program, fotoQuote, similarly presents a series of questions about the nature, use, and size of the photograph and presents a range of acceptable charges as well as suggestions for how to negotiate the fee. The program is available from Cradoc Corporation, P.O. Box 10899, Bainbridge Island, WA 98110, 1-800-679-0202.

In addition, the American Society of Media Photographers has prepared a set of sample forms, available for a fee, that can help with some of these business chores. The set includes sample assignment estimate and confirmation forms, model and property release forms, and invoice forms. The monograph *Assignment Photography*, published by ASMP, includes a detailed section on pricing.

Working with an Agent or a Photographer's Representative

Well-established photographers often work with an agent or a photographer's representative who takes on most of the marketing and negotiating tasks of being in business for yourself. This frees you to spend more of your time photographing.

In exchange, the photographer's representative earns a commission on work you obtain as a result of these efforts. A relationship with an agent or rep is usually spelled out in a written contract, which defines responsibilities, fees, and procedures for working together, as well as grounds and procedures for terminating the relationship.

Most photo reps work in large metropolitan areas, and chances are you won't need one unless you live in a large city and are working for a number of clients. To find a rep, consult *Guide to Literary Agents and Art/Photo Reps*, a relatively new directory that provides detailed listings of reps and agents across North America.

Record Keeping

There are several areas of your work as a freelancer that require careful record keeping: a filing system for keeping track of your photographs; a project management system for scheduling client projects and keeping track of client contacts and prospects; and a bookkeeping system for maintaining financial records. A personal computer can help you with each of these tasks.

Filing systems for your photographs involve archiving storage to protect the photographs and slides themselves, plus the ability to update your stock list (usually with a computer database or a card filing system) and find a particular photograph when you need it. Rohn Engh's book, *Sell and Resell Your Photos*, presents a variety of ways to approach these important tasks.

The computer also can provide help with client contacts and project scheduling. Several software programs exist for both IBM and compatibles and Macintosh computers. You want to keep track of your marketing efforts with potential and existing clients, submissions that have been sent, replies to submissions, and other ideas to pursue. A project calendar keeps you from letting deadlines or meetings slip by.

As a self-employed worker, you will also need to keep very careful financial records both of your income and of the expenses that qualify as tax-deductible. Some states require photographers to charge sales tax for their services. Many professionals recommend using an accountant when it comes time to file taxes. Self-employed individuals are also responsible for paying what is called a self-employment tax. This tax is essentially the equivalent to Social Security, which is normally paid through payroll deduction and by the employer. An accountant can also help with filing quarterly reports and make estimated tax payments to the Internal Revenue Service, which is required once you begin to make a profit on your business.

For Further Information on Freelance Photography

There are a wealth of books on the subject of freelance photography, so much so that you can easily feel overwhelmed with information. Some of the most useful sources include, but are not by any means limited to, the following:

Books

American Society of Media Photographers. ASMP Stock Photography Handbook; Business Practices Manual; Get it in Writing! Better Business Practices for Photographers (audio tape); Copyright Guide for Photographers; Magazine Photography; ASMP Photographer's Guide to Negotiating; Assignment Photography; ASMP White Paper on Copyright Registration. All ASMP publications are available from the association (address below).

- Crawford, Tad. Business and Legal Forms for Photographers. New York: Allworth Press, 1991.
- Cribb, Larry. How You Can Make \$25,000 a Year with Your Camera. Cincinnati, OH: Writer's Digest Books, 1991.
- Engh, Rohn. Sell & Resell Your Photos. Cincinnati, OH: Writer's Digest Books, 1991.
- Freelance Photographer's Handbook. New York Institute of Photography, Inc., 211 E. 43rd St., New York, NY 10017-4700.
- Gordon, Elliott and Barbara. How to Sell Your Photographs and Illustrations. New York: Allworth Press, 1990.
- Guide to Literary Agents and Art/Photo Reps. Cincinnati, OH: Writer's Digest Books (revised annually).
- Heron, Michal. How to Shoot Stock Photos That Sell. New York: Allworth Press, 1990.
- Heron, Michal. The Photographer's Organizer. New York: Allworth Press, 1992.
- Heron, Michal. Stock Photo Forms. New York: Allworth Press, 1991.
- Heron, Michal, and David MacTavish. Pricing Photography: The Complete Guide to Assignment and Stock Prices. New York: Allworth Press, 1993.
- Howard, Blair. *How to Sell Your Photographs: The Tricks of the Trade.* Cleveland, TN: Lionhouse Publishing Co., 1991.
- Kieffer, John. The Photographer's Assistant: Learn the Inside Secrets of Professional Photography—and Get Paid for It. New York: Allworth Press, 1992.
- Photographer's Market. Cincinnati, OH: Writer's Digest Books, annual.
- Piscopo, Maria. The Photographer's Guide to Marketing & Self-Promotion. Cincinnati, OH: Writer's Digest Books, 1987.
- Purcell, Ann and Carl. Stock Photography: The Complete Guide. Cincinnati, OH: Writer's Digest Books, 1993.
- U.S. Copyright Office. Copyright Basics (Circular 1). Copyright Office, Library of Congress, Washington, D.C. 20559.

Periodicals

- International Photographer. American Image IFPO/IFMO, P.O. Box 18205, Washington, D.C. 20036-0205.
- Photobulletin-Daily. PhotoSource International, Pine Lake Farm, Osceola, WI 54020. (Daily electronic listing that presents needs of advertising agencies, public relations firms, publishers, and corporations.)
- *PhotoPro.* 5211 S. Washington Avenue, Titusville, FL 32780. (Bimonthly magazine for professional photographers.)
- Stock Shooter. Redstone Publishing, 8 Thomas St., New York, NY 10007-1197.

Taking Stock. Suite A, 110 Frederick Ave., Rockville, MD 20850. (Quarterly newsletter published by expert Jim Pickerell.)

Organizations

- Advertising Photographers of America. 27 W. 20th St., New York, NY 10011.
- American Society of Media Photographers. 14 Washington Road, Suite 502, Princeton Junction, NJ 08550-1033.
- National Freelance Photographers Organization. Box 406, Solebury, PA 18963.
- Picture Agency Council of America. C/o 4203 Locust St., Philadelphia, PA 19104.
- Society of Photographer and Artist Representatives, Inc. Suite 1166, 60 E. 42nd St., New York, NY 10165.

Have Camera, Will Travel Travel Photography

The portability of your camera makes photography ideal for an "on-the-go" career involving travel. If you have a bit of wanderlust, like to explore new locales and use your camera to document the scenery, architecture, and people of the world, then travel photography could be your ticket to a rewarding career.

But travel photography isn't always about exotic ports of call. Any location is a potential travel opportunity for people from somewhere else. Even photographs of your hometown can sell as travel shots to a variety of clients.

The ideal situation for a travel photographer is a long-standing relationship with one or more major clients who send you to a broad array of locales and pick up the tab for air fare, hotels, and meals, as well as film and a hefty day rate. What is far more common is that you pay your own way to locations you wanted to visit anyway with the hope that you'll sell some photos on your return—maybe enough to pay for your film, developing, and a few miscellaneous expenses. Fortunately, there is a fair amount of middle ground between these extremes.

Bob Krist, one of the top travel photographers in the country, provides some delightful insight on the real life of a travel photographer. He has published extensively in all the major travel magazines, and he contributed a column to *Travel & Leisure* magazine for several years. When I asked him to describe an average assignment, this was his response: "Average assignment is almost a contradiction in terms, but most editorial assignments start with either an idea that I generate and pitch to an editor, or an assignment that crosses an editor's desk and then he or she calls me (hopefully) or whoever they want to use.

"The phone call usually begins with, 'How would you like to go to ———?" Then you say 'Yes' (you can't say 'no'). Then you begin the long, tedious task of researching and planning the trip. I spend an average of two days researching for every day I spend in the field. Phone calls, tracking down leads, reading previous articles about the place, finding guides or local help, checking out the minutiae of transport, begging help with expenses from tourist boards, packing equipment into smaller and smaller cases, getting shots and prescriptions. If you have any energy left to take pictures when you finally arrive, you've passed the first hurdle.

"Then you've got jet-lag, driving on the wrong side of the road, language barriers, bribes and tips, and being completely lost and disoriented to deal with. Then you have to take some great pictures.

"Then you get home. You've got jet lag, kid bribery, familial responsibilities, plus a couple hundred rolls of film to process, edit, and caption. Then you've got to do your expenses and remember how many colodnys you gave that bellboy to let you onto the hotel roof. Then you get your tray of slides together and venture into no-man's land—the editor's office—where you lay three weeks of blood, sweat, dysentery, and tears out in front of the assembled jurors and await your fate. Thumbs up, you live to get another assignment. Thumbs down, and it's back to driving a cab...."

The Primary Market: Travel Magazines

Travel magazines rarely employ staff photographers—except as photo editors who occasionally shoot a trip to get out of the office—so they rely extensively on freelancers to provide the

images essential for enticing readers to new travel experiences. Still, the competition is fierce, and the number of publications devoted to travel is fairly limited.

Larger-circulation magazines with reputations for quality are the hardest nuts to crack, but they also offer the most substantial rewards. National Geographic, the pinnacle for any magazine photojournalist/travel photographer, does not review work submitted by freelancers, but its subsidiary publication, National Geographic Traveler, uses freelancers for 95 percent of its approximately 80 photos in each issue. Pretty good odds. Similarly, Travel & Leisure magazine, a high-end magazine with a fair amount of snob appeal, uses freelancers exclusively.

Smaller magazines and regional publications probably offer the best initial opportunities for publication and portfoliobuilding. These are more likely to try new photographers, especially someone with fresh story ideas and a strong personal portfolio.

Where to Find Travel Magazines

Aside from browsing through supermarket newsstands, perhaps the best source of information for potential magazine clients is *Photographer's Market*. Published by Writer's Digest Books, it's updated annually, and its listings include information about what the publications publish, what they look for in photographs, and what they pay. *Standard Rate and Data Guide* and *Bacon's Publicity Checker*, available at your local library, both include consumer and trade magazines with listings of addresses and circulation sizes. It's up to you to make contact to determine editorial content and submission guidelines, as well as freelance hiring and payment policies.

Many of the smaller and more accessible magazines will be regional, state, or city publications, such as *Pacific Northwest*, *Ohio Magazine*, *Utah Holiday Magazine*, *Hudson Valley Magazine*, *Dakota Outdoors*, *The Chesapeake Bay Magazine*, or *Palm* Springs Life. Some exotic locations have their own travel publications: Hawai'i, Islands, Caribbean Travel and Life. Most of these publications use freelance photographs, either supplied on speculation, by assignment, or through stock sales.

Some corporations publish travel magazines that augment their products or services. Some of the best-known of these are in-flight magazines, such as Sky (Delta Air Lines) and Hemispheres (United Airlines), and Ford Times and Chevy Outdoors, both published by automobile manufacturers.

Foreign publications are another important market for the travel photographer. They often pay very well and can provide additional sales potential for photographs you've already sold in the States. It helps to know the language so you can write your letters to *France En Poche* in French and *Italia Touristica* in Italian—not to mention being able to converse with the locals when you're traveling. Many of the larger European travel magazines are large enough to operate offices in New York, Los Angeles, or San Francisco.

How to Get Started with Magazines

Once you get the name of a potential magazine client, call or write for submission guidelines and a sample copy or two. Review the publication carefully to determine its editorial "slant" with the photographs it publishes.

I once made a classic mistake when I was just getting started in the business. I had written an article about touring the Potteries in Stoke-on-Trent, England, for a magazine in the United States. It was an assignment, meaning they agreed ahead of time to publish it, but they weren't picking up the tabs for expenses.

I'd shot several rolls of the intriguing bottle ovens that once dominated the entire landscape of the area (and contributed to the black coal-dust that still lingers on many buildings). I had captured what I thought were wonderfully "arty" shots: beautiful bottle-shaped brick structures against dramatic skies

and Industrial Revolution-era brick buildings; shards of expensive Wedgwood pottery discarded in a turn-of-the-century wooden wheelbarrow; row upon row of "discount" Royal Doulton teapots and soup tureens. The lighting, depth of field, balance, composition—everything was perfect.

When I met with the editor, he flipped through the prints I'd made, reviewed all the contact sheets, then looked up and said, "Where are the people?" He was incredulous, and with good reason.

Without another word, he pulled out a copy of the magazine and directed me to page through it. I immediately caught on to what I had failed to notice before—*all* of the photographs the magazine published had people in them. Even landscape shots had a body in the foreground.

The story didn't run, and all I got paid was the kill fee. It pays to know your market thoroughly. (Believe it or not, I did live to get other assignments from that editor, and you can bet I had *lots* of people shots!)

Reviewing the publication gives you other valuable information as well: the name of the photo editor (essential), the balance of color and black-and-white, the preferred focal length, whether they print credit lines on photos, and, if you go back far enough, a good sense of what's already been done, as well as what there is that you could suggest.

Secondary Markets: General Consumer and Trade Publications, Newspapers, and Book Publishers

Photographer's Market, again, can provide information on other magazines that are on the look-out for travel photos, although it will require scouring the listings because they have not been indexed by subject matter.

Consumer Magazines

Consumer magazines—those sold on the newsstands to a general readership—are often targeted to specific groups of consumers, based on interests (*Bride*, *Backpacker*, *Fly Fishing*, *Auto* & *Track*, *Petersen's Photographic*) age, gender, or other demographic groups (*Seventeen*, *Senior Magazine*, *Working Woman*, *Family Life*). Don't forget the photography magazines (see the list in the Appendix). The pay may not be as high as for major travel magazines (\$35 to \$60 per photo compared with \$150 to \$400), but the production standard is high and will provide tearsheets you could show any prospective client.

Trade Magazines

Quite a few trade magazines—publications directed to specific industry or consumer groups—include articles on travel for their readers, especially those directed to a more affluent readership. Travel industry publications such as *Recommend Worldwide*, directed at travel agents, hoteliers, meeting planners, and agencies, include travel photography almost exclusively.

Newspapers

Newspapers, especially larger-circulation papers with Sunday editions, frequently include a travel section. Even small-town weeklies publish occasional travel stories—a new theme park or hiking trail, a renovated downtown, or a winter ski story. All of these represent stories with a "news hook" that make them sellable in the newspaper market. Close-to-home stories like these can be a good introduction to travel photography work. If you can put together a strong photo package of several photographs that present a varied yet representative picture of the location or place, your chances of selling it to the newspaper are good. Newspaper magazine supplements are also a strong travel market and a likely place for color to be used. These sections are also more likely to run travel features on foreign destinations. While newspapers, unlike magazines, employ staff photographers, they'll use freelancers, or "stringers" as they're called in the press, especially for locations away from the publication's city.

Because of the regionality of newspapers, you can often sell the same story/photos to several dailies at once. This doesn't work for the major-market newspapers that have national distribution, such as USA *Today* or even the *New York Times*, which is sold same-day on newsstands around the country.

Books

Book publishers often contract with authors to provide text for forthcoming books, but then rely on the graphic department to arrange for photographs or illustrations. Textbooks, especially social studies, geography, and foreign language texts, require a number of photographs that might come from a travel photographer's stock collection.

The recent spate of A Day in the Life of books provided opportunities for book publication for hundreds of photographers in several countries. The dream of publishing your own coffee table book of travel or destination photographs is realized by only a handful of photographers, but it's not an impossible goal. If you've got a unique idea coupled with stunning photographs—and there's nothing on the market that meets this need—your chances of finding a publisher are improved.

Preparing Your Presentation Package

The Portfolio

Once you have a solid understanding of the publication and its style, put together a selection of your photographs that will show the editor that you can take the kind of pictures they publish. Putting together a different portfolio for each potential client might seem onerous, but if the client has the potential of being a major player in your future income, it's worth the extra effort. Remember, too, that the best portfolios demonstrate your originality and commitment to both strong images and technical excellence. (See Chapter Five for more specifics on the portfolio presentation.)

Be sure to check the publication's submission guidelines for the number of images the photo editor is willing to look at. You'll want to have at least 50 photographs that will elicit the kind of interest you want. Include a range of photographs that indicate your style, but don't bother with the cute kid shots if what the publication prints is long-range scenics without people cluttering the foreground.

Similarly, if the publication prints only photos with people in them, such as *Touring America*, you don't want to submit only scenics or landscapes. If you send a message to the editor that you don't know what they want or how to get it, you won't get the job.

Organize your photographs into a sequence that is interesting and revealing of the range of your work. Look at the relationship of photographs in your portfolio—images that face each other on two-page spreads should strike an aesthetic balance, not a jarring discord. Be sure there's a balance of horizontal and vertical shots. Because of the format of virtually all magazines on the market, if you want to get a cover shot or a full-page bleed on the inside, it's going to have to be vertical.

Ideas and Cover Letters

The next step is to develop a list of several good ideas for stories that would make a perfect fit with the publication you're interested in shooting for. Some publications won't review portfolios unless they're submitted for consideration with a particular story idea. Your cover letter needs to present your ideas, your experience, and your special skills—all in a single page. If possible, present all this information in person.

Presenting Your Portfolio

If you live in New York (which is still the center for most magazine publishing) or another major city with a high concentration of travel publications, take the time to make personal phone calls to set up appointments with photo editors to show your work. If you're traveling to one of these cities, plan well in advance and try to set up meetings with as many prospective clients as possible. Your goal is to establish long-term relationships with clients who think of you when an assignment comes around.

Sometimes, especially with new photographers, a magazine's policy requires you to drop off your portfolio and they'll get in touch if they're interested. Include your business card and a selfpromotional postcard or flyer, which the editor can keep after reviewing your work. You want to leave a visual reminder, as well as all the standard information about how to reach you for assignments. If you haven't invested in a personal promotional piece, you could leave some tearsheets from previously published work or a few color photocopies of photographs for the editor to keep on file.

Travel pro Bob Krist describes his strategy, which usually begins with contacting the potential client to arrange for a portfolio showing. Or, if the magazine's policy requires, he drops off the portfolio with the hope that they'll like what they see and call for an interview or with an assignment. "I also get jobs by informing a broad range of clients and near clients of my upcoming travel plans," Bob explains. "If they have a story coming up in an area in which I'll be working, they often will 'piggyback' their assignment onto my existing job, thereby saving the travel expenses."

Even if you don't live in the Big Apple, in the age of overnight package delivery, fax, and e-mail, there's no reason for you to feel limited in your markets, whether you live in Tuscaloosa, Oklahoma, or Washougal, Washington. Write a query letter, again following submission guidelines, presenting a couple of dynamite ideas along with your portfolio. Check submission guidelines to determine whether previously published photographs are acceptable. If so, you might want to indicate the availability of stock travel photographs. An index by location and subject matter will be an important tool for selling stock photos to the travel market.

The Tourism Industry

The tourism industry—tour guides, cruise ships, airlines, major hotel chains, resorts, and travel agencies—is an important potential market for the travel photographer. More commercial than editorial or personal, tourism photography is involved with presenting a specific "product," whether the destination served by an airline, the fabulous food spreads on an ocean liner, or the elegant lobby of a first-class hotel.

Resorts and attractions, such as Disneyland and Six Flags, have been producing glossy self-promotion pieces and advertisements for years, but travel destinations themselves—cities and states—are getting in on the self-promotion act. In my home state of Oregon, tourism has become the third largest industry and is rapidly gaining on the number-two position currently held by forest products.

This is a story being repeated across Canada and the United States in regions of particular natural beauty or historic interest. Our countries are on the move, and cities, states, and provinces all over are clamoring for the wandering populace to come by for a visit. The chambers of commerce, tourism bureaus, and economic development offices are all preparing slick publications and advertisements that put their best scenic foot forward. To do this, they need your beautiful photographs.

The Tourism Product

In each of these situations, the "product" is paramount, but inevitably the client will want photographs showing people actively and quite thoroughly enjoying the product—so much so that it makes the viewer want to rush right out and buy tickets to go there. As you shoot, remember to keep in the front of your mind what it is that would make this situation appealing. Avoid showing crowds, unless it's an audience enjoying a performance.

Don't bother taking photographs in the rain, because most likely they won't be used—even if you're covering a rainforest. Chances are the image that will run shows the sun glistening off dewdrops the moment the rain stops. Shoot interiors if it's raining, but let the sun come out before you venture outside.

And never, never let the disturbing side of any travel experience creep into your corporate tourism photographs. While it might work in a photo essay for a more news-oriented client such as the *New York Times* to show hungry, begging children surrounding a tourist, it is most definitely not part of the "sell" for encouraging visitors to travel to that particular destination. Travel photography, unlike photojournalism, is involved with capturing an ideal and involving viewers to the extent that they feel part of the image, or at least that they would like to be.

Stock Travel Photography

Although Chapter Five deals with stock photography in greater depth, this is a market the travel photographer should not overlook. Many professional travel photographers also shoot stock to expand the revenue potential from any travel experience. A very few work exclusively as stock photographers, traveling to exotic locations to develop stock images according to specialized market needs or the demands of current trends.

Stock travel photos give clients a "safe" buy. They don't have to invest in a day rate or costly travel expenses for a photographer who may or may not be able to deliver what they're looking for. (You can't always count on bright sunshine on the northern coast of Scotland or even snow drifts in Vermont.) If they can find an image that already exists, so much the better. Sometimes stock photos provide the only solution for a company that needs an image *now* and can't wait for the time it takes to send a photographer on location, or needs a New Orleans Mardi Gras photo in July.

What Sells in Travel Stock Photography

Stock travel photographs, like all photographs for stock, should combine technical perfection with a clear and understandable subject. Images for travel should be beautiful, positive, and have strong use of color and composition. The current trend in stock photography follows advertising in its focus on brightly colored, strong images. They can be people in site-specific locations, scenics, landscapes, famous structures such as the Tower of London or the Statue of Liberty. You see these kinds of images in the brochures lining any display at a travel agency or tourism visitor's bureau. Generic images of tranquil white sand beaches washed by an aqua sea, a hiker at the edge of a precipice above the Grand Canyon, or a hang glider against the backdrop of Diamond Head are likely to sell again and again.

What it Takes

A good travel photographer needs to enjoy more than just taking pictures in a myriad of settings. Depending on your client, you will need some strong social skills as well.

People Skills

When I worked for *Sunset* magazine, a lifestyle publication that includes travel as approximately one-fourth of its editorial content, I often worked with people on the spot, asking them to be included in the photograph, directing them to stroll down the path toward me. ("Don't look at the camera! Great! Let's try it again....") Getting this to work with perfect strangers and having them walk away happy with you—and, by extension, the magazine—can play an important role in the final quality of your images.

This is even more important for tourism photography, where you are involved with photographing people in the process of enjoying (and having paid for) your client's services. You can't get in the way of their holiday, but if you approach it right, you can become part of their fun and memories while getting natural "models" for your photographs without paying model's fees. (If your client is picking up expenses, you'll want to offer lunch or a drink to people who go out of their way to help you get your photographs.)

Model Release Forms

Another part of working with people, particularly when working for tourism clients, is getting people to sign a model release form giving permission for their likeness to be published in the magazine, in promotional publications, or, in some cases, for unlimited promotional use. This is required whether you've used a professional model or taken advantage of people present on the scene as long as the person is recognizable. A lesser known fact is that if you can recognize a pet or private property in a photograph intended for advertising, these, too, require release forms from their owners.

Negotiating a release is essential; without one, you may have wasted your time taking the photographs. A corporate client *can't* use people's likenesses for advertising purposes without their permission (the legal term is *appropriation*), and many magazine publishers *won't*.

Technically, for editorial publications, if someone is in a public place, there is no legal basis for objecting to their image being published as part of an article in a publication. If they are in a public place, there is no "right to privacy" that is being violated; similarly, if the article is for editorial purposes rather than commercial (advertising), there is no "appropriation." However, many publishers prefer that photographers receive written permission to prevent misunderstandings and avoid harassment suits.

The Photographer's Personal Image

If you're being sent out on assignment by a magazine, chances are the editor will take into account the image you present. Can you fit into the environment you'll be working in? Are you presentable? Will you be able to arrange permission to photograph when you're on the spot and you've run into someone who doesn't want to let you through to your destination?

Technical Expertise

As with any area of photography in which you are trying to sell your skills or finished photographs, technical expertise is a given. When you're shooting the moonrise over Ama Dablam in Nepal or catching a surfer in the curl of a big wave on Oahu's Banzai Pipeline, you don't have time to wonder about f-stops or the best lens for the job. You need to understand your equipment so well that these decisions are second nature.

Knowing how to get around in a variety of cultures and settings is a valuable trait in this field. Juggling equipment, passports, tickets, and train schedules takes a certain degree of physical and temperamental stamina. You should also keep abreast of U.S. State Department travel advisories about safety conditions for citizens abroad. Sometimes the political climate in another country can make travel conditions hazardous. Canadian citizens should contact the Department of External Affairs.

Take Plenty of Pictures

Another consideration when on assignment for a magazine or other publisher is to be sure you present a lot of options. When working as an intern for the travel section of a major magazine, I went on my first assignment with one of the magazine's standard freelance photographers. We knew when we went out that the story would run one column with one black and white photograph.

The photographer, Michael Thompson, shot six rolls, with ten to twelve shots of each situation. When I asked why he took so many, he explained that it's a lot cheaper for the company to buy and process several rolls of film than to pay his day rate and travel expenses to reshoot. The magazine's editors aren't going to settle for something that merely "works" — even for a relatively insignificant shot for a small story.

Photographer/Writer Combination

Some magazines prefer to have story/photo packages submitted, but both pieces of the package must be top notch. Toward this end, you might want to develop a relationship with a writer, if your skills don't extend to the written word. John and Ellin Saverin work together as a team—he's a writer and she's a photographer, and they both have a deep love of travel and adventure that has taken them to every continent on the globe. Their clients have included a major corporation that wanted to document the building of a new factory in Asia with words and pictures; a cruise line that needed a dynamic travel brochure to send to its corporate clients; and a whole host of magazines, some of which are dedicated to travel but many that just liked the ideas John and Ellin had to offer.

"The key is coming up with a new angle, a new way of looking at something, or an 'undiscovered' destination," says Ellin. She and her writer husband have brainstorming meetings over morning coffee at least twice a week to come up with ideas.

"Sometimes we work on coming up with ideas to go with places we want to travel to; then we look for the client who might be interested," Ellin adds. "Other times, we focus on the client first and develop ideas to fit that particular market."

Either way, it's a strategy that has paid off. John and Ellin manage to work 10 months of the year; then spend their two "free" months traveling for themselves. "Although I have to admit we're never really on vacation," she says. "Wherever we go, I'm shooting pictures and John's taking notes in his everpresent notebook. But very often these turn into jobs we can sell when we get back, so it's worth it."

What it Pays

As with any other area of photography, the rate of pay depends on the client, and this can vary wildly. The local newspaper might pay as little as \$10 per photograph published; a tourism client might pay close to \$1,000 for a stock shot if it's unique; a magazine cover shot might command \$2,000. Day rates, too, vary according to the client and your experience. One new photographer I worked with charged \$15 per hour, or \$120 for an 8-hour day; a more experienced regional travel photographer's day rate was \$650; a photographer whose work is in demand might charge \$1,200 per day.

Other Benefits

"Comps," or complimentary fares, lodging, or passes, can sometimes be a side benefit for the travel photographer. If you're working on a legitimate travel assignment under contract and the magazine you're working for doesn't pay expenses, you might be able to arrange for discounted or "comp" (free) travel. Something that would be completely unethical for a photojournalist because of the need to be unbiased becomes more acceptable for the travel photographer because of the underlying assumption that the finished piece won't include "negative" photographs.

Be very clear, however, that as the photographer you have no control over the final choice of photographs to be used in the publication. You might offer to send prints (marked clearly with your copyright and the statement "For Personal Use Only") as a partial compensation.

Expenses and Who Pays Them

When working on assignment, get the terms in writing. Ask which rights the client is buying (see Chapter Five for a discussion of rights sales). Find out what will be included in billable expenses—air, other transportation, personal car miles, lodging, meals, film and processing?

If your client is paying for expenses, get at least 50 percent up front and, if possible, arrange to have the balance of expenses paid immediately upon return. Will you be compensated for the time you spend traveling, editing, and waiting around for the weather to clear? This time is usually billed at a proportion of your day rate. How many photographs are you contracting for? Is there specific subject matter or images the client wants? Are there any conditions or limitations that should be spelled out before you begin? Be sure to get all the issues clarified before you take off. The more specific the contract, the less likely there will be misunderstanding and disappointment on either your part or your client's.

Sample contract forms are available in a number of publications, as well as from the American Society of Media Photographers (ASMP).

For Further Information on Travel Photography

Organizations

American Society of Media Photographers. 14 Washington Rd., Suite 502, Princeton Junction, NJ 08550-1033. (Publishes newsletter and monographs on Assignment Photography, Forms, and Stock Photography Handbook.)

Society of American Travel Writers. 1100 17th St., Suite 1000, Washington, D.C. 20036.

Periodicals

Bacon's Publicity Checker. Bacon's Media Directories, 332 South Michigan Avenue, Chicago, IL 60604.

Outdoor Photographer. 12121 Wilshire Blvd., Suite 1220, Los Angeles, CA 90025-1175. (Scenic, Wildlife, Travel, Sports.)

Photo District News (Annual Travel issue). P.O. Box 1983, Marion, OH 43305.

Books and Directories

Haas, Ken. The Location Photographer's Handbook. New York: Van Nostrand, Reinhold, 1990.

Kodak Pocket Guide: Nature Photography. NY: Simon & Schuster, 1985.

McCartney, Susan. Travel Photography: A Complete Guide to How to Shoot and Sell. NY: Allworth Press, 1992.

Meehan, Joseph. Panoramic Photography. NY: Amphoto (Watson-Guptill), 1990.

Photography and Travel Workshop Directory (Annual). Serbin Communications, 511 Olive St. Santa Barbara, CA 93101.

- Purcell, Ann and Carl. Guide to Travel Writing and Photography. Cincinnati, OH: Writer's Digest Books, 1991.
- Purcell, Ann and Carl. The Traveling Photographer. NY: Amphoto (Watson-Guptill), 1988.
- Taylor, Adrian. *Photographing Assignments on Location*. New York: Amphoto (Watson-Guptill), 1987.
- Travel Industry Personnel Directory. Fairchild Books, 7 E. 12th St. New York, NY 10003.

Travel Photography, The Life Library of Photography Series. New York: Time-Life Books, 1972.

Other

Canadian Department of External Affairs. Travelers Advisory Service, Ottawa, Canada.

U.S. State Department Citizens Advisory Center. Washington, D.C.

Various government publications are available from the U.S. Government Printing Office:

- Foreign Entry Requirements (Publication No. 459X)
- A Safe Trip Abroad (Publication No. 154X)
- Your Trip Abroad (Publication No. 158X)

CHAPTER SEVEN

The Natural Scene Nature and Wildlife Photography

I f your love of nature and wildlife takes you outdoors with your camera, nature photography may be your niche. Getting started in this field takes patience and perseverance, but the benefit of spending your time in the great outdoors can mean more to some than a hefty paycheck.

But in addition to the romantic images of trekking backwoods trails or canoeing crystalline waters in search of elusive wildfowl, the successful nature photographer spends what may seem to be an inordinate amount of time in the office marketing photographs, captioning slides, researching prospective clients, and conducting the business end of the operation.

The Elements of Nature Photography

The wide world is the backdrop for the nature photographer's art, and all the flora and fauna provide the subject matter. Closely associated with painting in its aesthetics, nature photography encompasses sweeping landscapes and scenics, as well as super close-ups, taken with a macro lens, of flowers and insects. It also includes the more specific categories of wildlife photography and underwater photography.

Wildlife Photography

Wildlife subjects can range from the chickadee nesting in your back yard to elephants roaming the high plains of Africa, from spiny iguanas on the Galapagos Islands to an aerial view of an eagle's aerie in the Rocky Mountains. The wildlife photograph captures animals, birds, and insects in their natural habitat, providing insight into their life and behavior.

Underwater Photography

Underwater photography combines elements of both nature and wildlife photography. Underwater landscapes and plant life offer rich subject matter, as do the fishes and seagoing mammals of both fresh and saltwater environments.

We usually think of underwater photographers in exotic tropical locations photographing brilliantly colored fish and tiny seahorses. But any underwater environment is an opportunity for a photographer with the necessary skills and equipment.

Perils, Pitfalls, and Plusses

Norbert Wu, a nature photographer with a strong sense of realistic expectations in the field, wrote an article for the April, 1994, issue of *Shutterbug* magazine outlining "The Hard Truths of Nature Photography." He cautioned would-be nature photographers to take a good look at the trials and tribulations before choosing this career path.

He exploded several of the myths about nature photography, —first, that it is all excitement and adventure. He spends a lot of his time working very hard at marketing his photographs and lining up assignments. He doesn't mention the time spent in the darkroom for those photographers who prefer to handle this in studio. Nature photography also is *not* a guaranteed road to riches, nor does it necessarily bring a lot of opportunities for free travel. Norbert explains that his travel is done mostly at his own expense or as the result of speaking engagements rather than photo assignments. He has supplemented his photography income by writing, as well as going on the speakers' circuit. When he does travel, he "piggybacks"—arranges to photograph in as many destinations en route or in the area as possible, then expends a lot of energy making each of those opportunities pay.

In the end, though, he concludes, "It's still worth it.... With hard work and a good eye, it is possible to make a good living at this profession."

Getting Started

Margot Conte is a widely published nature photographer who has taught workshops in nature and wildlife photography and hosted the Nature Photography section of America On-Line's Kodak Photography Forum. She suggests beginners keep their day jobs while they develop their portfolio and potential client base. "I would not expect to pay the bills while breaking into wildlife photography," she advised one photographer interested in getting out of the darkroom and into the field. "Once you've gathered experience, a reputation, and contacts, then hopefully the money will start to come in."

There is a tremendous amount of competition in the field of nature photography, making this is a difficult area in which to make a living as the only source of support. Photographers who want to work solely by their shutters will most likely need to combine their love of nature photography with other areas, such as travel or commercial photography, at least in the beginning.

"In nature photography, you have to make your market—all areas are 'hot' if you can find a different slant and your work is outstanding," Margot adds. "I know one guy who does nothing but specialize in tree frogs, and his work has been published over and over. Now, if you're really a go-getter, specialize in a 'wanted area,' know how to go about marketing your work, and be the best in your specialization, you then have a chance, but you have to be very good and it is not easy work!"

When you're first trying to get your work exhibited or published, networking with established photographers or others involved in advertising, public relations, or publishing can help get you an introduction.

"There is no question in my mind that it always helps 'to know' someone in your chosen field, especially when it's highly competitive. But," Margot cautions, "once the door has been opened, then it's not 'who you know,' and you better be able to produce and sustain what you're doing. I doubt there are many people who would lend their backing to someone who did not have the talent, because it would then look bad for all. So, the final thought is, if you ask for help, be sure that you can deliver the goods."

Learning the Basics

As with any area of photography, the decision to go to school or to learn on your own is an individual one, and only you can determine what you need. Courses in the technical aspects of photography and darkroom work get you off the ground. Workshops on nature photography, too, can be extremely useful, especially if they involve getting out in the field for a lot of hands-on practice. There is no substitute for experience. Developing your own style comes with patience and a lot of practice. Consider the cost of film and developing to be a kind of tuition payment.

"In my opinion, you must know the technical part of photography like the back of your hand," Margot explains. "It is essential in wildlife photography because many times you will not get a second chance — as the eagle is coming in to scoop up a salmon, you should be ready, and not figuring out what fstop or lens you are going to use."

When she had her first show at Abercrombie, the president of Konica came to the show. "I apologized for being such a 'greenhorn' and said that I would go to school and bone up," Margot recalls. "He immediately said that I shouldn't. He thought that I had 'natural ability' and he didn't want someone to come in and try to change that. I never went. What I did was to study photo after photo. I collected and read nature and wildlife photography books that had comments by the photographers."

Recording Your Procedures

Keeping a log when you photograph is an important tool, both for learning from what you're doing in the field—in terms of fstops and lenses and shutter speeds, as well as the effect of lighting or atmosphere—and for keeping track of what you're shooting for captioning later on. A field notebook works well, but you might also want to carry a small tape recorder. It can save time and be used while you're moving from one spot to another.

"Try shooting at different times of day, with different lenses and angles," Margot advises. "Become as inventive as you can. Using a 200 or even 300 lens on the subject will give you a totally different aspect, showing not only detail, but imaginative images. Don't always choose a 'perfect day'—fog and rain can also bring you wonderful results."

Getting to Know Your Subjects

Part of learning the craft in nature photography is understanding your subject matter. Photographing scenics and landscapes requires some special understanding, especially of the changes of light throughout the day and in different kinds of weather. Experiment and learn what kinds of results you get under different conditions.

If you're interested in photographing wildlife, get to know your subject thoroughly. Know what signs a trumpeter swan gives before it's about to take flight. Know where the likely feeding areas are for the elk you hope to photograph. What time of day will the beaver emerge from its underwater home?

"If I were to give one word for photographing wildlife, it would be 'patience," Margot explains. "Wildlife don't keep the same clocks we do, so be prepared for very early mornings, not much midday, and activity again until sunset. Oh yes, and rain, sun, cold, heat—you name it—conditions you have never dreamed of! For me, it was a whole new exciting world. The nice thing about it is that you can adapt it to your own lifestyle. Wildlife photography can be done in your backyard, or on the great plains and refuges of the world. It's up to you. Unlike being in the same studio all day, you have an unlimited choice of locale."

Equipment

The most common format for nature photography is 35mm, primarily because of its portability. The lenses you need depend upon the type of photography you're going to be involved with. Scenics and landscapes generally involve wide angle or natural lenses, while wildlife photographs require longer lenses, up to 300 or sometimes longer. If you want to shoot close-ups of insects or flowers, you'll need a macro lens.

Margot advises that "once you decide, then you should get the sharpest, fastest lens you can afford." You can defeat your purpose in trying to be competitive if you don't have fine lenses.

A monopod is useful if you're using a long lens and have difficulty hand-holding the extra weight. Tripods can be cumbersome when working in the field, but some photographers work with tripods and trip releases to enable photographs of birds or other wildlife returning to the nest or den. A blind can be useful, too, for photographing wildlife, although some photographers prefer to take the time to allow the animals to get accustomed to their presence rather than bother with an extra piece of equipment.

The majority of wildlife and nature work that is published today is in color, although newspapers use primarily black and white. The film should be the slowest possible speed for the available light to increase the sharpness and color range. Slide film rather than print film is the predominant medium.

Employment Opportunities

Government Agencies

There are some opportunities for wildlife and nature photographers to work as staff photographers, especially if your educational background involves studying your subject matter. For example, Kevin Whitmore, a forestry graduate from Humboldt State College in the California Redwoods, combined his specialized knowledge of forest science with his love of photography in a career with the U.S. Forest Service.

Other government agencies that employ nature and wildlife photographers are the U.S. Fish and Wildlife Service, the National Park Service, the U.S. Department of Agriculture, and the U.S. Department of the Interior, as well as state government agencies with the same functions.

Underwater photographers might find employment with various research stations throughout the world, or with the National Oceanic and Atmospheric Administration, or NOAA. Employment with government agencies is discussed in more depth in Chapter Eight.

Private Organizations

Many private and nonprofit organizations have extensive interests in both wildlife and the natural environment. Organizations such as the Smithsonian Institution, the National Geographic Society, the Sierra Club, and large city zoos all employ staff photographers. Underwater photographers might work with special expeditions for Greenpeace or the Cousteau Society.

The pay scale for most of these positions, however, is not likely to be high. These nonprofit organizations use their resources primarily to fund the purpose for which they exist, and many times the people on staff come to these positions because of their own dedication to the cause. Their employment might also be based on grants for specific projects, terminating when the project is completed. A facility for grant writing could come in handy for keeping yourself employed!

The Freelance Markets

Most wildlife and nature photographers work as independent freelancers, taking assignments from a wide range of clients, or selling their photographs through a stock agency. Chapter Five discusses freelance photography more completely, but here are some specifics for the nature buff.

Magazines

Finding the clients who will buy your photographs is the tricky part of any photography work, and the answers are varied. Some of the most obvious choices are the magazines that specialize in nature and wildlife: *National Wildlife*, *National Parks Maga*zine, *Nature Photographer*, *Conservationist Magazine*, *Audubon Magazine*, *Bird Talk*, and *Bird Watcher's Digest*, among others. A great many regional publications involve scenics and wildlife photographs for that area, such as *Michigan Natural Resources Magazine*, *Dakota Outdoors*, or *Alaska Geographic*. For wildlife photographers, magazines devoted to fishing and hunting use a high proportion of fish and wildlife photographs by freelancers. *Field & Stream*, *Fishing World*, *Fly Fisherman*, and the more than 30 state *Game & Fish* publications all offer excellent sales opportunities.

Working with magazines, photographers often find that it helps to submit a query letter asking the editor if the magazine would be interested in seeing the photographs before actually sending them. In addition, submitting an article that accompanies the photographs can add to the likelihood of a sale. *Photographer's Market* is an excellent resource for finding magazine and other markets.

Stock Agencies

Most stock agencies handle some nature photography, but there are several that specialize in this field. Norbert Wu warns that stock agencies will account for a small proportion of your total income in nature photography, so it's important to diversify. Some agencies that carry a significant proportion of nature photographs on their stock list include Adventure Photo, Animals/Earth Scenes, Natural Science Photos, Natural Selection Stock Photography, The Wildlife Collection, and Geoscience Features Picture Library. See Chapter Five for more information on stock photography.

Book Publishers

Textbook producers are often one of the best customers of stock agencies, but there's no rule that says you can't sell to them on your own. Look in particular for those publishing texts on the subjects you specialize in, whether wildlife, botany, or geology. The art director or photo editor will be the person to approach initially, although you might be directed to the photo research department or a freelance photo researcher.

In addition to having photographs published in textbooks, you might someday wish to approach a publisher with enough photos to consider an entire book. The chances of having a book of your own color photographs published increases if there is a unity of theme and subject to give the publisher a "hook" or position to market the work from. Compelling text is also a plus, although less important than beautiful photos.

Paper Products: Greeting Cards and Calendars

This is a potentially lucrative area for wildlife photographers, especially once your work becomes better known. Walk through the calendar section of a bookstore around November and notice how many of them are filled with beautiful nature scenics or wildlife photos. The Sierra Club, the Audubon Society, and a number of other associations publish their own calendars in a variety of sizes and styles. Each needs to be filled with stunning photos—maybe yours!

Greeting card companies also frequently use scenics and wildlife photographs. A number of these companies are listed in the annually updated *Photographer's Market*.

Corporations

Corporations involved in producing slick annual reports can be a lucrative client prospect for any photographer. Look for a tie with the corporate identity or purpose with the photographs you've taken. Does the corporation contribute to the local wildlife refuge? Does it have a wetland on its industrial site that it has helped to maintain? Is it located in an area of great scenic beauty? Any angle you can discover will increase the chance of making a sale.

For Further Information on Nature and Wildlife Photography

Organizations

American Society of Media Photographers. 419 Park Ave. South, New York, NY 10016.

North American Nature Photography Association. 10200 West 44th Ave. #304, Wheatridge, CO 80033.

Underwater Photographic Society. P.O. Box 2401, Culver City, CA 90231.

Periodicals

Outdoor Photographer. 12121 Wilshire Blvd., Suite 1220, Los Angeles, CA 90025-1175. (Monthly publication for nature, travel, scenic, landscape, and wildlife photographers.)

Guilfoyle Report. A. G. Editions, 142 Bank St., New York, NY 10014.(Quarterly market tips newsletter for nature and stock photographers.)Wildlife Photography. P.O. Box 224, Greenville, PA 16125.

Books

- Green Book. A. G. Editions, 142 Bank St., New York, NY 10014. (Annual directory for nature and stock photographers.)
- McCartney, Susan. Nature and Wildlife Photography. New York: Allworth Press, 1994.
- Rowell, Galen. Galen Rowell's Vision: Art of Adventure Photography. San Francisco, CA: Sierra Club Books, 1993.
- Rowell, Galen. Mountain Light: In Search of the Dynamic Landscape. San Francisco, CA: Sierra Club Books, 1986.
- Seaborn, Charles. Underwater Photography. New York: Amphoto (Watson-Guptill), 1988.
- Zuckerman, Jim. The Professional Photographer's Guide to Shooting & Selling Nature & Wildlife Photos. Cincinnati, OH: Writer's Digest Books, 1991.

CHAPTER EIGHT

Serving the Public Government and Military Photography

I f your dream job includes relative security, great benefits, and adequate salary, you may want to consider working for the government. Although security is not absolute in the public sphere since it's dependent on taxpayers and budgets, the government is a big employer. Federal, local, and state governments provide employees with annual leave, sick leave, and health care.

Salary levels are in some cases lower for civil service jobs than in the private sector, but generally the benefit packages are so good that they make up for the lower pay. If you are hired as a temporary or project employee, however, which is more common with photography than with many other areas, your position may not include the perquisites that are a big part of what makes working for the government so attractive.

Because government often mirrors the private sector, the range of opportunity for photographers is great. Government agencies make use of all types of photography: portrait photography, industrial photography, scientific photography, public relations or press photography. You might find yourself taking formal portraits of government officials, or performing aerial photography for natural resources and civil departments. You may work as a law enforcement or forensics photographer or as a skilled technical photographer involved in satellites and missiles. Virtually all government agencies need the services of a photographer, but relatively few have photographers on staff. There are possibilities for both in-house and freelance employment with the government—but the competition is fierce. The challenge in freelancing with the government may be in finding your way through the bureaucracy to the people who need your services. There is wide variance among state and local government processes for classifying, paying, and hiring photographers, but federal government jobs are standardized.

Finding Photography Jobs in the Federal Government

There are approximately 3,000 photographers working for the federal government. Once you understand how the federal government organizes jobs, the searching and application processes are not that mysterious. All federal jobs are categorized by occupational number "series," and across all fields salary is based on "grade."

Grade is determined by education and experience. The job code "GS-1060-5" tells you that the General Schedule job classification is for the photography series and the pay scale is 5, which in 1994 means starting at \$18,907/year. Raises within each grade are classified as "steps," which are earned primarily by time spent on the job.

A Key to the Photography-Related Federal Job Series

When scanning federal job registers, knowing the series number can be essential. Following is a descriptive list of the photography-related job classifications in the federal government.

• The **Photography series (GS-1060)** includes jobs involving supervising or performing work dealing with still, video, or film cameras and in processing film and negatives.

- The **Photographic Technology series (GS-1386)** includes jobs involving science and engineering fields that utilize photographic technology. The work involves planning, research, design, and development of photographic equipment and techniques.
- The Audiovisual Production series (GS-1070) includes jobs involved with producing videos and television programs, radio broadcasts, films, slide shows, and multimedia shows.
- The Visual Information series (GS-1084) involves planning and designing visual materials.
- The **Illustrating series (GS-1020)** involves using electronic graphics or computer animation to produce illustrations and can involve retouching photographs.
- The Cartographic Technology series (GS-1371) involves aerial photography and photogrammetry.

The traditional method of application involves contacting an Office of Personnel Management Federal Job Information Center to apply for an open job or to register for employment. Some jobs are restricted for application. Personnel at the Job Information Center will guide you through the process. Sometimes written tests are required, and your application is then part of a pool and will be considered for all job openings for which you qualify.

The federal government, with the help of various agencies, has been testing a new procedure called the DEMO procedure, which involves applying directly to the agency unit advertising the job. Information about these job openings is available from Federal Job Information Centers or state employment offices near the unit. In both cases, the standard federal government application form is the SF171, an extensive form that requires full employment information for the past 10 years, information you should have in your files for easy retrieval.

The Range of Possibility

Every agency of the federal government probably uses photography in one way or another. From the official White House photographer to the biologist who photographs humpback whales from the air, photography's usefulness as a tool in documentation and presentation is unending.

The potential for opportunities, therefore, is great. However, the federal government is a big place with no centralized way to discover how and where your photographic skills can be best applied. You're in for a big research project, whether you are searching for a position within the government or freelance work from the government. Here are a few examples of specialized photography careers within the federal government.

Photogrammetry and Aerial Photography

A source of many jobs within the federal government and military, photogrammetry is described more thoroughly in Chapter Ten on scientific photography. The Defense Mapping Agency provides mapping, charting, and geodetic products, services, training, and advising to all elements of the Department of Defense. It also provides nautical charts and marine navigational data to merchant marine and private vessel operators, and maintains liaison with civil agencies and other international mapping, charting, and geodetic activities.

Jobs with the DMA, like many scientific photography jobs, require more than expertise in photographic techniques. Expertise in the fields of cartography, photogrammetry, geodesy, photo-interpretation, remote sensing, and a number of other scientific fields are emphasized in filling positions within the DMA. This is not a field for a general photographer, but for someone who is interested in photography within the sciences, this is one to follow up on.

The Bureau of Land Management, the U.S. Forest Service, and the U.S. Geological Survey also employ photogrammetrists

and aerial photographers. If you can pilot a plane as well as photograph, all the better, according to Ron Jameson, a marine biologist with the U.S. Environmental Protection Agency. Aerial photographers are needed frequently for biological and natural resource work.

The most common positions for photogrammetrists and aerial photographers begin at the GS-5 to GS-10 level, \$18, 907 to \$30,588.

Medical Photography in the Federal System

Medical photographers have many opportunities for positions in the federal government. Every Veterans Administration hospital requires photographers. Norma Jessup is a Medical Photographer (GS-1060-7) at the Northampton, Massachusetts V.A. Hospital. She started in 1982.

"I perform photography of patients, pathological specimens, autopsies, surgical procedures, and public relations activities," Norma explains. "I use techniques such as photomicrography, photocopy, and preparation of slide series. The work I do is used for local training, national publication, documentation, and international conferences. I use a variety of special techniques and equipment in the medical work. I don't work with video or computer graphics, but more and more, medical photographers are making use of those techniques."

Norma recommends that photographers seeking work in the medical field should have experience that has provided a knowledge of operating cameras and related equipment and handling developing and printing processes and techniques, as well as a general knowledge of medicine and anatomy.

"Working for the federal government has been a great advantage for me," Norma says. "I started out in South Carolina, but my family is from western Massachusetts. Eventually, I was able to shift into a position at the Northampton hospital. That easy kind of switch, with no loss of salary, would have been much more difficult in private hospitals."

Working at a Military Base as a Civil Employee

Working for the federal government as a civil employee at a military base can be another path for a photography career. Harold Senn got his start by training at the Air Force photography school and spent eight years in the Air Force before leaving for civil service.

Now he does industrial, public relations, and newspaper photography for the Charleston Naval Shipyard. His duties include having to "document the overhaul of Navy ships; run a complete portrait studio; process and print color negatives, color slides, and black and whites; and do miscellaneous government paperwork."

He has been feeling the effects of cuts on government spending for years. The shipyard for which he works is closing in 1996, and his lab, which employed four photographers three years ago, now gets by with only one—him. This is a bleak, but realistic, example of the effects of government cuts.

Harold has no intention of ending his photography career, however. One of the advantages of a career in photography is the abundance of possibilities for work. He's had a side business since he began in photography, working everything from weddings and babies to sports and models. Just because your position is cut doesn't mean your photography career is over. For Harold, taking pictures is something he'll always do.

Freelancing for Uncle Sam

Full-time photography positions with the federal government are hard to come by. Many more photography jobs in the federal government are filled on a temporary project basis. The research involved in working your way through the layers of agencies, departments, districts, and work units to the person who might be able and willing to hire you is extensive.

Ron Jameson, a marine biologist with the National Biological Survey, hires freelance photographers to help track marine mammal migration patterns from the air. He advises that the freelancer should "find out which agencies might use photography in your region and go directly to them with inquiries." Because there isn't one clearinghouse you can go to, you have to do the basic research yourself to make your name and your abilities known. Then if someone on the inside likes your work, that person can help wade through the bureaucratic procedures for hiring.

The Search for Opportunities

It may help to begin your search for information with the Federal Information Center. A great resource of general information about where and how to search, this center can give you names and numbers of agencies and offices. If you happen to hear about a job within a certain agency, you can call the center for more information about that agency as well.

Many books and publications exist to help you sell products and services to the federal government. Your nearest General Services Administration Office can provide you with a Directory of Federal Government Procurement Offices. This directory covers regional branches of agencies that buy products or hire services directly from outside the government.

Larger agencies such as the Forest Service, the Bureau of Indian Affairs, the Department of Fish and Wildlife, the Bureau of Land Management, and the National Biological Survey (there are many more), all would contract out for photography on a project basis, were it necessary.

The Catalog of Federal Domestic Assistance is a repository of grants and assistantships that contains information about contacts and ideas for small businesses and contractors. This catalog is not available at every library. If your public library doesn't have it, the Federal Information Center can tell you where you can find it in your area.

Additional Resources for Finding Work with the Federal Government

Every state's Employment Office or Human Resources Division has information about local federal job openings. If you are in a major city, visit the Federal Job Information Center for complete information and assistance. This office can also provide you with informative fliers about the application process and the principal agencies in your locale.

Federal Career Opportunities is a biweekly bulletin that lists job openings by series and pay classification number, job title, and location. It is not an exhaustive listing—some jobs exist in some departments that may not be listed—but it does include many job openings. Subscriptions to this publication—both hard copy and on-line—are available from Federal Research Service, Inc., P.O. Box 1059, Vienna, VA 22183-1059. Most agency offices have copies of the bulletin as well. The same company provides How to Get a Federal Job and Federal Application Forms Kit.

The Military

Careers in military photography offer some distinct advantages —training, apprenticeship, potential travel. While the pay scales may seem low (enlisted recruits start at \$8,500 per year), consider that the job includes housing, food, and health benefits, as well as educational training and opportunities for earning a college degree.

In the military, jobs are divided between officers and enlisted people. Many more possibilities exist for enlisted people interested in photography. As an officer, you would more likely be supervising photographers than shooting photographs, and there are no guarantees for officers that photography would be involved in their job.

148 CAREERS FOR SHUTTERBUGS

If you enlist, on the other hand, you can find out about photography jobs availability and sign a contract for a specific position. Conditions in the four branches of the military (Army, Navy, Air Force, Marines) change rapidly and have been affected greatly by recent cutbacks, so research the possibilities thoroughly and carefully. And remember, joining the military is a serious decision. The contract is binding, and if you are assigned as a combat photographer you would be required to fight if the need arose.

Many photographers have gotten their start in the military and praise the fine training available. The military has a need for many types of photography. As a military photographer, you could be shooting photos of equipment, taking pictures for public relations use, filming from the cockpit of a helicopter for aerial surveillance, covering the Pentagon, or photographing in combat. The military is also a prime employer of highly technical photography-related fields, such as photogrammetry and remote sensing for military applications.

A good place to begin your research if you are interested in a military career is with your local recruiting offices. They can provide information about the opportunities for training and work that currently exist in each of the branches of the service.

Photography Jobs in State and Local Government

Like the federal government, state and local governments use photography in countless ways. Finding out about these jobs means wending your way through less centralized but sometimes equally baffling bureaucracies than the federal government's. Your research skills will be well exercised as you look for possibilities within local and state governments, both as an inhouse and a freelance photographer.

Where You Can Look

- State colleges, universities, and community colleges—professors, printing departments, science departments, public relations offices, or recruitment offices
- State agencies such as Agriculture, Fish and Wildlife, Department of Transportation, Forestry or Natural Resources, Governor's Office, Tourist Bureau, or Human Services
- County governments
- City and local governments

Your local state employment division is a good place to start to identify state or local positions that may be open. Full-time positions as a photographer are rare. There may be one agency with a complete photo lab that services much of the statewide need for photographic services. In Arizona, for example, the state's Department of Photography operates a huge lab and provides services for all state agencies. By contrast, the Oregon Department of Forestry employs its own photographic technician who takes the work of aerial photographers and others and prepares the photos for use in cartography and publications.

If you decide to pursue potential opportunities in the freelance market, remember that as in the federal job search, you have to be devoted to the research process. Make many phone calls, follow up leads, contact as many people as you can. It can be difficult to penetrate the layers of bureaucracy to discover potential markets. You never know when you'll meet the one person who has information you need.

The Range of Possibility

Photography is an essential tool for state and local governments, just as it is for the federal government. Images are needed to advertise the state, to document government construction projects, and to explain natural resource problems to the public. Sometimes photographic support is needed in the scientific agencies to aid in research. Photographers are needed to provide images of evidence in county and local sheriff and police departments. Some examples of specialized government needs for photography follow.

Forensics Photography

To a large degree, the public image of a forensics photographer is overdramatized. Yes, your job may involve shooting at the scene of a crime. But in reality, the bulk of a forensics photographer's work involves slow, careful, accurate documentation of evidence. That means plenty of time in the lab taking pictures of bullets, documents, and weapons.

State police forces, county sheriff's offices, big-city police departments, and most medium-sized police departments support photography units of varying sizes. A civil service examination is usually the basis for getting the job. Of course, being a well-trained photographer is recommended and, in fact, required in some of the larger organizations. The pay hovers around \$25,000 to \$35,000 to start, with regular merit and cost-of-living raises.

Fire Photography

Like forensics photographers, fire photographers are often on the scene after the fire is put out, gathering evidence that might help solve arson cases. They are also involved with documenting firefighting efforts during a fire. Fire photographers wear protective clothing and use specially equipped cameras when covering a fire.

Both still and video cameras are used in fire photography, and depending on the size of the photography unit of the fire bureau, you may be responsible for both. Fire photographers usually come to the position from the ranks of experienced firefighters. They are responsible for public relations photos as well as photofinishing if a lab exists on site.

The pay scale for fire photographers is equivalent to firefighters' salary levels, established by local governments.

State Photo Services

Orrin Russie works as Coordinator of a Photo Imaging Services Lab that services state agencies from within a state agency. The lab is the only large in-house service in the state. He and four other photographers, all with at least fifteen years of experience, produce documentary videos for educational and training purposes and shoot, develop, and process still photos.

The lab does work for state departments, including the Justice Department, the Governor's Office, the Department of Insurance and Finance, and the Department of Human Resources. They do their own aerial photography to document all land acquisitions and surveys. If their projects require photogrammetric data, they contract with a private company that has the proper equipment.

Still images shot by the lab are used in several in-house publications for press releases and annual reports, as well as a selection of scenic photos that anyone can purchase. Photos also serve as documentation of public works projects such as highway and bridge construction, and as documentation for legal purposes.

In a typical week, Orrin may travel to a construction site for an agency and walk the site shooting photos for half a day; then travel by plane to another part of the state to do the same thing the next day. His job involves plenty of traveling and lots of assignment work.

Groups within agencies schedule portrait sittings as well. Sometimes Orrin travels to the agencies for portrait sittings or to photograph an event. And there's always copy work to get a publication ready to be printed. Orrin's job has plenty of variety, and he has plenty to do.

Surveillance Photography

Many photographers are employed with police and investigative agencies to be part of surveillance operations. The Federal Bureau of Investigation, the Central Intelligence Agency, and state police departments all have photography units, but entering this field of employment requires that you first be either an agent or an officer with the organization. The role as police officer or investigator or agent comes first; the photography is a tool in the performance of the job. Salaries start at \$18,000 to \$25,000 for police officers. Surveillance photographers might also work for private detective agencies or security services, especially if they have previous experience in law enforcement.

Part-time Photography

If you are willing for photography to be only a *part* of your job description, you may find more possibilities open to you. Pat Ray, Information Supervisor for the Oregon Department of Fish and Wildlife, notes that his position with the state is less than half-time photography—closer to 15 or 20 percent. In fact, there are no positions within the ODFW for full-time photographers, which is the biggest disadvantage for the aspiring natural resources photographer, according to Pat.

"A very common quality among natural resources agencies is a dedication to the resource," according to Pat; so if your passion is natural resources, a job that combines photography with writing and editing might be appealing. In his position, Pat researches and writes about various facets of fish and wildlife management, works on the radio show that he puts together with a coworker, produces news releases that can include photographs from the field, deals with the media, or is out in the field covering stories or projects. The photography he does is used in several in-house publications, slide shows, and presentations. For this sort of writing-editing-photography position, the salary range is currently \$18,000 to \$35,000. Entry-level salaries for photographers with state government agencies range from \$17,004 to \$18,609.

Advice from a Government Photographer

Jobs within government for photographers can be highly competitive, and in some areas, virtually nonexistent. At Orrin's lab, the budgets are so tight that they can't hire assistants or freelancers, though they sometimes use student interns.

Orrin's advice to the aspiring photographer is to remember that there are "not very many jobs for professional photographers with a good wage—period. The competition is keen." You have to be in the right place at the right time, Orrin advises, to find a position with the state. You must also be well-trained. And any experience you can get—as an intern, volunteer, or freelancer—will give you an edge.

For Further Information on Government and Military Photography

Professional Organizations

- Association of Federal Photographers. P.O. Box 46097, Washington, D.C. 20050.
- Association of Investigative Photographers. P.O. Box 479, Charles Town, WV 25414.
- Evidence Photographers International Council. 600 Main St., Honesdale, PA 18431.
- International Fire Photographers Association. P.O. Box 8337, Rolling Meadows, IL 60008.

154 CAREERS FOR SHUTTERBUGS

Books

- Lyons, Paul R. *Techniques of Fire Photography*. NEPA Fire Protection Association, 470 Atlantic Ave., Boston, MA 02210.
- Military Careers: A Guide to Military Occupations and Selected Military Career Paths. U.S. Department of Defense, U.S. Military Entrance Processing Command, 2500 Green Bay Rd., North Chicago, IL 10064-3094.
- Photography for Law Enforcement. Rochester, NY: Eastman Kodak Company, Publication M-200.

CHAPTER NINE

The World at Work

Industrial and Corporate Photography

hen you think of industrial photography, do you imagine big machinery and manufacturing plants, assembly lines, arc welders, and giant furnaces? Although industrial photography indeed encompasses manufacturing plants, it also covers a wide range of subjects, from executive portraiture in 25th-floor offices to modern-day mining operations at 200 feet beneath the earth's surface, from panoramic shots of a 400-acre industrial park to extreme close-ups of a tiny U-joint at an airplane repair facility.

Industrial photography involves photographing "industry" the people, equipment, machinery, and work of the nation's builders, manufacturers, engineers, agriculturists, and developers. From the press room of a major newspaper to the corporate offices of a Fortune 500 company, industrial photography offers both challenges and rewards for talented photographers.

Many industrial photographers freelance, although this field is often defined as "in-house" photography. Both kinds of opportunities exist within the field, and the earning potential can be the same for the entrepreneurial freelancer as for the corporate department head.

Some globe-trotting industrial photographers working either on staff or under contract for multinational corporations travel from site to site documenting the work of the corporation for annual reports, brochures, company recruitment publications, or press releases destined for the business pages of major newspapers or industry trade publications.

Problems of Industrial Photography

Industrial photography offers some tough challenges to creative photographers. Much of your time is spent working to get good photographs of objects that have little intrinsic visual interest or appeal in settings that may be colorless and dim and with subjects who may not be comfortable being photographed. Such circumstances can be enough to scare off the most dedicated of photographers. If you pull it off more often than not, you're going to be in great demand as an industrial photographer!

The industrial photographer needs to appreciate the purpose of the photographs, the message they will be used to convey, and the audience who will receive the photographs as part of a larger communication.

The photographer responsible for photographing employees for inclusion in the house organ, or in-house newsletter or magazine, should be able to approach each situation with a fresh eye in order to avoid a stale sameness in the publication's "look." Some of these publications have worldwide distribution to a circulation list larger than some daily newspapers.

A more practical consideration involves safety. Sometimes the industrial photographer is working in potentially dangerous situations with heavy equipment, high voltage electricity, molten metal, or scaffolding hanging from I-beams 40 floors up. Coordinating lighting and its accompanying cords and battery packs in these situations can be hazardous both for the photographer and the subjects. It's essential to have training in safety procedures, and to get full information about each situation before you go in to shoot.

Advice from Industrial Photographers

Walter Farrell has worked as an industrial photographer for a mining company in Nevada. His work has taken him to mining operations in Africa, England, France, and South America. On the home front, he spends his time both in the studio shooting portraits, still-lifes of raw and processed ore samples, and staged photo illustrations of engineering and chemical processes. After 18 years in the business, he's got some sage advice to offer.

"When you're working on location, do as much research as you can about the job before you arrive," he advises. "If you will be working with people, make sure they know you are coming, and are ready to cooperate. They may have a different understanding than you do about the project. Find out what you can about the setting, the lighting needs, and the availability of electricity. Develop a plan for solving the problems presented by the assignment, and then make a back-up plan."

Walter works with an assistant if the situation is complex or potentially hazardous. He feels that having an extra pair of eyes keeping track of all the variables can be well worth the expense of hiring a freelance assistant.

Corporate photographer Tamlin Gregory works for a major food-processing company in Iowa. She handles virtually all photography needs for the company, including advertising, public relations, quarterly and annual reports, the staff newsletter, and product packaging photos.

"It's a real whirlwind, but I love the variety," she says. "And there's a surprising amount of creative freedom, when you think of the subject matter. Canned corn isn't exactly my ideal subject matter, but you'd be surprised the amount of fun you can have setting up a still-life that communicates something more than corn kernels in a can."

Tamlin often hires freelance photographers and assistants, especially for working in the field. Her annual and quarterly report photographs often involve getting good agricultural photos of corporate farming operations, and sometimes her schedule doesn't allow her to be away from the central studio when the corn is ripe and ready for harvest.

"I'd advise beginners to seek out freelancing and assisting opportunities," Tamlin adds. "That's how I got my start, and the experience I gained was invaluable. I'm still using the tips I learned from the first photographer I assisted. He was a terrific mentor."

What You Need to Know

Because industrial photography can be expensive for the client—it may involve machinery shut-down or a halt in productivity among employees who are subjects—companies usually will not hire someone without a strong reputation. Your portfolio needs to reflect a high degree of expertise in photography itself, as well as a creative approach to capturing often prosaic images in an appealing, interesting light.

Your skills as a photographer need to be varied. You might need to photograph inside a large warehouse, at a banquet for corporate stockholders, or in a studio situation with a still-life setup. Photographers specializing in only one of these areas are most likely working independently. Staff photographers have to do it all.

Practical experience is the only way to get your start in this highly competitive field—preferably assisting an experienced industrial photographer. Working as a freelance assistant for a variety of independent corporate photographers can provide a broad range of experience in different situations and for different types of industrial clients.

A degree from a respected school of photography gives you the background you need to be hired as an assistant by an experienced professional. Although a degree isn't required, the experience you gain in all aspects of technical expertise will pay off. Corporate and industrial photography, at its best, expects much more than just a picture. The pictures must represent the company and its products or services at their peak, and to achieve this the photographer must have a high level of both technical fluency and creativity.

Specialty Areas in Industrial and Corporate Photography

When we think of corporate or industrial photography, it's easy to limit our thinking to Fortune 500 companies or auto manufacturers in Detroit. The field is much broader than that, and it includes many specialty areas of photography that have applications in other fields of photography as well.

Industrial photographers who work on staff tend to be generalists, available to handle the photographic needs of a variety of corporate divisions. The legal department might need photographs of faulty equipment; the security division might need you to photograph all staff people for identification badges; the marketing department might need a special product photograph for a trade show poster. In some cases, the industrial or corporate staff photographer must also operate or supervise a darkroom lab on site.

What follows are a few of the specialty areas of industrial and corporate photography. The list is not inclusive; virtually any industry could form the basis of a specialty.

Agricultural Photography

The agricultural photographer spends much of the time out in the field, whether it's a field of wheat in Nebraska, sugar cane in the Philippines, coffee trees in Colombia, or pineapple in Hawaii. Photographs of crops, insects, farm implements, planting and harvesting methods, soils, and damaged crops are all subject matter for agricultural photography.

Not all the time is spent outdoors, however. Photographs of laboratory operations and processing plants, or studio still-life and photo illustration shots for educational purposes, form other important aspects of the agricultural photographer's work.

Annual Reports

Many corporate or industrial photographers specialize in taking photographs for annual reports, those slick publications designed to impress stockholders with the corporation's stability and impressive achievements in the previous year. Any corporation or organization with public stock on the market must by law produce an annual report to its stockholders. For many corporations, the annual report becomes a major promotional tool to encourage more confident investment. Therefore, companies set aside significant budget resources for the preparation of this document.

The subject matter in annual reports varies widely. What the annual report photographer offers is a certain cachet or sense of style that will provide the corporation with a "look" to appeal to its shareholders. Annual report photos are prepared by either staff or independent photographers.

Architectural Photography

Architectural firms, construction companies, realtors, and the businesses or industries commissioning their work are all likely clients for architectural photography. Photographs of buildings, both exterior and interior, are frequently used in corporate annual reports.

Architectural photographers record the initial scale models created by the architects along with the finished realization of the design once the structure is completed, as well as all the stages of development in-between. Architectural photographs are used by architects to enter national and international contests, to submit to trade publications, and to provide visual portfolios to prospective clients.

Related specialties include construction and interior design photography. While the architectural photographer is interested primarily in a building's aesthetic elements, construction photographs provide an important record of building methods and procedures for construction corporations. The interior photographer works with completed interiors for the same clients, but with an eye toward capturing the design and details of a room. Hotels, restaurants, furniture manufacturers, architects, interior design companies, and corporations with expensive offices or public areas are all potential employers or clients.

Audio-Visual Presentations

Many organizations—both public and private, profit and nonprofit—have a need to communicate both with images and spoken information to an audience, a classroom, or on individual monitors. Making these audio-visual presentations is a major career field in itself, but because of its close relationship to photography, and the opportunities this field presents to photographers, it's appropriately included here.

Audio-visual slide presentations, filmstrips, and videos are all part of the medium, and each can involve photography. Because of the extensive use of audio-visual materials in education, many college students become familiar with the medium, perhaps working in an on-campus A-V lab.

Insurance Photography

Many corporations or businesses with significant resources tied up in expensive equipment will maintain a photographic record of acquisitions. Insurance companies also often want to document the condition of property they will be insuring or damages that have occurred to insured property. Only the largest corporations or insurance companies have on-staff photographers. This is primarily a freelance occupation.

Legal Photography

Although the age of digital computers and easy, seamless manipulation of images has cast doubt on photographs as reliable evidence, this is still an area in which corporate or industrial photographers can find opportunities. Corporations with the potential for liability claims may have need of photographic documentation for presentation to insurance companies or attorneys. Like insurance photography, this is an area with opportunity primarily for freelance photographers.

Public Relations Photography

While closely related to advertising, public relations involves more than just the product or service—it involves the entire company. Public relations activities involve in-house newsletters, press releases being sent to newspapers and trade magazines, and ongoing press relations.

Photographers in public relations work are photojournalists at heart, but their news-like photographs have a specific communications purpose beyond imparting information. The PR photograph involves a "spin" or "slant" that presents the company or people who work for the company in a positive light.

PR opportunities exist for both staff and freelance photography with any corporation or organization, such as a university, hospital, charitable organization, or PR firm, that manages public relations functions. Public relations firms, like advertising agencies, provide services to organizations that don't have their own PR departments.

Product Photography

Every manufacturer, producer, retailer, designer, and purveyor of goods or services needs to make the public aware of the product being offered for sale. Photography provides the visual component of that message. While product photography is primarily an advertising or commercial function, industrial and corporate photographers are frequently called upon to photograph the computers, cars, machine parts, boxer shorts, bean sprouts, or xylophones their company creates for public or corporate patronage. The uses of product photography are many. A product that has recently been developed must be patented to protect it from appropriation by another manufacturer. To apply to the U.S. Patent Office, a manufacturer must send photographs documenting the specific details of the product. Once patented, the product is prepared for marketing. Artistic or aesthetically pleasing photographs are taken for advertising and promotional purposes. Press packages are put together to send to trade publications to announce the new product, complete with photographs to be reproduced in the magazines.

Photographic Administration

The larger the corporation, the greater and more varied the needs for photography. In these cases, the department of photography might include 20 or more staff members, including darkroom workers and freelancers hired to pick up the extra work. The photographic administrator is most likely responsible for all photography operations, including processing laboratory workers, darkroom printers, and photographers.

Promotions to administration positions almost always come from within the organization, whether it's a large government agency or an industrial giant. A college degree is generally required for advancement to this level, though a demonstrated ability for management and organization will be most significant. The administrator might be responsible for a sizable budget, so coursework in business procedures and administration can be helpful.

Freelance Industrial Photography

There is room for both freelancers and staff photographers in the industrial photography field, and sometimes companies with in-house photographers hire freelancers as well. There are advantages and disadvantages to each choice. The in-house corporate photographer has the security of a regular paycheck, plus the added benefits of insurance and retirement coverage. Freelancers, on the other hand, have a regular income only if the jobs keep coming in regularly. Often corporate and industrial photographers work with agents or photographer's representatives, especially if they are in one of the larger markets such as New York, Philadelphia, Chicago, or Detroit.

Whether your goal is a staff position or a freelance business with a strong client base, industrial photographers recommend that you continually work toward building your portfolio, presenting your work to prospective clients or employers whenever the opportunity arises.

The Daily Routine

Like most other areas of photography, a "daily routine" is a contradiction in terms for the industrial or corporate photographer. Very little in this business can be called routine. One day you'll be photographing the CEO for the annual report, the next you'll be on a plane to cover an accident at the company's plant in Mexico. You might photograph a new product in the studio, a worker on the assembly line, a farmer tilling a field of wheat, or a wildcatter on the deck of an oil rig. And that might all be for the same company. Major corporations often have multiple investments that cross over industry lines.

Lewis Nelson, who owns a small industrial and scientific studio in Oregon, started his business twenty years ago after an exciting job shooting a slide presentation for the state of Washington. Because he was in graduate school, he knew the research scientists who became his first clients. From this beginning, he slowly built a client base among local industries and corporations. Lewis photographs small products or inventions for manufacturing companies throughout the state. Sometimes he takes the photos in his studio and occasionally he sets up a shoot in the plant.

One of Lewis' recent projects involved documenting the development and installation of a new recycling system at a pulp and paper mill. Over a period of two years, he shot photos of changes at the plant. The project engineer delineated the images that were needed for specific company purposes, and Lewis also provided images that represented the changes he had seen since his last visit.

Earning Potential

A staff photographer's salary might start at \$18,000 to \$22,000 and increase to \$40,000 or \$50,000 with the addition of supervisory responsibilities. Someone working in the darkroom of a large corporation department might earn approximately \$18,000 to \$20,000. The darkroom can serve as a good starting position. You may be asked to take some of the in-house photographs needed for the house newsletter.

An audio-visual specialist on staff receives a salary in the higher range, between \$35,000 and \$60,000. A specialist operating an independent A-V company can earn in excess of \$100,000 per year, especially when working with large corporate or industrial clients. For freelancers, *Photographer's Market* lists potential audio-visual clients, as well as other business and corporate clients willing to look at the work of newly established photographers.

A photographic administrator might earn between \$30,000 and \$40,000 to start, working toward \$50,000 or more in larger corporate operations.

The freelancer's income is based primarily on the amount of energy and time spent developing a base of clients, as well as the photography budgets of the clients themselves. Rates vary from \$100 to \$1,200 per day for corporate photography.

The clients paying the highest rates—up to \$7,500 per day —hire only the best, most innovative corporate photographers to work on annual reports for the world's richest corporations. But with a strong portfolio, technical expertise, experience, and a reputation for creativity and style behind you, you can begin to attract offers from clients willing to pay day rates of \$3,000 or better. You won't spend every day earning that amount of money, but you can do quite well as a freelancer if you expend a great deal of energy on the business end of lining up a steady base of clients and projects.

For Further Information on Industrial and Corporate Photography

Organizations

- American Society of Photographers. P.O. Box 3191, Spartanburg, SC 29304.
- Photographic Administrators, Inc. 1150 Avenue of the Americas, New York, NY 10036.
- Professional Photographers of America. 1090 Executive Way, Des Plaines, IL 60018.

Periodicals

- A-V Video. 25550 Hawthorne Blvd., Torrance, CA 90505. (A monthly magazine for audio-visual specialists.)
- Audio-Visual Communications. PTN Publishing, 445 Broad Hollow Rd, Melville, NY 11747. (Monthly magazine for audio-visual photographers.)

Industrial Photography. PTN Publishing, 445 Broad Hollow Rd., Melville, NY 11747. (Monthly magazine for industrial photographers.)

- Photomethods. Professional Photographers of America, 1090 Executive Way, Des Plaines, IL 60018. (A monthly magazine for corporate, commercial, and industrial photographers.)
- *The Professional Photographer.* Professional Photographers of America, 1090 Executive Way, Des Plaines, IL 60018. (The official monthly journal of the Association of Portrait, Commercial, and Industrial Studios.)

Books and Booklets

- Neubart, Jack. Industrial Photography. New York: Amphoto (Watson-Guptill), 1989.
- Photographing Buildings and Cityscapes. Rochester, NY: Eastman Kodak Company, 1990. Publication LC-10.

CHAPTER TEN

The Fantastic Voyage Scientific and Medical Photography

D o you have a scientific bent? Are you curious about astounding new technologies that are affecting medical practices and scientific research? If you have a fascination with and knowledge of human anatomy, biology, botany, the laws of physics, space research, or any number of areas in science and medicine, a career in scientific photography may be just where you're heading.

Scientific Photography Techniques

Photography's ability to see and to document what the human eye cannot see has always made it an important tool for scientists. In fact, for many years photography courses at colleges and universities were offered through the science department because photography itself was considered a science.

The techniques of extreme close-up or magnification photography, or *photomacrography*; microprojection photography of minute objects, or *photomicrography*; and the making of minute photographs of large objects, or *microphotography*, are at the core of the photography used for scientific application.

Photomacrography and photomicrography techniques can provide lasting records for the study of the process of a dragonfly's transition from a nymphal shell or the moment of an egg's fertilization. Microphotography is used in microchip technology, in which large but intricate drawings are photographed and reduced to tiny chips where the metals used in processing settle along the drawn lines and become conductors of electronic impulses.

High-speed or time-lapse photographs provide data that allow a zoologist to study the motions and physiology of a bat, or aid an astronomer in gathering data about the movements of satellites around a distant star.

Many of the other technical applications of photography optics and photogrammetry, for example— require specialized equipment and training, and are performed by a scientist or technician rather than a photographer. Some of the uses of photographic techniques and principles in the sciences may not look like photography at all to a shutterbug. And, in fact, scientists and engineers often take their own scientific photographs, making the need for a photographer less common than you might assume.

But don't abandon the idea just yet. Not only are some of these techniques accessible to even the amateur photographer, but there is photography work for the scientifically minded shutterbug who doesn't want to be an astronomer or physician or engineer. Photographers are needed to provide the images necessary to translate ideas and the results of experimentation, to provide images for press releases, newsletters, annual reports, and brochures, and to perform the variety of general photography needed in many scientific fields, as well as technical specializations with opportunities for the scientifically minded.

The Range of Opportunity

Photography opportunities in the science fields range from highly technical to very general. A freelance photographer could build a small business on producing images for research scientists. A scientifically minded photo expert could become involved in research and development of lenses and equipment in the optics field. A photographer could become an expert in photomicrography in a teaching hospital, taking pictures through a microscope. Following are some examples of the many photography-related careers in the world of science.

Instrumentation Photography

Most commonly associated with the military, where much of the research for space and defense application is done, this field is part of the engineering research process. Engineers need highspeed photographs to assist their study and development of rockets, missiles, and anything that moves through space.

Instrumentation Photographers may find themselves working on the research and development of instrumentation photographic systems. They may work on problem-solving for specific needs, such as measuring the trajectory of a rocket or the detonation of a weapon.

Photogrammetry

Photogrammetry, the art of measuring and interpreting vertical aerial photographs to make maps, is a photography-related career area that has been especially affected by computer technology, to the point of completely redefining the job. Technologies like Global Positioning System (GPS) and Geographic Information Systems (GIS)—computerized databases of spatial data—are changing the field.

It is possible to gain experience as a cartographer or technician without an undergraduate degree, but more and more often, particularly with the changes in the field related to systems like GIS, photogrammetrists have bachelor's degrees in engineering, computer science, geography, or a physical science. Used primarily for map-making and defense purposes, photogrammetry also has some biomedical applications, such as the measurement of a facial pattern before orthodontic treatment.

Optics

The optics field is a highly technical engineering field. It involves various photography-related careers ranging from technicians who shape lenses and optical elements using hand-operated grinding and polishing equipment to technicians who operate cameras and work in the lab to research and development technicians and scientists. Optics technicians often graduate from two-year training programs, gaining experience in various parts of the field through membership in clubs and societies.

The optics field is predominantly applicable within the space and weapons programs, but it is also vital in the research, development, and manufacture of cameras, binoculars, telescopes, and other optical devices.

Aerial Photography

In the biological and natural resource sciences, photography is a frequently used tool for aiding scientists in study. Photography is used to document events in the natural world, to record habitat for a certain species or for an entire ecosystem, to document population in an area, and to illustrate presentations and reports. Scientists usually take their own pictures in the field, but sometimes work is contracted out.

The most common sort of contract work is aerial, and some of that falls under the technical photogrammetry field. As an aerial photographer, you are at an advantage if you are also a pilot. Most aerial photographers do fly; if you don't, you'll need to work with a pilot.

Underwater Photography

Oceanographers and marine biologists work with photographers at marine laboratories and research stations around the world. Photographers might also work aboard research vessels such as those operated by the famous Cousteau Society. Research employment is primarily through universities, but private corporations, particularly those involved with off-shore oil or other resources, also hire photographers to document underwater terrain, wave action, or evidence of geothermal activity. Environmental agencies involved with the protection of endangered species or habitats will hire photographers to document conditions injurious to fish or wildlife.

An underwater or oceanographic photographer will need to be a skilled scuba diver with a thorough understanding of safety issues, as well as the technical demands of photographing underwater. Special equipment is also essential.

Other Specialty Fields and Opportunities

Photographers with special backgrounds in archaeology, botany, plant pathology, entomology, zoology—virtually any field of scientific endeavor— have opportunities for working in research situations, both on staff and freelance. Places of employment include the following:

- Government agencies
- Hospitals
- Manufacturing companies
- Museums of science and industry
- Research and development departments of major corporations
- Research organizations and associations
- Research stations
- Scientific laboratories
- Universities

Photographer as Lab Assistant

Andy Baird stumbled into a career in scientific photography when he got his first job in the Psychology Department lab at Princeton University. He learned to implant miniature electrodes into rat brains with high precision, and later to dissect the preserved brains for microscopic examination. He took pictures throughout the procedure; then created an animated film showing the action of neurotransmitter hormones at the nerve synapse in a symbolic form that made the complex biochemistry easy to grasp visually.

He went on to work as a lab technician at the University's Auditory Research Lab. "I again photographed everything in sight, from the staff to the bats and lizards, who were the subjects of our research on hearing," Andy recalls. "When one scientist obtained a small grant from the National Geographic Society to go to Costa Rica and study pollinating bats and their ecosystems, I went along as a field assistant and—of course photographer! I can tell you that nothing will get your luggage through customs faster than having a large, brilliant orange sticker that says, 'CAMERA EQUIPMENT/NATIONAL GEOGRAPHIC SOCIETY'!"

Freelancing

For those shutterbugs who want to remain photographers first and scientists second, one possibility is freelancing for scientists. The work involved in such a venture could range from photographing petri dish experiments for a graduate student to completing aerial photography for a natural resource agency.

Susan Peters, who works for an industrial, commercial, and scientific photography service in Corvallis, Oregon, photographs specimens for research scientists at the local university. Most often, she photographs bacteria, petri dishes, and autoradiograms—a technique using radioactive materials to sepacate bacteria and DNA, RNA, and proteins that are grown on lab gels. Another large part of her work involves slide copying. The nature of her work is changing, in part because computer technology has become so accessible to scientists, making it possible for them to generate their own images and graphs from personal computers. But the abundance of copy work and slidemaking may not change. The work is contracted to Susan at \$75 per hour; of course, rates vary depending on locale and demand, and a staff person would make considerably less per hour.

Stock Photography

Another option if you are fascinated with taking biological or medical photos is to sell your photography to textbook companies, scientific magazines, and pharmaceutical companies. One stock photo company includes over 200,000 biological images, most of them photomicrographs. Chapter Five includes more information about the stock photography business.

Job Outlook and Earnings

Science and technology will continue to become more important and more integrated into society in the future. However, as technology becomes more advanced, computer capabilities grow, and the applications for computerized photographic techniques become more "user friendly," straightforward photography jobs in the sciences may become tougher to find. Scientists have always taken pictures as part of their research, and technologies are more accessible to the nonprofessional photographer as well as increasingly important for the scientist to master.

A scientific photographer with a strong background in science and photography could obtain a staff position with a university or corporate research department ranging from \$18,000 to \$30,00 per year. Freelancers earn between \$15 and \$125 per hour depending on the sophistication of their equipment and skills.

Medical Photography

Within the medical profession there is a great need for photographs, from general photography of the places, events, and staff personalities for public relations use to patient and specimen photography for diagnosis and disease research. Taking photographs for diagnostic or investigative purposes often involves both highly specialized equipment and extensive training.

An in-house photographer or illustration department is common in larger hospitals and teaching hospitals. Sometimes technical photography is performed as one duty of a technician or nurse or even surgeon rather than a designated photographer. Highly specialized photographic needs must be met by technicians trained in the scientific processes. Medical photographers usually have knowledge of human anatomy, physiology, and surgery procedures.

According to a personnel officer at a small private hospital in Oregon, most small hospitals don't have enough funds to employ a photographer. In their case, a department manager who is also an amateur photographer does the hospital's inhouse photography. And physicians in the operating room take care of their own photography with the help of fixed equipment. But smaller hospitals without staff photographers may need to hire out photographic work. And in teaching institutions, larger hospitals, and VA hospitals, staff photography positions exist.

The Range of Work

The sorts of photography you might do as a medical photographer are varied. Taking pictures in the operating room of surgical procedures; documenting intensive care progress; photographing specimens, patients, newborn babies, and medical equipment; shooting the people, places, and events at the institution for public relations use—all of these tasks could be part of your job description.

176 CAREERS FOR SHUTTERBUGS

You could be involved in research using photomicrography taking pictures through a microscope with fine optics and a device for film transport—for photos of surgical or autopsy specimens, or animal research tissue to be used for teaching students. These photographs could be used for conferences and seminars, for information-sharing between departments, or for journal and book illustration. You could use infrared or ultraviolet photography for the purpose of disease investigation. Your duties might include film development, slide sorting, coordinating deadlines, making color slide duplicates, and slide binding.

Physicians and technicians use technical photographic techniques in their diagnoses and research. Gastroendoscopes photograph the inside of the stomach and esophagus. Ophthalmic medicine applies photographic techniques in its study of the eye, for observation and diagnosis. X-ray photography involves specialized training and equipment for technicians, and is a part of virtually every hospital, clinic, and laboratory.

Toward the 21st Century

If you are involved in the digital wave of the future, it has its medical applications as well. Electronic imaging systems are being refined for use in plastic surgery. These allow the physician to apply enhancements and alterations of a patient's facial features on screen, providing a "preview" before actually beginning surgery.

Medical schools, too, have developed computer programs as educational techniques, such as a gross anatomy dissector on Macintosh computers with step-by-step dissection procedures and digitized photographs that are so realistic that one medical student commented, "For some people, the dissector was so real and complete that they sometimes didn't have to come to lab."

The Work Day

Jess Lopatynski worked as a medical photographer for ten years at a children's hospital. A former instructor at Brooks Institute in California recommended that he apply for the position of staff medical photographer.

"As an 'in-house' photographer, your day is a combination of the mundane and the interesting," Jess explains. "At one time I did a study on blood flow using infrared photography for the Veterans Administration, but also did my share of public relations photos and 'grip and grins.' I might spend an hour in an operating room doing photos of club foot correction on a child, then spend all afternoon copying X-rays to slides."

Jess's photo assignments came primarily from physicians at the hospital, but also from administrative, nursing, and other specialized staff. He estimates that 10 percent of his work was studio work, 10 percent clinical, 20 percent clerical, 30 percent copy work, and the rest darkroom work.

What You Need to Know and What You Can Earn

Some medical photographers get involved in the field without specific medical training. Jess Lopatynski, for example, moved into medical photography from industrial photography—"from nuts and bolts to blood and guts," Jess laughs. Being a highly skilled photographer is enough, some say, for any photography job. Generally, however, it is advisable at least to gain a general background in the sciences and basic knowledge of human anatomy, surgical procedures, and medical practices. Brooks Institute and Rochester Institute of Technology are highly recommended training institutions for medical photographers.

The salary for entry-level medical photographers on staff can range from \$18,000 to \$20,000, advancing to \$28,000 to \$35,000 and more. Positions at private teaching hospitals start slightly higher.

For Further Information on Scientific and Medical Photography

Books

Scientific Imaging Products. Rochester, NY: Eastman Kodak Company, 1989, Publication L-10.

Periodicals

Journal of Audio Visual Media in Medicine. London: Butterworth-Heinemann for the Institute of Medical Illustrators.

Journal of Biological Photography. Chapel Hill, NC: Biological Photographic Association. Quarterly.

The Journal of Imaging Science & Technology. Springfield, VA: The Society of Imaging Science and Technology. Bimonthly.

Professional Associations

American Society of Photogrammetry and Remote Sensing (ASPRS). Biological Photographers Association. 115 Stone Ridge Drive, Chapel Hill, NC 27514.

International Society for Photogrammetry (ISP). Leonardo da Vinci 32 20133, Milan, Italy.

Ophthalmic Photographers Society. 3632 Blaine Ave., St. Louis, MO 63110.

The Society for Imaging Science & Technology (IS&T). 7003 Kilworth Lane, Springfield, VA 22151.

CHAPTER ELEVEN

The Digital Revolution Electronics, Computers, and Their Impact on Photography

The Future Is Here

Every aspect of photography has been or will be affected by the development of computer and digital technology. The change has been dramatic, wide-reaching, and so rapid that it's nearly impossible to keep up with new developments.

Ray DeMoulin, former Kodak vice president and director of the Center for Creative Imaging predicted, "Within five years most photographers will have used the computer to improve or modify their pictures in some way." Some futurists have predicted the end of photography as we know it. Others would remind us that such predictions were made about painting with the advent of photography, when what we really got were the Impressionists and the Cubists, the Fauvists and the Abstract Expressionists. Some predicted the end of black and white photography when color images began to dazzle us with their brilliance. Instead, we continue to see deeply moving, richly beautiful images in silver gelatin or platinum palladium prints.

Still, anyone contemplating a career in photography, at whatever level, is well advised to begin exploring the new media, for digital technology is indeed the future. It's not the only future, and the wave may not have crested yet, but the whole world is riding it, and if you're not in there swimming you could just get lost in the flotsam.

180 CAREERS FOR SHUTTERBUGS

The income opportunities in this field are quite high because of the demand and the level of expertise required. That may change as more and more people develop computer skills, but the photographer's "eye" will be a valuable asset in the world of professional image making.

The Sky's the Limit

From the business side to the creative, computers are revolutionizing the way photographers do business. Those who have embraced the technology are finding new opportunities and exciting possibilities for developing their own creativity. Although it's intimidating at first, and there's a steep "learning curve," the new technology can ultimately mean an amazing amount of control and freedom for photographers.

Some photographers are becoming involved in the new technology because of changes being made in the workplace. Others are just eager to try something new. "I've been getting into digital imaging as a cost-effective method to provide clients with what they want," one photographer said recently. "Besides, I'm tired of being in the darkroom and I'm impatient. Electronic imaging is so much faster." Photo pro Douglas Kirkland argues that the benefits of digital photography far outweigh the drawbacks.

What the Technology Means

Put simply, digital photography means that a photographic image is reduced, through the marvels of high mathematics and computer technology, to a set of digits or numeric codes, one for each pixel of space on the image. A pixel is a dot that forms an image when combined with a lot of other dots. The image on a television screen, a computer screen, or even a newspaper page is composed of pixels. In order to print or transmit an image, it must be broken into these dots.

The size of the dots determines the finished quality of the image. In European television, for example, the pixels are smaller and therefore the image is sharper. American television is moving in this direction.

An image reproduced in a newspaper has much larger dots than one printed in a magazine on glossy paper. The smaller the dot, the sharper the image, but variables such as paper quality need to be taken into consideration before deciding what size the dots should be—in printing technology, these dots are referred to as line screens.

A newspaper would reproduce images at a resolution (degree of sharpness) of 80 or 100 lines per inch (lpi). A magazine's photograph resolution would be 133 or 150 lpi. A very highquality printer of postcards or art prints might use a resolution as high as 175 or 200 lpi. For true photographic quality, the resolution pushes to 4000 lines.

Kodak Photo CD

Kodak's Photo CD is a new means of storing and viewing photographs. It allows you to develop your film onto compact discs that can be "read" by a CD-ROM reader that's attached to your computer or to your television set. It looks just like the music CDs that have replaced record albums and cassette tapes as the medium for storing recorded music.

Both photo and audio CDs are digital media—the images and sounds are broken down into digital information that can be accessed randomly rather than in linear form, as with a video or cassette tape.

What You Need to Get Started

To have your photographs transferred or developed onto a Photo CD, all it takes is dropping your film with a photofinisher that provides Photo CD. What you'll receive when you pick up your photos are processed film and prints, as well as a Photo CD complete with an Index Print, which shows a thumbnail-sized image of each photograph on the disc. You can have more images added to your disc when you're ready to develop more film, or if you decide to transfer existing photographs to the disc. Each disc can contain approximately 100 images.

Images are placed on the Photo CD at five different resolutions, from low to a super-high resolution that is higher than any current need. It's Kodak's way of preparing for future advances in printing technology. The cost of having images transferred to Photo CD is not much more than the cost of processing and printing film traditionally, aside from the purchase of the CD itself, which is less than \$10.

Computer Connection: CD-ROM

To look at your photographs once they're on the CD, you need a CD-ROM reader and a viewing device, either a computer monitor or television. If you have added film to the CD since it was originally printed, your reader must have "multi-session" capability; otherwise it can only view the images printed onto it in the original session.

In order to exploit the digital darkroom's capabilities with these images, you will need a computer, monitor, CD-ROM reader, and the appropriate image editing software, such as Adobe Photoshop. Photo CD images have been processed just as you would process your film, but often the image needs to be "color corrected" before it matches your intent.

Be sure you have both the memory and hard disk storage capability to handle the large image files. The Photo CD is a read-only device, meaning you cannot alter images on the CD itself but need to transfer them to your computer's hard disk. A high-resolution color image can take up 10 to 20 megabytes of disk space.

To print the images, if you're working in black-and-white, a laser printer will provide a low-resolution proof. Laser or inkjet color printers provide low-quality proof images for color photographs. For truer representation, a dye-sublimation printer will give very good reproduction for both color and black and white, but the cost of these printers means you'll most likely be taking your computer disc to a service bureau, unless you work for a large company that has a high-resolution color printer. Thermal wax printers fall between dye-sublimation and laser or ink-jet in both quality and affordability.

The Possibilities for Photo CD

The potential uses for Photo CD are as infinite and varied as for standard photographs. What the new technology allows that is not available with the traditional are the possibilities of interactive presentations, books, portfolios, stock catalogs, and transfers via electronic communications.

Portfolio CD

One of the newest developments has been Kodak's Portfolioformat CDs, which individual photographers can use to create portfolio presentations. They're also used in businesses, schools, and other organizations to create multimedia presentations for viewing on television screens or the computer.

Multimedia means you can combine moving images, music, speaking, and still images into an integrated presentation that also can be interactive. For example, the photo buyer sits down at the computer, pops your Photo CD into the drive, and listens to a flourish of music, and then a voice asking which photographs the viewer is interested in seeing: wildlife and nature, exotic travel, people at play, or architecture. The viewer types the appropriate response or clicks the right button, and off you go—a completely narrated "slide show" presentation.

The Portfolio program consists of three separate software components. Two of the three, Create-It and Arrange-It, are used by the photographer to create the presentation. These are currently only sold for Macintosh computers. The third component, Build-It, is sold to photo labs and service bureaus equipped to print Photo CDs.

The photographer gathers the images, creates the text or adds the music background in Create-It, determines the order and speed of presentation in Arrange-It; then takes the whole thing to the service bureau for Build-It to merge the information into a multimedia presentation.

Digital Cameras

Rick Smolan, producer of the "Day in the Life" series of books, produced an interactive book on CD called *From Alice to Ocean*. He integrated photographs along with narration and the sounds appropriate to the setting. The potential of digital technology for educational programs on geography and virtually any subject is staggering.

Another major development, but one that is still at that extremely expensive new-technology phase, is the digital still camera. Rather than use film, these cameras take photographs digitally, storing the visual information on a microchip or disk inside the camera. Several camera manufacturers have developed them; even the Associated Press has released its own digital camera.

Digital cameras were developed primarily for photojournalists who need to capture images rapidly and get them to the newspaper in a hurry. Kodak's Professional Digital Camera System, for example, can capture 2.5 images in a second, and can store up to 400 to 600 compressed images on the 200 megabyte disk inside the camera back, which is either color or monochrome. The camera incorporates traditional camera lenses that enable the photographer to work in much the same way as with traditional film-based photography.

The reproduction quality of the images is excellent for the digital cameras, although less so for the less expensive video still cameras with fixed focal lengths. The still-video camera produces images consisting of 250,000 to 500,000 pixels, while the digital camera images typically consist of 1.3 million pixels.

The camera can be linked to a modem, which allows images to be transmitted over normal phone lines to any computer or picture desk capable of receiving files in the specific digital format, or it can be hooked up directly to the computer and the images can be "downloaded" onto the computer's hard disk. The images can then be edited using image-editing software on the computer to prepare for insertion into the newspaper or news magazine.

Scanning Technology

Photographs can also be digitized on scanners that use light to "photograph" the photograph, film negative, slide, or transparency, and then translate the visual information into digital data. Scanning technology has been part of the printing industry longer than electronic publishing, which has begun to change everything. Photographs or transparencies were placed on expensive drum scanners and enlarged or reduced to produce the film negatives to the size needed for printing the image in a magazine or catalog. Now drum scanners have been attached to complex computers that take the same information and digitize it so that the computer can use the original again and again at a variety of sizes. It only needs to be scanned once.

Scanners range in size and quality, from hand-held scanners and home office "desktop" scanners to high- and super-highresolution drum scanners operated by service bureaus or color houses. The cost of preparing scanned images for use in the computer depends on the quality of the final printing production and the capability of the service bureau to provide color correction.

This process is more expensive than Photo CD, but the advantage of using the service bureau for digitizing images comes from the expertise of the scanner operator and the imaging specialist. Together they scan and correct the image to achieve the truest color representation and sharpest image. The Photo CD operator simply scans and prints the images to disc without evaluating the color correction.

Computer "Darkroom" Software

Taking the photograph has always been only part of the process of creating a photographic image. The darkroom, where you process and print the film, presents a whole set of challenges for achieving the optimal image. This capability exists in remarkable similarity in the digital environment.

Once the image is brought into the computer—via scanning or Photo CD—you need to make sure that when the image is reproduced it will be true to the original scene that it captured. In the computer, you can dodge and burn, perform unsharp masking to sharpen the focus, adjust the color balance or hue saturation, and lighten or darken an entire image much as you would in the darkroom. In the digital darkroom, you have the added ability to lighten only the midtones or only the shadow areas, or to perform any number of creative alterations using a wide range of filters. You can see the result on screen, and, if you don't like it, you can change it with the touch of a button.

What gives you this capability is the computer software. Programs such as Adobe's Photoshop or Aldus's Digital Darkroom include all the "tools" you need. These are extremely complex programs that require a large investment of time in either professional or self-training to become proficient.

Ethical Issues

The capabilities of the new technology have completely shattered the old saying "a photograph doesn't lie." Although it was possible to make photographs lie with the old technology, now it's possible to create completely seamless, undetectable superimpositions. The ethical question of how much one can alter an image for the sake of aesthetics or some other less noble need and still maintain the integrity of the image has stirred a lot of controversy.

In the editorial world of journalism—both newspaper and magazine—the line has been drawn quite firmly. A press photographer who asked a firefighter to pose for a photograph was fired for having staged it, for interfering in the representation of truth. Changing the content of an image electronically would also be clear grounds for dismissal.

That's not to say that there isn't room for manipulation of an image in its digital form that remains within the bounds of ethical representation. In the darkroom, the photographer practices a number of techniques to enhance the content of the photograph, not alter it. These are traditional darkroom techniques that in no way compromise the integrity of the photograph's content.

Photographer and designer Jim Williams believes the question of a photograph's integrity has always been not the image itself, but the reputation for reliability of the *source* of the image.

"When we see a photo in a newspaper," he explains, "we trust not only that it's not faked, but that it reasonably represents the significant parts of the scene because we rely on the journalistic integrity of the newspaper. If we see a glamour photo on a magazine cover, we might exercise a bit more skepticism in deciding to believe that the model is really that gorgeous in real life. And if it's a photo in an ad...well, most of us learn at an early age that the real thing never looks quite as good! If digital imaging has any effect on the believability of photographs, it's simply going to be a matter of throwing the question back onto the reputation of the source, not by asking 'Is that picture real?' so much as 'Can I trust the source of it?' And that's good."

Taking Off on Your Own Career Path

If you're heading for college, look for a school that has developed its computer program in either photojournalism or art photography. The Brooks Institute in California and the Rochester Institute of Technology in New York both offer extensive programs. The Center for Creative Imaging in Camden, Maine, offers a program of intensive workshops and training created in cooperation with Kodak and the Apple Computer Company.

With most states suffering budget cutbacks, not many programs attached to art departments or journalism schools have been able to invest in the expensive equipment required to offer quality instruction in the new digital technology. A good resource for information about photography programs is Photobase, a cooperative system of on-line technology and electronic bulletin boards that can connect you with schools worldwide.

Aside from college programs, many computer stores, digital camera manufacturers, and some service bureaus offer training seminars that can get you started. A lot will depend on you. Like learning photography itself, learning to work in the digital environment involves trial and error and repetition for you to become a master image maker.

An internship or apprenticeship with a top-quality prepress service bureau would easily be worth a year's college tuition. You'll learn more quickly working side by side with an expert who can help you get several stages along on the learning curve.

Digital Career Opportunities

There are many career options available that involve the new digital technology and touch on photography as part of the job. Listed below are some of the areas that involve photography almost exclusively as it relates to the new technology.

Electronic Imaging Specialist

The individual involved with getting the photographs into the computer, and then preparing them for printing is an electronic imaging specialist. The title may change from job to job, but the work being done, whether for an advertising agency, a corporation, or a magazine publisher, is very similar.

A background in photography can be extremely valuable in this position. A knowledge of printing processes and computerimage software is essential.

The imaging specialist receives film, transparencies, or prints from photographers (or, depending on the size of the company, takes the photographs as well); then arranges for the images to be transferred into digital format for use in the computer. This may be done by sending the photos to a Kodak Photo CD processor or to a service bureau that scans the images using a highresolution drum scanner, or by scanning them in house on a slide, film, drum, or flatbed scanner.

Once the images are in the computer, the specialist uses photo enhancement software to prepare the final image for the final product. The images then go on disk (or through electronic file transfer on a network of in-house computers) to the graphic designer, who places the images into the electronic layout.

Electronic imaging specialists also work for hospitals, industrial photography studios, printing plants, newspapers, the military, federal and state government agencies, and photofinishing companies.

Publishing

The electronic revolution has most rapidly been embraced by the magazine and newspaper publishing industries. These industries were the pioneers in early word-processing systems, and they have again been quick to see the cost-effectiveness of the new technology over the long term.

Many new magazines and newsletters or tabloid papers have sprung up because of the new technology. Desktop publishing systems enabled virtually anyone to become a "publisher," as long as there was enough capital to pay for the printer.

Many of the larger publications and those with specific interests in the computer industry are already involved with inhouse photo imaging. The entire publication is most likely "laid out" on the computer screen rather than the drafting table. In the past, photographs would be sent to the "stripping" department to be "stripped in" to the film negatives for printing. Today, the film comes out of the imagesetting machines with every element in place, ready to create the plates for the printing press.

The book publishing industry has been slower to move to the new technology, but the change is coming. It might take some salesmanship to persuade the vice president for design at a major publishing house that the graphics department is not doing all it could without someone in house to assure that topquality images will appear in the books and on the covers. There is enough of a learning curve in the entire industry, however, that someone coming in with a thorough understanding of the new technology will have a decided advantage.

Advertising Imaging

The move in magazines and newspapers toward electronic imaging has fueled change among advertisers as well. Ad agencies and corporate ad departments can reduce the cost of producing advertising considerably by using electronic media. Traditionally the advertising agency would prepare an ad campaign using the same image in a variety of promotional ads, mailers, brochures, or posters. The image would be printed a different size in each, which required re-creating the image to the correct size for each product. Digital technology means that the image is scanned once at the largest size, and then electronically reduced in the computer to fit all the other sizes. The result is a significant savings in the budget for photographic imaging.

Corporate and Industrial Imaging

Jim Williams works as a in-house photographer and graphics specialist for a large consumer-products company. His time is split between computer graphics and taking photographs for the packaging of his company's products. When he shoots photographs, it is with the specific intent of putting them into digital form through Photo CD. He uses a 35mm camera and the film goes straight onto CD. "I don't even bother with contact sheets!" Jim says. "I've been having good results, both for proofs and printed four-color sales promotion pieces we've done."

Jim also works with other photographers who provide stock images, and he is often frustrated that so few have come up to speed with the new technology. "I would *love* to work with a photographer who could say, 'Do you want the chromes, a Photo CD, or TIFF files on an optical disk? Just let me know what you need and I'll take care of it.' Someone who did that would have a real competitive advantage!"

Service Bureaus

Service bureaus, or color houses as they are sometimes called, have invested in the expensive technology required to take photographs and digitize the information directly into the computer to allow image editing and the repeated use of an image in printed matter.

192 CAREERS FOR SHUTTERBUGS

Scanner Operator

The person responsible for operating the scanning equipment must be extremely knowledgeable about the production of color film for printing purposes. Arguably the best scanner operators come from a background in traditional color prepress.

The scanner operator takes the client's film, slides, prints, or transparencies and establishes the specific needs for preparation of the printing film. Knowledge of how different preparations of film affect the final printed piece depending on how it is printed is essential.

A scanner operator makes from \$25 to \$50 per hour, and more if the scanner operator also owns the service bureau. Service bureaus charge from \$35 to \$250 for each scan, depending on its size and the quality or resolution of the scanner, and from \$65 to \$300 per hour for any retouching work.

Digital Imaging Specialist/Technician

The imaging specialist or technician takes the scanned image in the computer and makes the fine-tuning adjustments to assure the ultimate quality of the image's reproduction. This individual can also create "masks" to drop the background out of a photograph of an object or person, as is often done in mail order catalogs. The specialist is also capable of creating special effects as desired.

A digital imaging specialist working for a service bureau earns from \$12 to \$50 per hour.

Video Editing

Many news broadcast organizations have begun to use computers in the editing of videotapes that will run during the newscast. The advantages of speed and the ability to program them into computerized video and sound management systems have made this option very attractive. The ability to take video images and work with them in a computer environment also has uses in the corporate and industrial world. Sales presentations, training seminars, and informational presentations can all benefit from a sophisticated blending of multimedia film, sound, text, and still imagery that the computer is capable of creating.

A video editor for a broadcast company might expect \$20,000 to \$25,000 as a staff salary in broadcasting, slightly more in an industry or corporate position.

Stock Photography

Although there is some concern that the Photo CD revolution will cut deeply into the stock photography market for traditional images, the entrepreneurial photographer sees the new technology as an advantage. "Photographers could be exploiting digital imaging by thinking creatively," Jim Williams suggests. Digital distribution allows the photographer to create highly targeted collections of special-interest photos and market directly to the photo buyer.

For example, a lot of Jim's work involves food products, and though stock agencies carry all kinds of food photo setups, they rarely meet his needs. "I'd love to have a CD with photos of *individual* food components—a hamburger patty from various angles, a hamburger bun from matching angles, potato salad likewise, different kinds of plates," he explains. "Starting with these individual elements, I could composite all kinds of food shots. Every agency, newspaper, or grocery chain that does food work would use a CD like that almost constantly and would be willing to pay hundreds for it."

Several stock agencies are converting to Photo CD because of the growing use among photo buyers of electronic media for prepress production, which means doing everything except the printing on the computer. For potential earnings in the stock photography area, see Chapter Five.

On-Line Stock Access

Another new development is in the area of computer on-line services. The Kodak Picture Exchange, a new global image marketing service, is an on-line database of tens of thousands of stock photography images. Subscribers to the on-line service can use a database to search for images by keyword; then order the transparency for publishing from the stock agency at regular rates. Seventeen stock agencies joined the on-line service.

Another on-line service, offered by Comstock Inc., lets customers order and download compressed digitized images directly onto their computers. Seymour, an on-line program offered by Picture Network International, a major stock photo agency, allows customers to select images, complete an order form and receive billing information, and then retrieve the high-resolution image ready for inclusion in electronic layouts or order transparencies, film, or disks.

The Future

The computer and digital revolution is still in process. Because the technology is changing so rapidly, there is considerable discussion as to whether Photo CD will ultimately go the way of 8-track tapes. However, the durability of the discs and the information printed on them assures that they'll not easily be dismissed. In addition, the extensive popularity of CD-ROM technology will assure at least some degree of longevity.

Cable TV is the next step in the digital progression, though not completely developed yet. Kodak demonstrated the capability of transmitting Photo CD images over a Cable TV network at an industry trade show. Ultimately consumers could access an on-screen personal database of family photos, such as Photo CD photos, perform cropping or editing, then send the image across the network to other family members. Other options might include sending images over the cable network to retailers at other locations for prints to be made.

From here, who knows where the new technology will lead? Maybe even the sky won't be limit enough.

For Further Information on Digital Photography

Organizations

Photobase. American Video Institute, Rochester Institute of Technology, P.O. Box 9887, Rochester, NY 14623-0887.

Technical Association for the Graphic Arts. C/o RST, P.O. Box 9887, Rochester, NY 14623.

Books

- Aaland, Mikkel. Digital Photography. New York: Random House, Inc., 1992.
- Breslow, Norman. Basic Digital Photography. Boston, MA: Focal Press, 1991.
- Holzmann, Gerard J. Beyond Photography: The Digital Darkroom. Englewood Cliffs, NJ: Prentice-Hall, 1988.

Larish, John. Digital Photography: Pictures of Tomorrow. Torrance, CA: Micro Publishing Press, 1992.

- Larish, John. Photo CD: Quality Photos at Your Fingertips. Torrance, CA: Micro Publishing Press, 1992.
- Larish, John. Understanding Electronic Photography. Blue Ridge Summit: Penn Tab Books, 1990.
- RIT Research. Using Photo CD for Desktop Prepress. (Booklet available from RIT Research, Rochester Institute of Technology, Rochester, NY 14623.)
- In addition, the Eastman Kodak Company in Rochester, New York, publishes a number of pamphlets on Kodak Photo CD and Digital Camera Systems.

196 CAREERS FOR SHUTTERBUGS

Periodicals

Photo CD Magazine. P.O. Box 579, Batavia, IL 60510. (Ask about free subscription offer to users of Photo CD technology. At press time, this offer was expected to continue indefinitely. To receive a free subscription, send a photocopy of the index card from any Photo CD disk you have processed, along with your name and address, to PHOTO CD Magazine CIS Offer at the address above.)

Photoelectronic Imaging. 1090 Executive Way, Des Plaines, IL 60018.

The following publications regularly include sections and articles on the new technology, as well as product reviews:

PhotoPro Magazine. 5211 S. Washington Ave., Titusville, FL 32780. Shutterbug Magazine. 5211 S. Washington Ave., Titusville, FL 32780. Photo Electronic Imaging. 1090 Executive Way, Des Plaines, IL 60018.

The Fine Art of Photography Artist Photographers

F ine art photography is an art medium that allows the photographer to create a visual expression of a personal vision or expression. The fine art photographer is bound by no limits of technology or medium, freely combining and experimenting to develop a unique aesthetic.

The acceptance of photography as a fine art medium has increased steadily since William Henry Fox Talbot published his photograph "The Open Door" in 1844. It has been acknowledged as the first photograph published solely for its aesthetic value. It wasn't until the 1890s that the first photography exhibit by a major art museum was mounted by the Royal Academy in Berlin. Today most museums of fine art have extensive collections of fine art photography, and fine art galleries increasingly number photographers among the artists they represent. The number of galleries dedicated to exhibiting photography also has increased.

While all this has been good news for fine art photographers, the reality is that it is still very difficult to make a living exclusively from fine art photographs. Harrison Branch, a professor of art at Oregon State University, estimates that between 2 and 10 percent of those involved in fine art photography are able to make a living at it. "And that's being generous," he adds with a laugh.

198 CAREERS FOR SHUTTERBUGS

Among the highly successful fine art photographers are the big-names such as Annie Liebowitz, Edward Weston, Walker Evans, Duane Michals, or Herb Ritts. Their prints earn top dollar through galleries in New York and across the country. But developing that level of name recognition takes time, dedication, perseverance, and, foremost, a distinctive, original, powerful personal style.

For many photographers, being able to engage in the creative side of their work is the reason they take wedding photographs or portraits, or work a day job as a lab technician. These other jobs keep food on the table; the fine art photography feeds the soul.

What it Takes

Creative photographers, says Harrison, don't need an academic degree. "You need talent, and you need luck."

Luck comes with developing the gallery connections that get your work shown. "You have to find those who like your work, understand your work, and are willing to exhibit your work," Harrison explains. "You may be one of the world's greatest photographers, but if you don't have any gallery connections, your work never gets shown.

A Way of Seeing

The talent part of Harrison's formula, he says, has to come from within. "You must have some kind of imagination," he insists. "You have to have an eye. It's an old cliché, but it applies to photography the same way it applies to painting, printmaking, graphic design, or any other visual area. If you don't have an eye, you're just taking up space."

The "eye" involves the artist's way of seeing, the artist's approach to creating visual images. The elements of design—com-

position, light, texture, form, value—are all important, but to Harrison they are secondary to the artist's idea.

"You have to be able to make your photograph communicate something, some essential reason for existing besides just being a pretty picture. It should communicate something about what I know. It should enlighten me about something I don't know. You could be the world's greatest photographic technician, but if you have no sensitivity, no eye, it won't make your photographs exciting or moving. Technique alone does not make a photographer."

Another important learning tool involves looking at the work of others—reading books on photography, haunting the art galleries and museums, browsing the library bookshelves of art photography books. "Look at everyone and everything," Harrison advises. "Don't limit yourself by only looking at work by people you like. Look at work by people you don't like. Ask yourself, 'Why do I like this person?' and 'What is it about this work that I don't like?'"

An Ability to Solve Visual Problems

While a degree in photography isn't required, there's a great deal that can be learned in the classroom aside from technical knowledge. Good programs in photography help you learn how to approach taking pictures as a means of solving a visual problem.

"In school, assignments are given so that you can go out and challenge your imagination, to see how inventive you can be," Harrison explains. "In the best situations, you're challenged not only by your professor but by your fellow students. Once you're out there in the world working on your own, you have to maintain that inventiveness, that sense of personal challenge."

Finding others to critique your work can be very useful, even to the professional photographer with years of experience. Joining a photography guild or association can provide that kind of help. "You can do nothing but benefit from having other people around to talk to about photography," Harrison says. "It's one of the best learning tools there is—having someone else's shoulder to cry on!"

The Determination to Keep Going

Perseverance and tough skin are also important attributes for a would-be-successful fine art photographer. It takes a fair amount of gumption to walk into an art gallery and ask to show your work, and then have to wait and watch while the gallery director looks through your portfolio. Perhaps a worse situation is waiting weeks after having dropped your portfolio by the gallery only to have it returned with a short form letter saying, "Thanks, but no thanks."

One photographer recalls showing his work to a gallery director in New York who fanned through the pages in about ten seconds, put them down on the table, and walked away without a word. That's about the height of the rudeness you can expect to encounter, but it's important to remember not to take it personally or let it stop you.

Harrison argues that the same is true for critiques from fellow photographers. "Take them with a grain of salt. They're part of a learning process, not personal attacks. They're meant to make you a better image maker."

The Emergence of Digital Photography

In talking with fine art photographers, you'll find an entire range of reaction to the impact of digital photography on fine arts. Some are vehemently opposed to the manipulation that digital photography allows once the photograph has been taken. Others are gleefully pursuing the many creative doors the new technology has flung open.

Jim Williams is a corporate photographer by day, a fine art photographer on his own time. At the office, he is very involved with the new technology, using it to enhance and manipulate images to create advertising and promotional products.

In his own work, however, he likes to keep the images raw. "Having worked with digital image manipulation daily for five years now, I've had a kind of backlash," Jim says. "My personal photography documents the lives and work of ballet dancers. Because ballet is a classical art, I used to work very hard at clean, uncluttered compositions—making sure the edges were straight, with no awkward corners or odd bits of scenery sticking in, no intrusive background elements. I've even tried taking flawed pictures and 'improving' them by erasing distractions, smoothing backgrounds, and so on. But I almost always found I liked the original image better. I'm starting to enjoy flaunting the photographic nature of my pictures, using their imperfections as a badge of unretouched authenticity!"

Starting Out

Harrison emphasizes darkroom work for his students. He recommends shooting extensively, taking notes on exposures and apertures, and then working in the darkroom and taking more notes on the results.

"The more photographs you take, the better," Harrison advises photographers starting to develop their professional interests. "The more times you go out and photograph, the more you have to come into the darkroom to develop film, and, consequently, the more comfortable you feel developing film. The more you develop film, the more times you have to print. The more you print, the more comfortable and knowledgeable you will become about printing. It's like riding a bike. The more you do it the better you're going to get.

"But you have to want to do it. I can't make you want to do it. I can provide you with the information and technical knowledge and guidance, but the bottom line still is that it has to come from you, the individual. And those are my best students, the ones who are still doing it today because they understood that 'I'm not doing it to please Harrison Branch, I'm doing it because this is what I love to do."

Equipment

If you're just starting out in photography, Harrison cautions against spending thousands of dollars on equipment. The payback is very slow, and you may decide that photography is not your bag. You don't want to end up stuck with a lot of sophisticated equipment you're not using. A moderately priced 35mm camera and a couple of lenses will get you started.

Once you are ready to make a commitment, though, he recommends buying only high quality equipment, and, if you can afford it, investing in a medium format camera because of the increased size of the negative.

The Artist's Portfolio

The portfolio is what will get your work out, which is the primary goal of the fine art photographer. It should contain the very best of what you do. It should include work that is representative of what your concerns are as a visual artist. If you work only in black and white, then don't include the two or three color pieces you did five years ago. The portfolio should represent what you are currently involved with as a creative photographer.

Depending on the type of work you do, you might want to include an artist's statement about your work that covers your intent, your motivation, your experiences, or whatever is relevant for the viewer who is looking at your images. Some would argue that text is superfluous, that your photographs must stand on their own merit. This, as with many other elements of fine art, is in the mind of the beholder and something you must decide for yourself. You will also want to include a resume. If you've had previous exhibits, list these according to date and location, as well as whether the work was shown as a solo show or as part of a group exhibit, an invitational or juried exhibit. Also include any educational background or relevant work experience. The gallery director will be interested to know that you taught a workshop on silver gelatin printing, but not that you flipped burgers at McDonald's. Most galleries will post a resume of the artist's work during a solo or two- or three-person exhibit, so you will want to have one prepared.

Getting Your Portfolio to the Galleries

Before you can line up a show to get your work seen by the public, you need to have it scrutinized by any number of gallery directors. It isn't essential that you live in the same community in which the gallery operates, but it definitely helps. In New York City especially, gallery directors like to be able to bring potential clients to your studio or darkroom to meet with you and discuss your work.

Contemporary galleries, especially those in major cities, are most likely going to be interested in your work if it is experimental both in content and in technique. Creative artists are always "pushing the envelope" of the medium, seeking innovative means of expression or presentation that will capture the viewer's eye or imagination. Many galleries, however, are looking for highly traditional or representational images that appeal to a broader audience of clients. These include nature galleries, wildlife galleries, and Western galleries, among others.

Photographer's Market can help provide clues as to which gallery is appropriate for your work. It lists approximately 150 gallery spaces interested in showing work by photographers. Some of these are museums, others are university art galleries, but most are galleries dedicated to fine art photography. Look for galleries that are interested in the kind of work you do.

204 CAREERS FOR SHUTTERBUGS

Don't bother sending beautiful floral color photographs to the Silver Image Gallery, for example. At the same time, sending abstract photos to a gallery that specializes in wildlife and scenics is a waste of postage.

The publication Photography Galleries and Selected Museums: A Survey and International Directory lists photography galleries throughout the world. Art In America magazine publishes an annual directory of artists, museums, and galleries. It isn't indexed for photography museums, but you can look through the artist index for people you know to be photographers; then check out the galleries where they are represented. Finding artists whose work is in a similar category with yours is the clue to whether or not the gallery will be an appropriate choice.

Often a gallery will want to begin to represent you without making the commitment for a one-person show. This is a foot in the door. But you will want to be fairly aggressive about bringing the gallery new work at least twice a year, as well as about making sure your work is being shown to prospective clients. If your work can sell from the stacks, you're much more likely to be granted an exhibit.

Other Exhibition Opportunities

Galleries and museums aren't the only places where photography can be shown and offered for sale. Many corporations, restaurants, and other businesses have lobbies or other areas where they will show artists' work. Sometimes these less formal exhibits can be very beneficial for the new artist—you never know who might notice your work during the dessert course or while waiting in the lobby for the elevator. In these situations, the owner of the building or restaurant is not as likely to take a high commission on any sales. Frequently they take no commission at all.

Earning Potential

The likelihood of making a living at fine art photography is directly proportional to the level of name-recognition you enjoy: the better known you are, the more money you'll make. People will know your work, will ask for it in the galleries, and, consequently, galleries will be happy to carry your work because they know it will sell. Your reputation doesn't have to be a national one. If you can develop a strong following in your home town, you can count on more consistent sales, and then build on that reputation in surrounding areas.

Galleries take a substantial commission from all sales, generally 40 to 60 percent, so you will want to price your work in such a way that the net amount is acceptable to you. Gallery directors will advise you if they think you've priced yourself out of the market, or, conversely, if they think you've under priced your work.

Most galleries will want an exclusive relationship with you, at least in the city or area in which the gallery is located. Such relationships are open to negotiation, but having exclusive rights to sell work by particular artists is one means by which galleries establish their clientele.

You will also want to have a separate price for work that has been matted and framed to help compensate you for these additional expenses. Some galleries prefer to frame work themselves to maintain a sense of consistency in the gallery.

The pricing of your work is dependent on the market in which it is being offered for sale, the demand for your work or for your style of photography, and the expense involved in producing the work. Individual photographs can range in price from \$25 to \$15,000, although the latter would be for a well-known photographer whose work is being actively sought by a wide group of collectors.

Grants

A number of public and private foundations provide funding for artists to work on specific projects or to have the freedom for a period of time to pursue their artwork without the need to seek employment not related to art. Most states have arts councils that offer individual artist grants, and photography is generally included as one of the eligible art media. Major foundations such as the National Endowment for the Arts and the Guggenheim Foundation also make substantial grants to visual artists.

Related Careers in Fine Art Photography

Art Photographer

As an artist yourself, you understand the importance of visual presentation of art work. You also have the specialized skills in photography that many other fine artists lack. Artists need portfolios in order to present their work to galleries, and the better the photographs, the better the art work will be represented.

Working independently, you can establish a good business as an art portfolio photographer, particularly if you live in a city with a larger-than-average artist community, such as New York, Los Angeles, San Francisco, Santa Fe, or Seattle. Art galleries also call upon art photographers to take photographs of work by artists they represent.

Staff photographer opportunities are available on museum staffs and auction houses such as Christie's, which has branches in New York, London, Amsterdam, and Paris. Jerry Markovitz worked for the Metropolitan Museum of Art in New York, where he photographed new acquisitions in the museum's enormous art collection. He was one of five photographers on a media staff of twenty. A salaried photographer might make a starting salary of \$15,000 to \$23,000. A freelancer's income is limited only by the number of artist clients, the going rate for art photography work, and how many clients can be scheduled into the year.

Photography Gallery Director

Often the owner of a fine art photography gallery will prefer to turn over the curatorial and daily operations tasks to a gallery director. A fine art gallery director must have an extensive knowledge of both traditional and contemporary photography techniques, the history of photography and photographers, and the current trends in the fine art of photography.

A photographer with enough capital might decide to open a gallery and run it. A gallery conducts exhibits of contemporary photographs, either presenting one or two photographers at a time, or a group exhibit of work by several photographers. Photographs are offered for sale, both from the exhibit walls and from the "stacks," usually an extensive collection of photographs kept in archivally controlled flat files or framed and in racks.

Earnings in this volatile field depend on who is responsible for the overhead and, to a large extent, the overall economy. Art is a luxury for most people, and during economic downturns, art sales drop dramatically. A staff director, however, can usually count on a salary ranging from \$13,000 to \$25,000, depending on the location and overall size of the gallery.

Museum Photography Curator

Several museums in the country have developed extensive photography collections, which are curated—reviewed, selected, and purchased—by a photography curator. A photography curator would need a strong background in the history of photography and fine art photography, either as an art historian or as a fine art photographer with a degree in art history. Opportunities in this field are limited to large cities or institutional museums or galleries. Salaries start at approximately \$20,000 per year and rise to \$35,000.

Learning to Fly

I'll end this chapter with Harrison's trademark advice to his fine art students: "You have to learn to crawl before you can walk. You have to learn to walk before you can run. And you have to learn to run before you can fly."

For Further Information on Fine Art Photography

Organizations

- American Photographic Artisan's Guild. C/o Professional Photographers of America, Inc., 1090 Executive Way, Des Plaines, IL 60018.
- Association of International Photography Art Dealers. 1609 Connecticut Ave. N.W., Washington, D.C. 20009.
- Council on Fine Art Photography. 5613 Johnson Ave., West Bethesda, MD 20817-3503.
- En Foco, Inc. 32 E. Kingsbridge Rd., Bronx, NY 10468.
- Friends of Photography. 250 Fourth St., San Francisco, CA 94103-3117.
- International Center of Photography. 1130 Fifth Ave., New York, NY 10128.
- International Museum Photographers Association. 5613 Johnson Ave., Bethesda, MD 20817.

Periodicals

- Aperture. 20 E. 23rd St., New York, NY 10010. (Quarterly magazine of fine art and contemporary photography.)
- Art Calendar. Rt. 2, Box 273-C, Sterling, VA 22170. (Monthly publication that includes gallery listings, grants information, and articles of interest in the fine arts.)
- Entry. Box 7648, Ann Arbor, MI 48107. (Newsletter published 10 times per year; guide to photographic competitions and juried exhibitions.)

Books and Pamphlets

- Carson, Jeff. Photo Gallery & Workshop Handbook. Cincinnati, OH: Writer's Digest Books, 1991.
- Crawford, William. The Keepers of Light. New York: Morgan and Morgan, 1979.
- Davis, Harold. Successful Fine Art Photography. New York: Images Press, 1992.
- Lent, Mas and Tina. Photography Galleries and Selected Museums: A Survey and International Directory. National Public Data, P.O. Box 1442, Rochester, NY 14611.
- Persky, Robert S. The Photographer's Guide to Getting & Having a Successful Exhibition. New York: The Photographic Arts Center, 1987.

CHAPTER THIRTEEN

Related Photography Careers

More Opportunities for Camera Buffs

I f you crave cameras and equipment, dig the darkroom, or like to keep things in motion, you've a whole range of career options to choose from. Clicking the shutter is what comes to mind first when we think of photography, but there are many jobs to be done that are essential if photographers are to see their photographs in print.

Working Magic: Darkroom Technicians and Photo Processors

I remember as a child watching my father developing some photographs he'd taken with his old Brownie. I think we were in a makeshift darkroom he'd created in the downstairs bathroom. The memory of place and time are fuzzy, but I vividly remember the sense of magic as I watched a plain piece of paper, floating in a bath of what looked to my five-year-old eyes like water, transform into an image of me and my mother and sisters at a lake where we'd been camping. I was speechless with the wonder of it. When I took my first photography class, venturing into a real darkroom with labeled brown bottles and large tubs for the developer and fixer baths, I recaptured that singular delight in the unfolding of images before my eyes. It's no wonder many who are interested in photography choose careers in the processing and printing of film created by others.

Dark Room Film Processing and Printing

Aside from its inherent fascination, the work of photofinishing and printing is a major industry. Photofinishing sales for amateur photographers alone represented \$5.5 billion in 1992. There are many job opportunities in this field, from one-hour processing labs that require little experience to custom labs that serve professional photographers with high-quality processing and printing.

The employment outlook for photographic processing workers is good. The *Vocational Careers Sourcebook* predicts a fasterthan-average growth in the industry until the year 2000. In 1990, there were more than 76,000 photo processing jobs. Salaries vary according to the level of skill required, as well as other factors, such as geographical location and the size of the lab. The range to expect is between \$10,000 and \$30,000 a year, with an average starting salary of approximately \$15,600.

Advancement into management positions requires additional specialized knowledge and training in photography and photo processing mechanics, or perhaps special training in the machinery used in the processing and printing of film. Supervisors, assistant managers, managers, and department heads are all positions of responsibility that can be achieved by starting as an unskilled film processing technician.

Custom Photo Labs

The most specialized of photography labs are those serving the needs of professional photographers and portrait studios. The

212 CAREERS FOR SHUTTERBUGS

demand for quality is high and standards are exacting. These labs process most of the work by hand, taking individual care with each job, rather than using color processing machines found at large commercial labs or one-hour labs.

Other custom labs exist in corporate or industrial situations, most especially at camera and film manufacturing plants. Some large portrait or commercial photography studios incorporate their own custom labs on site, and most large newspaper and magazine publishers operate on-site darkrooms with specially hired darkroom technicians rather than photographers processing film. Some universities, too, have on-campus darkroom operations that serve public relations needs, as well as photo work for academic departments.

Employment in these labs requires a high level of skill, experience, and training beyond basic darkroom photography. You must have thorough knowledge of film and its properties and the chemistry involved in its development and printing, as well as the ability to control these variables to produce prints and transparencies that do justice to the professional photographer's vision. A good custom lab technician forms a partnership with the photographer to produce the best possible results.

One-Hour Photo Labs

These photo processing "minilabs" are popping up all over the country. In my small town, there are at least six places where I can drop off film and come back in an hour for my prints. One place even offers drive-through film processing and espresso!

The largest one-hour chain operations are Fotomat and Fox Photo, with approximately 1,600 locations combined. With more than 24,000 retail photofinishing outlets in the United States alone, opportunities for entry-level employment are wide open.

The processing machines, like those in commercial labs, require very little technical skill to operate, and these positions account for a large number of photo processing jobs. Because the machines process and print an undeveloped roll of color film in only two size options, enlargements and reprints are still sent out to commercial labs.

Wages for operators range from minimum wage to \$7 per hour, depending on the geographical location, size of the operation, and experience level. An individual who has invested in a photofinishing machine has an income potential of \$30,000 to \$50,000 or more annually. Depending on the size of the lab, opportunities for advancement might include positions as assistant manager or manager. Salaries at this level range from \$12 to \$15 per hour or \$20,000 to \$35,000 per year. With experience in this field, advancement into commercial or custom lab management is a natural step.

Commercial Photo Labs

These large processing plants represent about 50 percent of all photo finishing employment opportunities. They serve drugstores, grocery stores, and other retail outlets that offer dropoff services for photo finishing.

Commercial processing labs serve the large amateur photography market. The equipment used to develop and print film is extremely sophisticated, so the workers do not need to be highly skilled in photographic processing to operate them. Still, opportunities exist here for skilled developers, who are hired in supervisory or management positions.

In commercial labs, the print developers attach the film from a film canister to a leader on the machine, attach sensitized paper for printing, and then, while operating the machine, check it for temperature controls and watch as the prints emerge to make sure the prints are being processed accurately. Any problems are referred to the quality control supervisor.

In addition to processing film for prints, commercial labs handle reprints, enlargements, cropping, and special printing requirements. These tasks are handled by individuals with experience in developing and darkroom technology.

214 CAREERS FOR SHUTTERBUGS

Courses in photography, darkroom processing, chemistry, and mathematics can be beneficial in photofinishing. Most photo processing workers in commercial labs have at least a high school diploma, while many hold two-year certification from community or vocational colleges or technical institutes. Certification programs enhance opportunities for supervisory or management positions.

On-the-job training programs provide opportunities for advancement and specialization, which can lead to self-employment or employment with custom labs. Many of the larger photo processing labs offer continuing education training to keep employees on top of emerging technologies.

The Digital Technology Boom

According to *Specialty Lab Update*, a newsletter published for commercial labs, people labs, and in-house photo finishing labs, "commercial labs have aggressively embraced electronic imaging services," while people labs, those primarily serving professional photographers and portrait studios, "have taken a wait-and-see approach."

The most popular applications of the electronic imaging equipment thus far, according to Ted Fox, Photo Marketing Association Group Executive for Marketing Information, are computer-generated slides for presentations, desktop publishing, electronic photo composition, and photo retouching and restoration.

The increasing popularity of electronic imaging in commercial labs opens the door for employment in higher-skilled and, therefore, higher-wage positions. Marketing of these new services has been challenging for many commercial companies, so if you present good ideas for bringing in new customers, you'll have excellent job prospects!

Photo Retouching and Restoration

I remember when I was in high school and had been elected the head of an organization I belonged to. My new position required that I get a professional portrait done. I was devastated to wake up on the morning of the photo session and discover not one but three blemishes. The heartbreak of teen-age acne!

"Not to worry!" said the photographer. "I'll just have the photo retouched and you won't notice a thing." More darkroom magic. The end result was wonderful. I looked much better in that photograph than I ever did in the mirror! It's still one of my favorites.

Photographic retouch artists work with air brushes, tiny paint brushes with specially blended chemicals and pigments, and, increasingly, with computer software programs to remove spots from negatives, smooth skin tones in portraits, blend out objects in the background, and generally enhance the image. Photo restoration involves copying a photograph that has been damaged or is deteriorating, then retouching the negative to try to rebuild or recreate the missing portions of the original.

Training in the art of photographic retouching and restoration can happen in college courses, specialized training seminars, and on the job with custom photography labs. Employment opportunities exist in custom labs, professional portrait and commercial studios, large commercial labs, and industrial or corporate in-house facilities. Major chain operations frequently offer restoration work, which is sent to centralized processing labs with retouch and restoration artists on staff.

A skilled photo retoucher can also find employment as an independent, establishing a relationship with a number of processing labs and professional photographers. The earning potential for a professional retouch artist can be between \$30 and \$50 per hour.

Camera Sales

All those photographers, both the professionals and the millions of hobbyists, bought their cameras from somewhere. There are thousands of retail outlets, several major mail order companies, and a number of opportunities for wholesale selling of cameras to both of these outlets. All offer job opportunities for camera enthusiasts.

What You Need to Know

Whether you work in a retail store, the camera section of a large department store or as a representative for one of the many camera manufacturing companies, selling cameras requires a thorough knowledge both of the merchandise and of photography itself. You need to be able to respond to questions about how the camera performs under various conditions, and you need to be responsive to complaints or questions from your customers.

One of the most basic requirements for any job in the retail sales business is an interest in people. If you enjoy working with a wide variety of people and like to answer questions and swap stories about photography and cameras, camera sales is a career path that you might enjoy.

Corporate Sales Representative

A camera sales or marketing representative working for Nikon or Olympus or Minolta or any of the other camera producers is assigned a territory to cover. The representative is more than a salesperson who travels to retail camera stores in the assigned territory to sell camera equipment. This person also serves as a resource of information about the cameras and the company's customer support. Larger camera stores often will hold seminars for customers interested in a particular line of cameras, and the representative might be asked to lead the seminar or be on hand to answer questions. The representative also trains the retail salespeople so that they will be able to explain to their customers the special features of the equipment.

In addition to direct selling skills, a knowledge of marketing and advertising strategies is also helpful. Toward this end, it is often helpful to have a degree or coursework in business or marketing to complement your knowledge of photography and cameras. The sales representative often assists the retail stores in developing advertisements for the products. Sales records for each store must be analyzed to be certain that the right products are being offered for sale based on the store owner's knowledge of store patrons and the sales representative's analysis of previous trends.

Other sales opportunities for camera manufacturers are as trade show or mail order representatives. The territorial sales representative may also handle trade shows, and mail order sales representatives might work for a separate branch of a large photographic retailer.

Job Opportunities

The five major camera companies, based on sales in North America, are Canon, Minolta, Nikon, Olympus, and Pentax. Photographic equipment was one of the leading commodities imported in the United States, representing \$3.8 billion dollars in 1992, according to the Foreign Trade Division of the Department of Commerce. Each of the five leading companies employs an extensive sales force throughout the United States and Canada.

Sales representatives generally receive a base salary, plus commissions and reimbursement for expenses. Companies might also offer incentives or bonuses for the sale of higherpriced items. Sales representatives can expect to earn between \$30,000 and \$50,000 or more, depending on their sales success.

Retail Sales

Virtually every town with a population of 20,000 or more has some store where you can buy a camera, whether it's the back counter at the local department store, the camera department at Wal-Mart, or the Nikon counter at New York's famous Willoughby's. While the pay is not as significant in retail sales for camera or department stores, working in camera sales can provide an excellent opportunity to learn about cameras and their manufacturers as you develop your career in photography.

Retail Sales Clerk

Retail sales clerks can expect a starting hourly wage equivalent to minimum wage or slightly higher. You'll be expected to absorb a tremendous' amount of information on the job about the cameras, both new and used, being offered for sale, as well as the film and its processing. With the expansion of your knowledge and responsibilities, your wage could increase to \$9 per hour, plus commission.

Dan Wilson began working for a large photography retail store in Seattle while studying photography at the University of Washington. He worked part time while school was in session and full time during breaks.

His initial task involved soaking up information from more experienced sales clerks and visiting manufacturer's representatives, helping customers look at used equipment, and selling film. Once he'd developed a strong knowledge base, he began actively selling the cameras. For each camera he sold, he received a bonus, or "sales spiff," which varied in amount depending on the value of the camera.

"The salary was never anything to write home about," Dan says, "but I learned so much about cameras and film that I feel it was just an integral part of the education I paid to receive."

Another benefit of the job, according to Dan, was being able to purchase his own camera equipment at a significant discount.

Photographic Equipment Buyer

Photo equipment buyers, on the other hand, command a salary that makes this an attractive career choice. Buyers are employed by the larger department stores and camera stores and may have responsibility for attending trade shows and sales seminars offered by the equipment manufacturers. A degree in business or marketing is a definite plus in this position, but along with this must come experience with and a love for photography, cameras, and equipment.

The buyer must be able to look at sales trends and keep track of developments in the photographic equipment industry. A knowledge of the clientele, whether predominantly hobbyists or professionals or a mix of highly skilled amateurs and pro shooters, helps the buyer to determine what should be kept on the store's shelves.

A starting salary for a buyer with retail sales experience in photographic equipment, as well as a college degree, ranges from \$20,000 to \$25,000. Earnings increase with additional responsibilities for management.

Retail Sales Manager

The manager in a photography retail store or department has responsibility for training, hiring, and scheduling, as well as analyzing sales and marketing trends. The manager might have buying responsibilities as well as sales on the floor of the department or store.

Middle managers, those with on-site responsibilities for handling sales and customer support questions, can expect to earn a starting salary of \$24,00 to \$26,000. Middle managers usually rise from the ranks of experienced retail sales clerks. District or regional managers for larger chain operations earn between \$30,000 and \$60,000.

Camera Repair

Camera repair is closely related to retail sales because often camera stores will offer to service and repair the cameras they sell, as well as others, either on site or as a clearing house for the various manufacturers they represent. If you're interested in the intricate workings of the camera's interior, a career in camera repair can provide challenges for years. The new developments in cameras each year mean the repair person must keep up to date with the changes, as well as maintain a working knowledge of older cameras that are still in use.

Jeff Owen runs his own camera repair shop in Ontario, California. He'd been interested in photography in high school, and after a knee injury forced him to leave his job in construction work he started selling cameras in a small town camera store. He was active in photography as a hobby, so the job suited him.

"The store, like most, had several junk cameras that customers had brought in but refused the repair estimates and never returned to claim," Jeff recalls. "I'd always been pretty good at fixing things, so I decided to take some apart and see what made them tick. I found I was able to figure out the mechanics and managed to get some of them working. I then found a nice repair guy in Los Angeles who was willing to answer my questions and get me started in repair."

Jeff continued doing repair work, all the while studying electronics and reading all he could about the mechanics and electronics of cameras. "I then started going to training seminars and still do in order to stay on top of the new technology. I will buy a camera once I see that it is going to be a reasonably frequent repair job, then take it apart to learn how to fix it on my own before I try to do that to a customer's camera."

Jeff now works as an independent contractor. "It's not easy to get into this business, but there are a few ways of learning the trade," Jeff explains. "Most techs end up getting jobs with manufacturers and learning their cameras, then going to work for independent repair shops specializing in whatever they did at the factory. Others, like myself, who can fix a wide variety of manufacturers' equipment, just keep hitting the books and learning new cameras as they come out."

Vocational technical schools, community colleges, and home study courses, as well as manufacturing associations and the Society of Photo-Technicians, offer opportunities for training in this field. Good camera technicians can earn from \$25,000 to \$50,000 a year, depending on how quickly they work and how many different types of cameras they can work on.

What You Need to Know

A camera repair technician usually receives training in electronics or manufacturing technology at a college or vocational training school. Training programs offered by camera manufacturers provide specific understanding of individual brands of cameras, as well as the workings of cameras in general. Manual dexterity, soldering and mechanical ability, and the patience to deal with tiny parts are essential.

Job Opportunities

Technicians are hired by large retail stores, manufacturers, and specialty repair shops. Whether you're paid an hourly wage or by the repair project, earnings will range from \$12,000 per year for a trainee to \$30,000 per year as a technician. Advancement within manufacturing company repair departments to management with supervisory responsibilities brings pay levels to between \$30,000 and \$50,000.

The specialized skills of the camera repair technician make it possible for you to work on your own, establishing client relationships with retail owners in your area, as well as individual camera owners. Your hours are your own, and the earning potential equals or perhaps exceeds—depending on how much work you take in and the prevailing rates for repair work in your area—what you might make as an employee for someone else.

Teaching

The teaching of photography is an extensive profession that encompasses virtually every college, university, community college, and high school in the country, not to mention special vocational schools, adult education programs, and the many thousands of workshops and seminars offered throughout the United States and Canada.

For most teachers, this is a full-time career choice. For others, particularly those offering seminars or workshops, teaching is a means of giving to others the benefit of their skills and experience, which they received on the way to a career in photography.

While teaching has the advantages of long vacations, good benefits, and a livable salary, teachers earn every one of those benefits. Keeping the interest and attention of, not to mention inspiring and genuinely teaching, a room full of 15- to 18-yearolds in high school, or 18- to 21-year-olds in college, takes a great deal of planning and patience. It also takes its toll both physically and emotionally.

Teaching Photography in High Schools

The curriculum in public high school programs varies from state to state, from district to district. Whether the school offers courses in photography often depends on the school's budget. If there's room for electives, photography is one of the most popular.

The photography teacher might come to teaching through an art background or through a degree in photojournalism. In every state, public high school teachers must have at least a bachelor's degree and certification or a license for teaching. Some states require that teachers earn a master's degree during the first ten years of teaching. Private schools are not bound by the certification requirements, but most will require a college degree.

The high school photography curriculum will be basic and general, providing students with an understanding of taking photographs, using the camera, and processing and printing in the darkroom. The photography teacher also might be responsible for supervising the student newspaper and yearbook staffs, or for teaching other subject areas, such as art or journalism.

Salary levels for high school teachers vary from state to state, but an average starting salary is usually between \$18,000 and \$25,000 per ten-month school year. The top of the pay scale for teachers is generally between \$38,000 and \$60,000, more if they teach summer school.

Teaching Photography in Universities

Photography professors on college and university campuses are generally found in either the fine art department or in the department of journalism. Depending on the size of the photography program, there may be only one photographer or as many as 20 at a school such as the Rochester Institute of Technology in New York or Brooks Institute of Photography in California, which are considered by many to be the most comprehensive photography programs in the country.

More than 300 colleges and universities offer degrees in photography, while photography courses are offered at nearly all others. The number of courses taught by college faculty varies according to the size of the institution and whether faculty are required to pursue professional research, or in the case of photographers, exhibition or publication. At a teaching-oriented institution, faculty might teach three to four courses per quarter or semester. At research institutions, the teaching load might vary from one to four courses per term. To teach at the college level, you need a "terminal degree," which for photographers most likely means a master of fine arts degree (M.F.A.). For photojournalists, the equivalent might be a master's degree in photojournalism, or an M.F.A. in photography. Generally only professors of the history of photography would pursue a Ph.D.

An excellent resource for information about photography teaching positions is Photobase, an electronic system of bulletin boards and databases that connects participating photography schools around the world. See the address at the end of this chapter.

Salaries for instructors or assistant professors, the entry-level position in college teaching, range from \$18,000 at the very lowest to \$34,000. The highest salary levels for tenured faculty with many years of teaching experience are \$60,000 to \$85,000.

Teaching Photography in Vocational-Technical Schools, Community or Junior Colleges, and Adult Education Programs

Teaching photography in vocational-technical, community or junior college, or adult education programs often takes a very specific, job-oriented approach. The curriculum focuses on the basic issues of learning to use the camera effectively, understanding darkroom techniques, and mastering the essentials of lighting and composition. Although the photography courses at junior colleges might be taught in the art department, the main emphasis will be on the practical aspects of photography rather than more advanced creative exploration.

To teach at this level, you must have a bachelor's degree or, increasingly, a master's degree. Some states might require additional credentials for teaching at public institutions. Salary levels for entry positions range from \$16,000 to \$25,000 and increase to a range between \$35,000 and \$65,000.

Teaching Photography Workshops for Aspiring Professionals

Photography workshops are offered on a wide range of topics, including ambient light, Zone System photographic techniques, infrared, still life, wildlife, glamour, fashion, and virually any subject in front of or behind the camera lens. You'll find workshops on marketing your photographs, getting your work exhibited in art galleries, and finding your own personal "vision."

Photographers who lead workshops and seminars are typically working professionals with a great deal of experience in a specific area of photography. There are a number of established workshop programs or institutes that offer short-course seminars throughout the year. Some workshops are only offered during summer months or off-season times for the university professors or professional photographers who teach them.

The annual *Photographer's Market* lists some 140 established workshops, and several photography magazines include listings regularly, either as part of a regular feature or in the classified ad section.

Individual tuition fees for these seminars range from \$100 per day to \$3,000 or more for a two-week intensive program. This fee covers all expenses and overhead, including the instructor's fee. Individuals who establish their own seminars, therefore, have tremendous earning potential, but one must consider the expenses of advertising and facilities.

Teaching Basic Photography Courses for Photo Buffs

In addition to the professional workshop circuit, many local community schools or organizations offer basic photography courses for hobbyists. Depending on the organization, the fee charged, and the number of students you can handle at a given session, this can be a worthwhile sideline to a freelance career. It can also be just plain fun helping to turn someone else on to the enjoyment of photography!

Photographer's Representative

Many photographers, especially those whose work is in demand, don't have time to take care of the business end of photography—promoting themselves to potential clients, arranging meetings, scheduling photo sessions, and negotiating fees. They'd much rather spend their time behind the camera than on the telephone or behind a desk.

That's where the photographer's representative comes in. The rep works much like a literary agent. It's the rep's job to match the photographer with the clients, make the contacts and sell the photographer as the best one to be hired for a particular project—or for future projects. The rep also handles contract negotiations, which, although a time-consuming and tedious process, determines both the photographer's and the representative's income.

A photographer's representative will work for several photographers at once, but will usually seek to present one specific photographer for a given job or client, working to match the photographer's style and specialization with the client's needs. Reps make sales presentations to art directors and department heads of major corporations and advertising agencies. They need strong sales skills, as well as good organizational and negotiating skills.

The photographer's representative may work with a consortium of representatives, both literary agents and artist's representatives, or alone. Photo reps work in major metropolitan areas, primarily New York, Los Angeles, and Chicago. Earnings are based on a percentage of the negotiated fee for the photographer, so the more work you can gain for your photographers, the more you earn.

Motion Pictures: Film, Video, Television

The moving pictures industry—whether the Hollywood movie machine, the local television news, or wedding videography provides enough opportunities for an entire book by itself. This book, therefore, will only present a brief introduction to some of the opportunities in movie and video as an acknowledgment of the close relationship between moving and still photography.

In virtually any area of photography discussed elsewhere in this book, you will find a market for moving images, as well as for still photography. Even magazines are starting to come out on CD-ROM and incorporate video or movie clips as part of the overall package. The future of video technology is wide open and changing all the time.

At Work in the Movies

The movie industry is almost exclusively operated in the rarefied world of Hollywood, a part of the sprawling landscape that is collectively known as Los Angeles. Some film work is done in New York and Miami, but the majority is done in Los Angeles or, when on location elsewhere in the world, by film crews based in L.A.

Los Angeles is also home to two major universities offering degree programs in cinematography: the University of California at Los Angeles (UCLA) and the University of Southern California (USC). A degree in cinematography is no guarantee of a job. For that you need talent, reliability, good contacts, and a lot of luck.

The ultimate goal of many a camera operator is to be a film director. Others are quite happy with the title "Director of Photography," which is one of the categories for the annual Oscar awards. The movie business offers a broad range of challenges, as well as the potential for a lucrative career.

Camera Operators

Any aspect of the movie industry is difficult to break into, whether you're an aspiring actor or a would-be camera operator. The reality is that there are far more people eager to do the jobs than there are jobs to be done. It's a glamorous industry, suffused with excitement, with a promise of a big payoff—someday. Getting started means sweeping floors, running errands, moving props, and anything else that gets you "on the set." From there, making connections, showing your film clips to anyone who will look at them, and just plain luck are what might open the right doors.

If the magic works, you can expect to earn a minimum of \$150 per day as a film loader, \$180 per day as a second assistant camera operator, \$190 per day as a first assistant, and \$275 per day as a camera operator. These are representative of union rates, and most films are made by union operators. After an eight-hour day, the rate is time and a half, double time on weekends or holidays.

Special Effects and Animation

Harley Jessup works for Industrial Light and Magic, the company that brought us the special effects in *ET*, the all-time top money-making motion picture, as well as *Star Wars*, *Hook*, and a number of films requiring a little industrial magic. His training is as a graphic designer, but a great deal of his work involves photography, including movie film, still photography, and frame-by-frame motion pictures. Similarly, Will Vinton, creator of the California Raisins, works on a frame-by-frame basis to animate the Claymation figures of his now famous commercials.

Camera operators in the area of special effects and animation photography can earn from a modest \$25,000 per year for a small studio to \$50,000 or more per year at a larger organization involved with big-budget pictures. Creativity, an artist's eye, and a technician's capabilities are all prerequisites in this exciting new field.

Television

According to Nielsen Media Research, the company that brings us the Nielsen ratings of television programs, 98 percent of Americans own a color television set. In 1992, the average American household had the television set turned on for an average of 7 hours every day.

Each of those programs involved the work of a camera operator or, as they're sometimes called, engineers. Comedies, mysteries, dramas, made-for-television movies, and news programs are filmed by camera operators who belong to either the International Alliance of Theater and State Employees or the National Association of Broadcast Employees and Technicians.

While the majority of television programs are filmed in New York or Los Angeles, quite a number are filmed in other parts of the country. The Mary Tyler Moore Show, for instance, filmed some segments in Minneapolis. The short-lived but well-done program, Frank's Place, was filmed in part in New Orleans. Miami Vice and The Streets of San Francisco were also shot on location.

Beginners should look for jobs at one of the many smaller local stations throughout the country, or with a cable television network.

Broadcast News

Camera operators for both studio and field work are behind all the images we see on television news programs. Special video cameras are used to tape events, and then transmit the visual images to the station for broadcast. Local news programs are often the starting point for careers in television news, especially for camera operators. Major cities in every state and province have their own local television stations, sometimes several competing stations. These provide excellent career opportunities; however, your first job is likely to be in the film library rather than behind the camera. Be prepared to be patient.

Advertising

Major advertising agencies rather than television networks or stations are the employers of advertising filmmakers. The making of an advertisement is not unlike the making of a television program or motion picture. There's a director, an art director, a producer (the client), a camera operator, and a host of behind-the-scenes stylists and assistants. The pay scale for camera operators in this demanding industry, as with the advertising industry for still photographers, is significantly higher than for many other areas.

Corporate and Industrial Film Work

The needs for videos and films in the corporate and industrial world are many and varied. Companies, organizations, and governmental agencies all hire camera operators and filmmakers to create nontheatrical films with a specific message and purpose. Large corporations have camera operators on staff but might also hire an independent. The starting position in corporate film work is as a production assistant.

Here are a few of the uses for film and video work in business and industry:

- Training films
- Product advertising and marketing videos
- Headhunter videos designed to attract top executives to work for large corporations
- Informational videos that promote products, an organization or company, or operations or procedures
- Sales videos that provide the sales representatives with information about products and sales strategies
- New purchaser videos that give instructions to consumers on how to use or apply products they've purchased

The World of Freelance Videography

One of the drawbacks to working on your own in the film industry is the expense of both equipment and film—not to mention processing. The relatively inexpensive video recorders and camcorders, which use ready-to-watch video cassettes—have made moving picture photography accessible in the way the first instamatic cameras brought still photography to the masses. With proper training, experience, and that intangible "photographer's eye," you can become a valuable asset to a variety of potential clients.

Aside from a camcorder or video recorder, you need to have some means of editing the tapes you make. Unless all you are doing is creating an inventory of objects for insurance purposes, you will need to rearrange the visual information you've recorded. It's impossible to imagine being able to plan so carefully and film so perfectly that all elements of a video appear in proper sequence without any extraneous details.

The computer has made video editing more simple and less expensive. With a minimal investment in equipment—a video board for the computer, cables to attach your video camera or player, and the necessary software—you're ready to roll.

Here are some examples of the kind of work you can find as a freelance videographer:

- Real estate videos showing properties available for sale
- Tourism videos for local chambers of commerce, tourist bureaus, resorts, cruise ships, or tour operators
- Art videos for exhibition in modern galleries
- Sports videos for children's sports events, local team sports, or collegiate sports
- Children's dance recitals or school programs
- A "day in the life of your child" or children's party videos

232 CAREERS FOR SHUTTERBUGS

- Convention videos for trade and professional shows
- Horse or pet show videos for sales to individual owners and riders
- Personal music videos for aspiring musicians
- Audition videos for aspiring actors
- Weddings and other celebrations such as Bar Mitzvahs, Bat Mitzvahs, First Communion, or Confirmation services
- · Family histories or interviews with grandparents
- Videotaping meetings for organizations, public hearings for government agencies, or presentations for businesses
- Training tapes for business and industry
- Demonstration tapes that present basic information on products and services or how to use equipment
- Self-critique tapes for professionals in all areas who want to "see" how they're doing their jobs
- How-to videos for mail-order marketing
- Witness interviews for legal cases
- Videotaped resumes or job applications and interviews

Photography Writer

One final career option is the photographer who combines a deep knowledge of the medium with a desire to inform others about the industry. The photography writer does all kinds of writing about photography—equipment reviews, informational articles, editorials or opinion pieces, and magazine articles on every conceivable subject related to photography. These writers work for camera, film, and photography equipment manufacturers, marketing companies, and magazines or trade publications. They might also work as freelancers, combining their photography experience and writing skills to sell articles to a variety of clients. They are also book authors, writing about photographic methods, techniques, and genres to help photographers learn more about their craft.

A salaried writer will earn between \$15,000 and \$35,000 per year, depending on the employer. A writer with responsibility for advertising copy will earn a bit more than one who works strictly on editorial text. Freelance photography writers earn their income through magazine sales, primarily, or from book royalties. This can be a strong sideline for a photographer with the necessary skills.

Some Final Words of Advice from Someone Who's Done It All

Andy Baird started photographing with box Brownies as a child. He progressed through early Polaroids to a 35mm Argus in his teens. He stumbled into a science photography career out of high school, traveled to Costa Rica as a photographer on a research project funded by the National Geographic Society, built his own processing drum for his kitchen "darkroom," built a microcomputer, and wrote his own paint programs. In 1984, he got involved with computers and their relationship to photography and is now involved with multimedia CDs.

Throughout all these experiences, photography has been a mainstay. Andy offers some sage advice with which I'd like to end this book.

Here are a few tips for those who want to get serious with photography—whether for love of art or for cold cash.

• Start simple. Learn the basics of photography before you invest

in that auto-everything SLR. A few months or years spent with an all-manual camera will give you a solid foundation to build on. Start with black and white and learn to develop and print even if, like me, you're drawn to color. Most of all, learn to see. No amount of equipment can help you if you can't do that.

- Stay simple. Don't succumb to the old "if only I had this lens, I could take really good/creative/professional photos" syndrome. Over the years I've accumulated a set of lenses ranging from 7.5mm up to 400mm, and you know what? I do 95 percent of my shooting with just two lenses: a 24mm wide angle and a 100mm macro. Your own favorites may be different, but the point remains: The love of equipment is a snare and a delusion that will lead you astray and fritter away your time and money. Get good equipment, but only get what you really can use—and then use it, abuse it, master it completely before moving on to another purchase.
- The best accessory is film. If you're looking for something to spend money on, spend it on film. Never scrimp on film. Keep plenty of it around (your refrigerator's vegetable bin is a good place to stash a few dozen rolls). Don't be afraid to waste it on grab shots, long shots or other "risky" pictures. Your mistakes are your best teachers, so be sure to make plenty of mistakes. Take risks and you'll improve far faster than the careful planner who makes every shot count.
- Carry a camera everywhere, all the time, and pictures will seek you out. Don't think that you can occasionally strap on a camera and go looking for pictures when the mood strikes you—you'll find they elude you. Even if it's just a point-andshoot cheapie, having a camera on you at all times does more than ensure you can get those unexpected grab shots. It magically educates your eyes; the mere consciousness of having a camera on your person makes you see better...all the time.
- Give yourself assignments. It doesn't matter whether you have a client or a teacher telling you what to photograph. Tell yourself. Assign a subject and then photograph it. Pick some-

thing you're interested in—reflections, children, hubcaps, old people—and really study it. Even better, pick something you're not interested in, something mundane, and see whether you can make it interesting by seeing it in a different way.

• Take notes. Carry a pocket notebook with your camera, and whenever you can, write down your lighting, exposure, aperture and other variables. The more information you have when you look at the processed images about what you were doing when you took the photo, the better your chance of recreating that serendipitous accident—or avoiding that fatal mistake. ANDY BAIRD

For Further Information on Careers Related to Photography

Organizations

National Association of Photographic Manufacturers. 550 Mamaroneck Ave., Harrison, NY 10528.

Photo Marketing Association International. 3000 Picture Place, Jackson, MI 49201.

Sections included in PMA membership:

- Association of Professional Color Laboratories (APCL)
- National Association of Photo Equipment Technicians (NAPET)
- Photo Imaging Education Association (PIEA)
- Professional School Photographers of America (PSPA)

Professional Societies, for which membership is limited to certified professionals, include:

- Certified Photographic Counselors (CPC)
- Society of Photo Finishing Engineers (SPFE)
- Photographic Art and Science Foundation. 111 Stratford, Des Plaines, IL 60016-2105.

Society for Photographic Education. P.O. Box 222116, Dallas, TX 75222-2116.

Society of Motion Picture and Television Engineers. 595 W. Hartsdale Ave., White Plaines, NY 10607.

236 CAREERS FOR SHUTTERBUGS

Society of Photo-Technologists. 6535 South Dayton St., Suite 2000, Englewood, CO 80111.

Society of Teachers in Education of Professional Photography. 371 Greenport Dr., West Carrollton, OH 45449.

University Photographers Association of America. C-389 ASB, Brigham Young University, Provo, UT 84602.

Books

Stanton, Eileen. Cash in on Your Camcorder: 102+ Ways to Make Money and Have Fun with Your Camcorder. Albuquerque, NM: Sandia Publishing Corp., 1989.

Periodicals

Darkroom Photography. LFP, 9171 Wilshire Blvd., Suite 300, Beverly Hills, CA 90210.

Photo Lab Management. PLM Publishing Inc., 1312 Lincoln Blvd., P.O. Box 1700, Santa Monica, CA 90406.

Photobase. American Video Institute, Rochester Institute of Technology, P.O. Box 9887, Rochester, NY 14623-0887.

Photographic Processing and PTN (Photographic Trade News). PTN Publishing Co., 445 Broadhollow Rd., No. 21, Melville, NY 11747-4722.

Photomethods. 1090 Executive Way, Des Plaines, IL 60018.

VGM CAREER BOOKS

Cover Letters They Don't

Guide to Basic Cover Letter

Joyce Lain Kennedy's Career

Successful Interviewing for

Careers Checklists

Executive Job Search

Guide to Basic Resume

Forget

Strategies

Writing

Writing

Out of Uniform

Slam Dunk Resumes

College Seniors

GREAT JOBS FOR

Foreign Language Majors

Approach an Advertising

Agency and Walk Away

with the Job You Want

Bounce Back Quickly After

Choose the Right Career

Find Your New Career Upon

Get & Keep Your First Job

Have a Winning Job Interview

Hit the Ground Running in

Improve Your Study Skills

Jump Start a Stalled Career

Get into the Right Law

Losing Your Job

Change Your Career

Retirement

Get Hired Today

Your New Job

Land a Better Job

School

English Majors

History Majors

HOW TO

Psychology Majors

CAREER PORTRAITS

book

Animals

Music

Sports

Teaching

CAREER DIRECTORIES

Careers Encyclopedia Dictionary of Occupational Titles **Occupational Outlook** Handbook

CAREERS FOR

Animal Lovers Bookworms **Computer Buffs Crafty People Culture Lovers Environmental Types** Film Buffs Foreign Language Aficionados Good Samaritans Gourmets **History Buffs** Kids at Heart Nature Lovers Night Owls Number Crunchers Shutterbugs Sports Nuts **Travel Buffs**

CAREERS IN

Accounting; Advertising; Business; Child Care; Communications; Computers; Education; Engineering; Finance; Government; Health Care; High Tech; Journalism; Law; Marketing; Medicine; Science: Social & Rehabilitation Services

CAREER PLANNING

Admissions Guide to Selective Business Schools **Beginning Entrepreneur** Career Planning & **Development for College** Students & Recent Graduates Career Change

VGM Career Horizons

a division of *NTC Publishing Group* 4255 West Touhy Avenue Lincolnwood, Illinois 60646–1975

Launch Your Career in TV News Make the Right Career Moves Market Your College Degree Move from College into a Secure Job Negotiate the Raise You Deserve Prepare a Curriculum Vitae Prepare for College Run Your Own Home **Business** Succeed in College Succeed in High School Write a Winning Resume Write Successful Cover Letters Write Term Papers & Reports Write Your College Application Essay

OPPORTUNITIES IN

This extensive series provides detailed information on nearly 150 individual career fields.

RESUMES FOR

Advertising Careers **Banking and Financial** Careers **Business Management** Careers College Students & Recent Graduates **Communications Careers Education Careers Engineering Careers Environmental Careers** Health and Medical Careers **High School Graduates** High Tech Careers Midcareer Job Changes Sales and Marketing Careers Scientific and Technical Careers Social Service Careers The First-Time Job Hunter